PAINTING IN
EIGHTEENTH-CENTURY
FRANCE

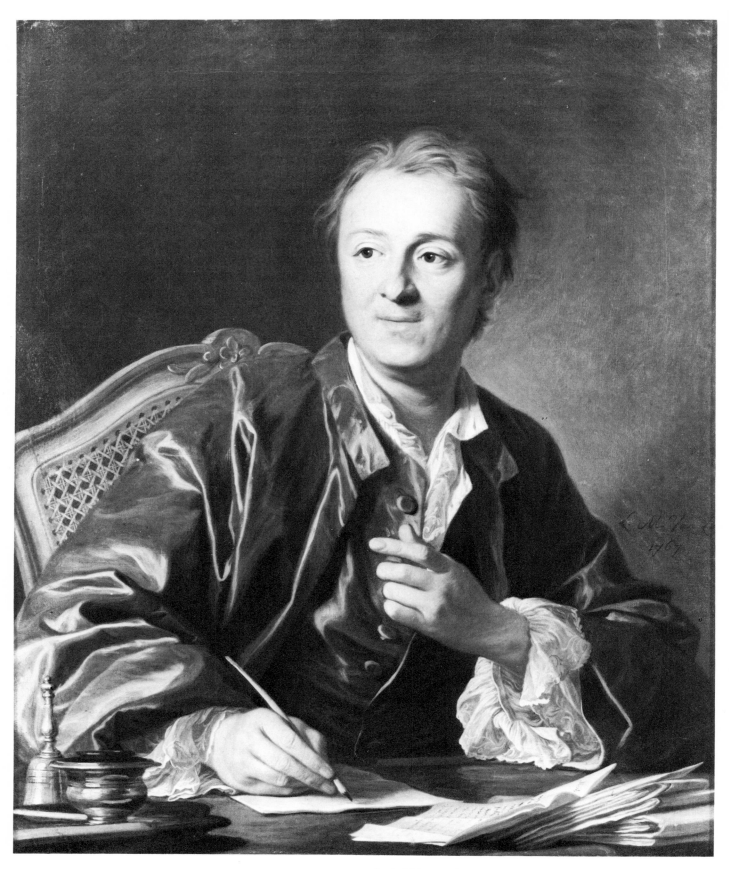

LOUIS-MICHEL VAN LOO: *Denis Diderot.* 1767.
Oil on canvas, 81 × 65 cm. Musée du Louvre, Paris

PAINTING IN
EIGHTEENTH-CENTURY
FRANCE

PHILIP CONISBEE

PHAIDON · OXFORD

Phaidon Press Limited, Littlegate House, St Ebbe's Street, Oxford
First published 1981
© 1981 by Phaidon Press Limited

British Library Cataloguing in Publication Data
Conisbee, Philip
Painting in eighteenth-century France.
1. Painting, French
I. Title
759.4 ND546

ISBN 0-7148-2147-0

Phototypeset by Tradespools Limited, Frome, Somerset
Printed in Great Britain by Morrison and Gibb Limited, Edinburgh

CONTENTS

In memory of
KEITH ROBERTS
(1937 – 1979)
and
IAN HILSON
(1946 – 1980)

PREFACE

Until the late 1960s, French art of the eighteenth century was commonly presented in terms of a neat polarity between the 'frivolous' rococo style of the first half of the century and the more 'serious' neoclassical revival of the second half. Of course, anyone with a deeper interest in the period was aware that the overall picture was a good deal more complex than that; but the popular view (in so far as there ever has been a 'popular' view of the eighteenth century) was then, and remains, far removed from anything that would have been acceptable in the period itself.

French eighteenth-century painting has been undergoing a quiet reappraisal during the last ten years or so, mainly at the hands of French scholars, though important work has been done elsewhere, particularly on the other side of the Atlantic. To the present writer, the Jean Restout exhibition organized at Rouen in 1970 by Pierre Rosenberg and Antoine Schnapper was an important demonstration of the continuity of the tradition of monumental figure-painting throughout the eighteenth century. As I wrote in a review at the time, 'It is instructive, if not always wholly delightful, to step back from the boudoir and the cabinet and consider that serious and committed grand manner which, with many surprises to offer us, continued from the time of Jouvenet to that of David.' But that remark still implied a refusal to come to terms with the functions and ideology of such art, or with its austere, ambitious, and often difficult ideal beauties, which *do* offer their own delights.

To the late Keith Roberts, who commissioned this book, it seemed desirable to present to the English-speaking public in this introduction a view of the art of the *ancien régime* that would balance the more private art, which colours the common view of the period, with its until relatively recently neglected public art.

My greatest debt is to all the specialists, such as those named above—and many more, some of whom are named in the Bibliography and the Biographical Notes—on whose painstaking researches a general book of this kind must be based; they will be its severest judges. For financial assistance I am pleased to acknowledge the Research Board of Leicester University, which has enabled me to visit France on several occasions.

My dedication is to two friends, who would have been among my most exacting readers: Keith Roberts, who with his keen enthusiasm encouraged me to write the book; and Ian Hilson, who understood so well the meaning of the *fête galante*.

Philip Conisbee
Leicester, 1980

INTRODUCTION

The object of this book is to provide a brief survey of painting in France during the last two reigns of the *ancien régime*. Artistic life in eighteenth-century France was highly centralized, on Paris, and even more narrowly on the Académie Royale de Peinture et de Sculpture. Although there were several lively provincial artistic centres, the Parisian scene is our concern because of its central importance in France and because Paris held a leading position in European art as a whole.

The approach adopted is thematic rather than a sequence of biographies, but brief biographical notes on the artists mentioned in the text can be found at the end of the book. The text is organized in order of the hierarchy of the genres of painting as it was understood in the eighteenth century. The genre of history painting has been divided into religious and secular works, because the former have never been accorded their true importance in general studies of this kind.

The difficult decision to end this survey at the Revolution was determined partly by considerations of space. To discuss the radical changes in artistic life (especially its institutions) and in patronage that were brought about by the upheavals of the Revolution would simply have allowed less attention to be paid to the earlier, and nowadays more neglected, part of the century. But to end at that date also has the advantage that we can look at the last century of the *ancien régime* as something complete in itself. It has always proved difficult for students of any aspect of France in the eighteenth century to resist the temptation to read the century as a preparation for the cataclysm of the Revolution, or as a historical and cultural interlude between the great achievements of the age of Louis XIV and the exciting dramas of Republic and Empire.

With the exception of David in the late 1780s, eighteenth-century French painting was not dominated by great and influential individuals. The academic system of art education, inaugurated under Louis XIV in the middle of the seventeenth century, was so thorough and uniform that it produced a large number of talented artists, who were above all trained to supply a fairly specific demand for didactic or decorative history paintings. A number of exceptions to this pattern— Watteau, Fragonard, Chardin or Greuze, to name the most brilliant—have been too readily singled out for admiration, as a result of the Romantic interest in originality and individuality. But the present book attempts to set such painters into perspective with the artists who constitute the rule of the eighteenth century rather than the exception, and who were at least as much admired in their day.

In order to approach a school of painting as diverse and complex as that of eighteenth-century France, the modern spectator has to adopt a relativistic view of the different genres, one to which his eighteenth-century counterpart was more

conditioned. Almost any informed spectator in the mid eighteenth century would have cited the names of several of the history painters discussed here in Chapters Two and Three, as the significant artists of his day. It was in the genre of history painting that the highest ideals and aspirations of the art were thought to be embodied. Watteau and Chardin, for example, were greatly admired in their day, as in ours; but only within their chosen genres, and even then only by certain circles of connoisseurs. Moreover, it will not help our understanding to approach, say, an enormous altarpiece by Van Loo, or a history painting by Brenet, with eyes attuned to delicately finished cabinet pictures by masters of the *fête galante* or the still life. Modern taste appreciates an art that is private—in the sense that we enjoy a feeling of private communion with the artist, and also in the related sense that we enjoy an art that is not demonstrative, but seems to conceal more than it reveals. A great amount of eighteenth-century art is public, demonstrative, and even declamatory— often proclaiming noble and evelated ideals that have no relevance to our private preoccupations and little bearing on public issues of the twentieth century. Thus it does require an act of imagination on our part to understand the aspirations behind, say, an allegorical *Apotheosis of Hercules* (Fig. 64), the respects paid to du Guesclin in the Middle Ages (Fig. 78), or a *Preaching of St Augustine* (Fig. 39). These represent the official, public art of the Crown, State and Church. Similarly, decorative painting, for which we have little use, may seem like an irrelevant triviality today; but for the eighteenth-century painter it was one of the commonest and most lucrative demands on his talent.

Imaginative effort is required even to enter into the world of Watteau or Chardin, for they too worked for a society very different from ours. During the period of the *Régence* (1715–23) the centre of French society moved from Versailles to Paris, where Philippe, Duc d'Orléans lived at the Palais-Royal. Refined social life now flourished in the more intimate and private *hôtels* of Paris, which had replaced the pomp and splendour of Louis XIV's Versailles, setting the tone for the rest of the century. It was a highly sophisticated society, and cultivated the polite arts to a degree scarcely seen in Europe before or since, with intimate social and intellectual gatherings, conversation, letter-writing, and flirtation. And for all the social tensions and aggravations which existed under the surface, it was still a world of absolute authority and hierarchy, in politics and in manners, descending from the monarch (his supremacy asserted by his panoply of curtains and columns, Figs. 89 and 90) to de Troy's bourgeoisie (Fig. 96), or Chardin's kitchen maids (Fig. 141), all of whom seem to know their place in the order of things.

It was very much that world of relative social stability, with a privileged class seemingly pursuing a life of ease, dalliance and refined culture, that formed the nineteenth-century Romantic image of France before the Revolution. This nostalgic image of the *ancien régime* developed especially with the Restoration of the Bourbon monarchy in the second decade of the nineteenth century. Indeed, that image was founded not least on the artful idealism of Watteau, Boucher, Fragonard, and other decorative painters, which was in any case, quite arguably, tacit propaganda for a certain view of the world. Although the work of Watteau and other rococo painters was neglected and disparaged by the neoclassicists during the last decades of the eighteenth century, it was not entirely forgotten. David, for all his severe style and Revolutionary principles, admired both Watteau and Fragonard, although he did not share their aesthetic and could not have recommended them for imitation. There were always a few connoisseurs, discerning collectors and astute dealers who maintained an interest in the art of the earlier eighteenth century.

The most articulate and eloquent of a long line of nineteenth-century devotees to French eighteenth-century painting were the brothers Edmond and Jules de Goncourt—connoisseurs, collectors, men of letters, and also, in their way, careful historians. In a series of articles published over some twenty years, and collected in 1875 as *L'art du dix-huitième siècle*, they brilliantly crystallized the nostalgic view of the previous century that the Romantics saw in its painting. But if we compare the names of the artists studied by the Goncourts—Watteau, Chardin, La Tour, Boucher, Greuze, Saint-Aubin, Gravelot, Cochin, Eisen, Moreau, Debucourt, Fragonard, Prud'hon (six of whom are engravers and illustrators)—with those admired at the Salons of the eighteenth century by contemporary critics or holding notable positions in the art world of their day, it will be seen that 'The Art of the Eighteenth Century' is a misleading title indeed!

However, in spite of meticulous research by other nineteenth- and early twentieth-century historians into the public and 'official' art of history painting, and the patient transcription and publication of nearly all the official documents concerning eighteenth-century artists and the State, the Romantic, 'Goncourt' view has remained deeply attractive (not least to wealthy collectors—think how 'collectable' such art is, being small-scale and easy on the eye, and of the aura of wealth, taste and luxury it has!) and still dominates the popular conception of the art of the *ancien régime*. It is hoped that the present volume will go some way towards redressing the balance by giving a view of painting in France in the eighteenth century that would have been recognizable to an informed spectator of the day.

1 THE ARTIST'S WORLD

French and especially Parisian artistic life in the eighteenth century was dominated by the Académie Royale de Peinture et de Sculpture, and it is important to understand the role played by this institution in the lives of all the painters we shall discuss. The Académie was founded by Colbert in 1648, as part of a centralizing policy that would bring all artists under government control, and to ensure that the talents it nurtured would be engaged in promoting the ideology of Louis XIV and his régime. The Académie was the responsibility of the Surintendant (or Directeur) Général des Bâtiments du Roi, who kept an eye on its business, and through whose office royal commissions passed to the artists. The Surintendant would also make recommendations to the King in such matters as the appointment of Premier Peintre du Roi. The Académie was organized on hierarchical lines, with about fifty officers (some of them honorary), comprising a Directeur, Chancelier, Recteurs, Adjoints-à-Recteur, Professeurs, Adjoints-à-Professeur, Conseillers, and a Secrétaire; then there were about fifty or more Académiciens and about forty Agréés, but all these numbers fluctuated. An Agréé was a probationer, who on reaching a standard of competence approved by the Académie would be received as an Académicien. Members of the Académie had a monopoly on royal commissions, and also had exclusive rights to show works at its official exhibitions at the Salon du Louvre.

Artists tended to come from relatively modest social backgrounds, but there were some notable artistic dynasties established by the beginning of the century, such as the Boullogne family (who were wealthy financiers) and the Coypel and Van Loo families. Membership of the Académie was in itself a social distinction, and if the artist was one of the few to become Premier Peintre he could hope for elevation to the nobility and for decoration with the royal Ordre de St Michel. It was common for an artist to have had a father who was a skilled artisan, such as a carpenter, frame-maker or painter-decorator. Working in a church, a public building, or the _hôtel_ of some nobleman or wealthy financier, our artisan, assisted by his son of twelve or fourteen, would come into contact with painters and sculptors—that is, 'fine' artists with all the prestige of connections with the Académie. The youth may have manifested some talent for drawing and it would take little social or financial ambition for his father to suggest him as a trainee or assistant to one of the painters. He would thus become apprenticed to a master, helping with the mixing of colours and the preparation of canvases in his studio, learning in this way the rudiments of painting technique, and being taught to draw. A more formal education was offered at the Académie, and to benefit from this the aspiring painter would have to be

sponsored by an Académicien (normally his master), who would sign for him a *billet de protection* to show that he had received some basic training.

The fundamental practical instruction at the Académie was in the drawing of the human figure. After enrolment the young artist would copy drawings or engravings of anatomical details—heads and limbs, eyes, noses, mouths, and so on. Then he would be permitted to copy drawings or engravings of whole figures made by his teachers or by approved old masters. After about a year of this training he would move on to study casts from famous antique sculptures, or works by recognized modern masters. Only at this stage, when he had thoroughly assimilated a series of visual formulas for rendering in two dimensions parts of the human figure or the whole of it, and had his efforts checked and approved, would our student be permitted to draw from the nude male figure in the life class. The various stages of this education can be read from left to right in a didactic engraving by Cochin (Fig. 1), published in the *Encyclopédie* to show the ideal training for a draughtsman (the student at the extreme right is a sculptor, working in soft clay relief after an antique statue). There was a range of conventional postures for the life model, who would adopt a pose for about two hours, three days each week, and then another pose for another three days, sometimes aided by a rope, staff, box or cushion. Two etchings by Carle Van Loo (Fig. 2) show different poses; countless students in the eighteenth century must have had to copy these and similar designs in the first stages of their training as draughtsmen. It is indicative of the aims of academic education that such figure-drawings came to be known as *académies*, as can be seen on the title-page of Van Loo's series of etchings.

A drawing by Cochin (Fig. 3) shows the life class in operation, with teachers offering instruction to some of the students. Evidently some seats were better located than others, and students were admitted to take their places in the life room by strict order of hierarchy, with the sons of Académiciens first. Both the drawing and the engraving by Cochin show students at work by artificial light, which ensured a controlled and constant illumination of the models, whether live, sculpted or cast. This training in drawing from the model might last several years, and constituted the final practical instruction at the Académie. The young artist was expected to learn the craft of painting in the studio of his master. At the Académie regular drawing classes were complemented by theoretical courses on

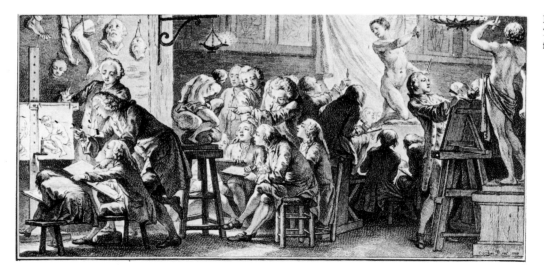

Fig. 1. CHARLES-NICOLAS COCHIN: *The Drawing Academy*. Engraving from the *Encyclopédie*, 1763

Fig. 2 CARLE VAN LOO: Two etchings from *Six Figures Académiques*, about 1743

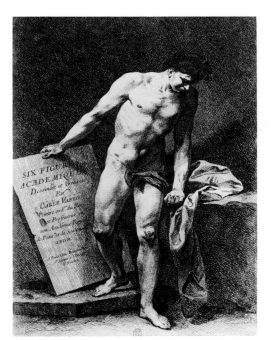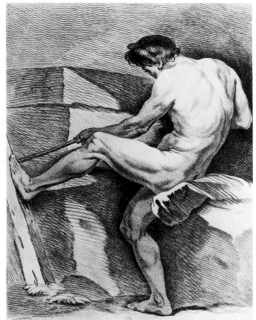

anatomy, perspective and geometry, and students were also instructed in literature, and in religious and ancient history. Lectures were given on practical matters such as colour or chiaroscuro, and some, of a more historical and critical nature, on admired old masters such as Poussin or Le Sueur. The emphasis on a rigorous and systematic study of drawing was not without its critics, and it must have required great tenacity not to be overcome by such discipline and such pressure towards uniformity. The painter Chardin (although a staunch supporter of the Académie) felt that many artists, already bored and drained of interest by such a long and conventional training, would be at a loss when they came to confront nature for themselves. His friend and admirer the critic Denis Diderot (1713–84) shared this liberal and naturalistic aesthetic viewpoint when he wished he could take young artists on their way to the Louvre by the sleeve and urge them: 'Look in the streets, gardens, markets, houses, for that is where you will get the right idea of the true movement and action of life. . . .' However, the rigour of academic training must in large part account for the generally very high standard of French historical and religious painting during the eighteenth century—Chardin never attempted the historical genre, for he had never benefited from the solid foundation of draughtsmanship provided by the schools of the Académie.

History painting was the end to which this intensive study of the human figure was directed. The European humanistic tradition in art theory, dating back to the Renaissance in Italy and taking antique statuary as an exemplar, stressed that the noblest and most important role of the artist was to represent the actions, ideas and ideals of man, measure of all things. Hence history painting was intellectually and morally the most elevated genre of the art, followed in order of importance by portraiture, genre painting, landscape, and still life, all of which were seen to approach 'mere' nature more closely. This hierarchy of the genres, codified for French artists by the theoretician André Félibien at the end of the seventeenth century, formed the generally accepted basis of artistic activity in our period, though its assumptions did not go entirely unchallenged. Moreover, it was not

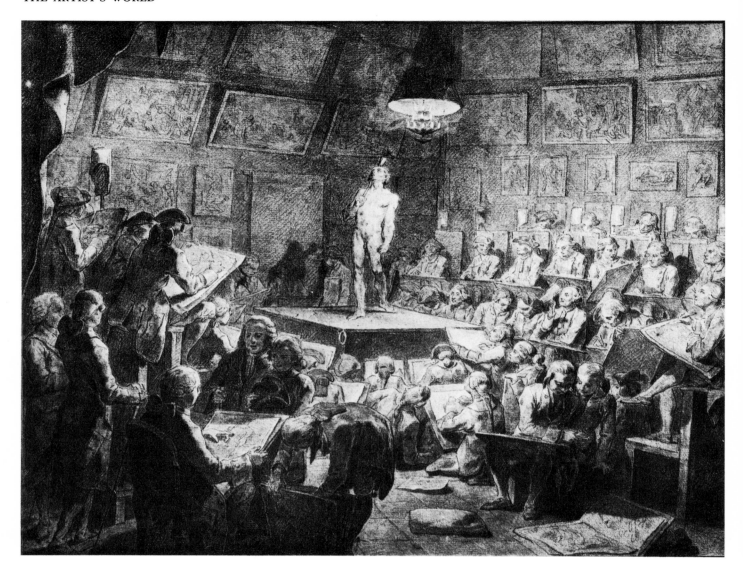

Fig. 3. CHARLES-NICOLAS COCHIN: *The Life Class*. About 1760. Chalk on paper. Whereabouts unknown

simply the depiction of any human activity that was considered the most worthwhile deployment of artistic talent, but that of the actions of the heroes of humanity, at moments of moral or historical significance, which might be exemplars for the more common run of men. Thus the human figure was considered the very foundation of painting, the prime expressive vehicle of action, thought, and emotion. In addition to acquiring a perfect understanding of anatomy, and of the numerous narrative and expressive possibilities of the human frame through a variety of poses and gestures, the artist had also to observe and master how the 'passions of the soul' were expressed in the human physiognomy.

The study of physiognomic expression has a history as long as that of the humanistic theory of painting, but the first text written on this topic by an artist for artists, which remained the basic text for French painters of the eighteenth century, was a lecture given by Charles Le Brun in 1668, of which versions were published in 1698 and 1718 under the title *Conférence . . . sur l'expression générale et particulière*. Although Le Brun's ideas on this subject were in fact quite sophisticated, the

various shortened and popularized published versions do him little justice. More important than his theories of emotion and its expression were the ways in which he (and even more so the engravers after him) codified these expressions into neat visual formulas that could be readily adapted and imitated. The range of emotions he analyses under the following headings might have been extracted from the plays of Corneille or Racine: admiration; boldness; esteem; veneration; ecstasy; disdain; horror; dread; simple love; desire; hope; fear; jealousy; hate; sadness; physical pain; joy; laughter; crying; anger; extreme despair; rage. Le Brun made a series of drawings to illustrate his ideas, and these were published as engravings in various editions from 1696 onwards. The six rather schematic illustrations in Fig. 4 were published in the 1718 edition of his *Conférence*; the fuller rendering of *Fear* (Fig. 5) is one of a series of plates engraved by J. Audran in 1727, with brief commentaries based on Le Brun's ideas. Generations of students at the Académie and elsewhere had to copy such engravings. These stock expressions of emotion can be encountered in hundreds of history paintings throughout the eighteenth century, but especially during the first thirty years or so, in the work of painters such as

Fig. 4. *Expressions.* Engraving from *Conférence sur l'Expression*, 1718, after Charles Le Brun

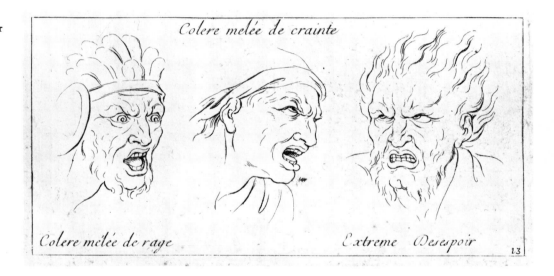

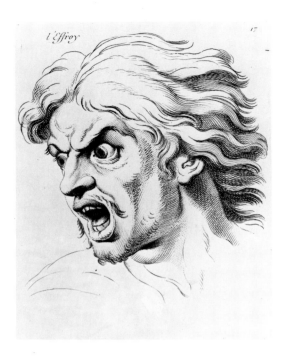

Fig. 5. *Fear*. Engraving after Charles Le Brun by
J. Audran, 1727

Charles-Antoine Coypel (Figs. 62 and 70), who grew up under the immediate influence of Le Brun's teaching. It was not until well into the Romantic period, with only rare exceptions in the eighteenth century, that artists attempted to extend their pictorial vocabulary of facial expression.

Our student, with a thorough knowledge of anatomy, gesture and expression, was offered inducements to excel, in the form of quarterly *petits prix* for various types of drawing, which would allow him to proceed through the academic system. When efforts were made to reform the Académie in the middle years of the century, new prizes were instituted, notably the *Prix d'expression* in 1759. This was proposed by an *honoraire-amateur* of the Académie, the Comte de Caylus, 'to stimulate and encourage pupils to make a detailed study of heads and especially the expression of emotion', as he said in a lecture. Cochin made a drawing of the competition in progress (Fig. 6), including portraits of three Académiciens in attendance. The competition, which was held once a year and lasted for three hours, was the only occasion at the Académie when a female model was employed; of course she was fully clothed, and only her head was drawn. Caylus also instigated a *Prix d'ostéologie* and a *Prix de perspective* in 1764, and the portrait-pastellist Quentin de la Tour in 1776 proposed a *Prix de l'étude de la tête ou des mains* and a *Prix d'anatomie*.

When the young artist was a fully proficient draughtsman, and had developed a sufficient painting technique in his master's studio, he would enter for the *Grand prix*, also known as the *Prix de Rome*: the successful candidate could look forward to about three years in Rome, as a *pensionnaire* of the King at the Académie de France. The competition began early in April, when the candidates presented themselves individually to a Professeur; in a room together, the latter would suggest to the pupil a theme, normally from the Bible, for which he had there and then to sketch a composition design in oils. These sketches, which tested the candidates' powers if invention, were then discussed at a meeting of the Académiciens, who selected not more than eight of the best. These were then worked up to their full scale, in the privacy of individual studios prepared for the occasion to prevent outside

assistance. Judgement was made at the end of August, in a vote of all the Académiciens. The canvases were of a more or less standard size (over 1 metre by about 1.5 metres) and would include about five principal figures. Unsuccessful candidates could re-enter themselves in subsequent years. Jacques-Louis David, for example, made three attempts before winning the *Grand prix*. At his second attempt in 1773 the subject was the morally exemplary one of the death of Seneca (Fig. 7), which he has interpreted with a spirited, painterly flourish, highly operatic poses and gestures, and lively play of light and shade. While the lofty theme and the Italian baroque references of the group on the left should have pleased his master Vien (see p.62), the plump and supple forms of the women on the right suggest Boucher, also once a mentor of the young David. Perhaps it was the more up-to-date, Poussinesque 'correctness' of his *Antiochus and Stratonice* (Ecole des Beaux-Arts, Paris) that finally gained David his place in Rome in 1774.

The history painter was expected to be a man of wide culture, well versed in all aspects of history and literature as well as in the traditions of his art. In 1747 it was felt that the young winners of the *Grand prix* would benefit from a more thorough intellectual training before their departure for Rome. Thus, as a part of the general reform of academic art education undertaken at this time by the Directeur des Bâtiments, Le Normand de Tournehem (which is discussed further in Chapter Three), the Ecole Royale des Elèves Protégés was opened in 1749, and here the prize-winners could follow courses in history, literature, and geography, in addition to continuing their artistic development. This institution was directed by Carle Van Loo from 1749 until his death in 1765, then by his nephew Louis-

Fig. 6. *Head and Expression Competition.* Engraving after Charles-Nicolas Cochin by J. Flipart, 1763

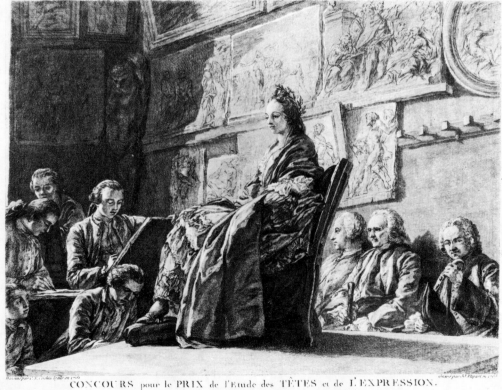

CONCOURS pour le PRIX de l'Etude des TÊTES et de L'EXPRESSION.
Fondé à l'Académie Royale de Peinture et Sculpture par M.ᵉ le Comte de CAYLUS Honoraire Amateur en 1760

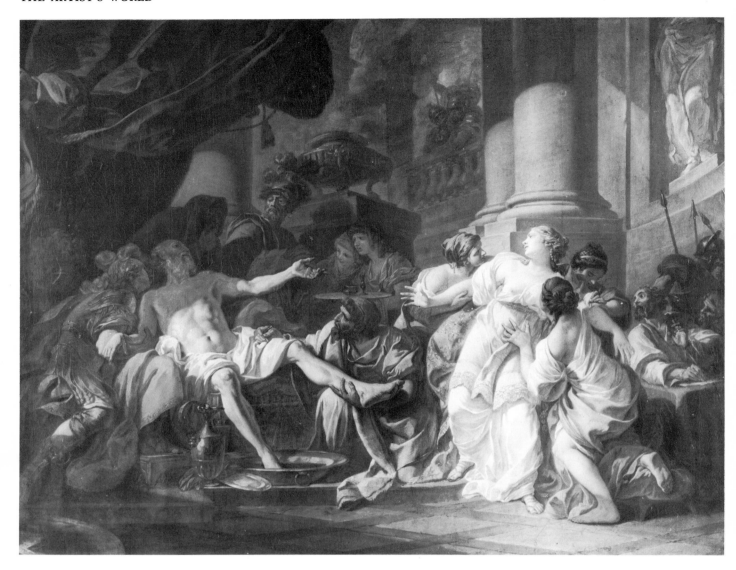

Fig. 7. JACQUES-LOUIS DAVID: *The Death of Seneca*. 1773. Oil on canvas, 123 × 160 cm. Musée du Petit Palais, Paris

Michel, and finally by Vien from 1771 until its closure in 1775. The all-important Professor of History was Nicolas-Bernard Lépicié, who devised the academic programme; he was succeeded in 1755 by Michel-François Dandré-Bardon, who remained until 1775. Time was also devoted to geometry, perspective, and anatomy, and to copying famous sculptures and paintings by old masters. Every evening there would be drawing from the life.

Thoroughly prepared by his long and exacting training, our student would be ready for the coveted trip to Rome, which in the eighteenth century was still the artistic capital of Europe. The *pensionnaires* lodged there at the Académie de France, where they also pursued their studies under the Directeur, normally for three years. The Directeurs of the Académie de France in Rome during the eighteenth century were Charles Poërson (1704–25), Nicholas Vleughels (1725–37), Jean-François de Troy (1738–51), Charles-Joseph Natoire (1751–74), Noël Hallé (1775), Joseph-Marie Vien (1775–81), Louis-Jean-François Lagrenée (1781–87), and François Guillaume Ménageot (1787–92). Vleughels was one of the most interesting,

sympathetic, and effective of these Directeurs, not least because through his efforts in 1725 the Académie was able to move from the cramped and undistinguished Palazzo Capranica to the much grander Palazzo Mancini on the Corso (where it remained until Napoleon provided the Villa Medici in 1803). On this fashionable thoroughfare the Académie became a French showpiece and a centre of social life for the international public which thronged Rome. For example, the *pensionnaires* took a prominent part in the annual carnival, which included processions along the Corso in costume. In 1748 they contributed a procession whose theme was 'a sultan's caravan to Mecca', a pretext to design exotic Turkish costumes, which are recorded in paintings, drawings and prints by Jean Barbault, Vien, and other students. In a more directly political way, French ambassadors in Rome used the splendid *palazzo* on the Corso for important receptions. Vleughels had taken great pride in fitting out the interior with the finest hangings and furnishings and a collection of sculpture. There were close relations between Vleughels and the French Ambassador, Cardinal de Polignac, who had a keen interest in art: in 1729 Polignac had organized spectacular celebrations in Rome to mark the birth of the Dauphin (the future Louis XVI), and the designs for these were prepared by the French students there. The correspondence between the Directeurs in Rome and the Surintendants des Bâtiments in France give us a good idea of daily life at the Académie, with reports on the progress of students, details of some of their extramural escapades, and information on the international social and political life of the day.

The primary aim in sending young French artists to Rome was to enable them to tread the classic ground that Poussin had trod in the previous century and to study the remains of antiquity and choice examples of the modern grand manner in the works of Raphael and his school, the Carracci and other Bolognese artists of the seventeenth century, and, as the century wore on, tenebrist painters such as Caravaggio and Le Valentin. The *pensionnaires* were also encouraged to visit artistic centres outside Rome, such as Florence, Bologna, and, especially under the directorate of Vleughels, Modena and Venice, the latter traditionally considered the best place to learn the art of colouring. In the 1750s funds were made available for students to undertake these extra travels. Drawing, however, was still the basis of their curriculum—from the life, or from celebrated sculptures and monuments. But they were also required to paint copies for the King, notably after Raphael and the Bolognese masters of the seventeenth century. Rome was also an exciting centre of modern art, and young Frenchmen had much to learn from natives such as Gian Paolo Panini (1691–1765), Sebastiano Conca (1680–1764), Marco Benefial (1684–1764), and Pompeo Batoni (1708–87), not to speak of influential foreigners, such as Gavin Hamilton (1723–98), later in the century.

From 1754, as well as two or three drawings after old masters, *pensionnaires* were required to send to Paris a painted study of the nude (*académie peinte*), such as David's *Patroclus* (Fig. 8), and a painted head expressing some emotion (*tête de caractère*); again, the stress was on the human body as a vehicle of expression. They were strictly answerable to the King through the agencies of their Directeur in Rome and the Surintendant in France; only in exceptional circumstances were they permitted to accept commissions. The emphasis of their studies might vary slightly, according to the inclinations of a particular Directeur; Vleughels and later Natoire (once his pupil) encouraged the students to sketch landscapes in and around Rome, a practice not normally accorded any importance in academic training. Indeed, it was felt in France that the affairs of the Académie in Rome had become rather lax under the long directorship of Natoire (1751–74), never a doctrinaire

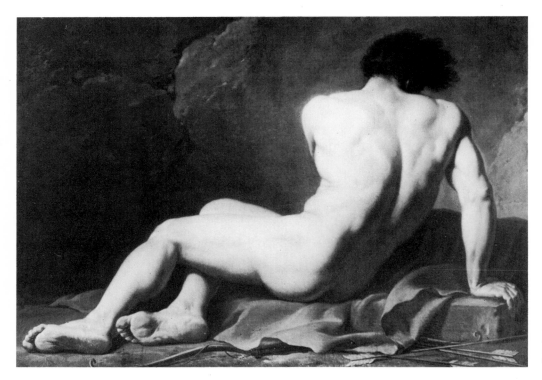

Fig. 8. JACQUES-LOUIS DAVID: *Patroclus*. About 1780. Oil on canvas, 125 × 170 cm. Musée Thomas Henry, Cherbourg

academic painter, and mainly concerned with drawing delightful landscapes and pressing for his own elevation to the nobility. However, in Paris and in Rome, profound aesthetic changes were taking place during the 1770s, while Natoire, in his own eighth decade, still adhered to the aesthetics of an earlier generation. Thus in 1775 the Surintendant d'Angiviller sent the solid and reliable Noël Hallé out to reorganize the Académie, a preparatory exercise for the directorship of Vien, who was a leader of the classicizing academic revival which was determining the course of French painting in those years.

There were some promising young French artists who, although not *pensionnaires* of the King, were none the less allowed to live at the Académie. They included François Boucher, who arrived in Rome at his own expense in 1728, there having been no royal funds available when he won the *Grand prix* in 1724; Jean Barbault, who took an active part in the Roman carnival of 1748, but who secretly married in 1753 and had to leave the Palazzo Mancini; and Hubert Robert, who accompanied the French Ambassador, Marquis de Stainville, to Rome in 1754. Other artists, such as Joseph Vernet, or even foreigners such as Joseph Wright of Derby (1734–97) were not resident, but were allowed to make use of certain facilities at the Académie. While Vernet in fact preferred to go off and sketch from nature in the Campagna and along the Neapolitan coast, Wright took the opportunity to make drawings after sculptures and casts in the collections of the Académie (Derby Museum and Art Gallery).

On returning from Rome—or, if he did not make the privileged visit, after completing training at the Académie in Paris—the artist was expected to present a work for approval to the Académiciens. If the work was considered to be of an adequate standard, the artist was approved (*agréé*) and then had to prepare a special piece (*morceau de réception*) in order to be received (*reçu*) as a member of the Académie,

an Académicien, in one of the genres of painting. The subject of the *morceau de réception* was specified, and the work had to be completed within a given time, usually one year. The Académie was not usually rigid in its application of principles, however, and was in practice prepared to bend them in order to receive artists of talent who did not conform to its theoretical ideals. Thus Antoine Watteau, some five years after becoming *agréé*, and with a subject of his own choice, was received on 28 August 1717 in a special category devised for him alone, *peintre de fêtes galantes*, establishing a new genre for the early eighteenth century. Chardin, also an exception, was *agréé* and *reçu* on the same day in 1727, with *The Skate* (Fig. 139) and *The Buffet* (Louvre, Paris). Fragonard was *agréé* in 1765 with an ambitious history painting, *Corésus and Callirhoë* (Louvre), but, like some other artists, he never submitted a *morceau de réception*. He chose to develop his career more independently and modestly (from the academic point of view) as a decorative painter, and by producing drawings and cabinet pictures for private collectors. Greuze, on the other hand, submitted *Septimius Severus and Caracalla* (Louvre) as his *morceau de réception* in 1769, in the hope of being received as a model Poussinesque history painter, but the Académiciens misunderstood his aims, and also criticized his drawing, receiving him only as a *peintre de genre*. Mortified by this insulting demotion of his work, Greuze submitted no more works to the official Salon exhibitions until 1800. He might well have become an exemplary history painter, but successfully chose to prove his abilities in other ways. However, his extreme reaction demonstrates the importance academic recognition could assume for an artist's sense of status and self-esteem. Once made an Académicien, the ambitious artist might aspire to pursue his career through the hierarchy of the Académie as an office holder, but only if he was a history painter could he reach the top. Another perk for the Académicien was the provision of a studio at the Louvre, and in some cases accommodation also. But space was limited, and allocated at the discretion of the Premier Peintre and the Directeur des Bâtiments.

The most important public event for members of the Académie was the Salon, an exhibition held only rarely in the early part of the century, but more regularly every year or every other year after 1737. In that year the exhibition was held in the Salon Carré of the Louvre, and the word 'Salon' has since become a general designation for many different types of exhibitions. When a great many works were shown— sometimes about five hundred paintings, sculptures, drawings and prints—the exhibition extended into the Grande Galerie and the Galerie d'Apollon. Works were displayed to best advantage according to the academic rank of the artist, and in relation to their scale. The thankless task of organizing and hanging the works of his colleagues fell to the *tapissier* or *décorateur*, who in the middle decades of the century was Chardin. The efforts of the *tapissier* were inevitably criticized by some artists and visitors; but he was at times able to make telling juxtapositions of works. Two-dimensional works were hung almost from floor to ceiling; in Saint-Aubin's drawing of the Salon of 1767 (Fig. 9) the enormous altarpieces by Doyen and Vien destined for the church of Saint-Roch (see Figs. 44 and 45) would have been prominent and clearly visible despite their height, but smaller pictures in the third and fourth rows up must have been hard to see. The exhibition opened on 25 August, the Feast of St Louis and the King's nameday, and lasted for about three weeks. This was sometimes extended by a few days and important royal commissions which had been hung high could be moved to eye-level for a time. Sculptures and some cabinet pictures were displayed on tables in the centre of the room (until later in the century), and Swiss guards were employed to keep an eye on

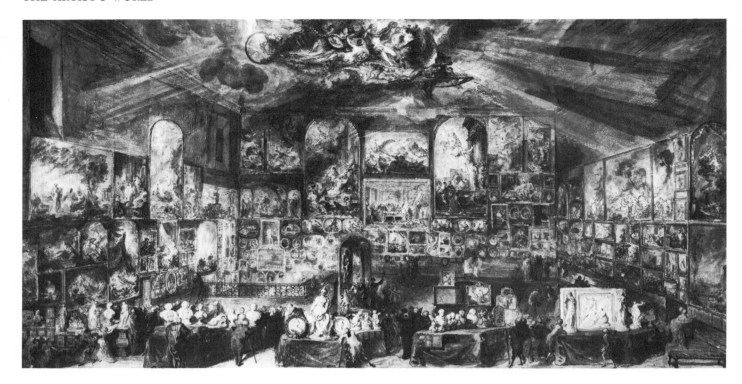

things. Saint-Aubin's splendid drawings inspired the engraver Martini to publish views of the Salons of 1785 (Fig. 10) and 1787, and in the former we can see David's celebrated *Oath of the Horatii* prominently displayed. Even in the engraving the clarity and forcefulness of David's picture suggest reasons for its success.

A *livret*, or brief catalogue, was sold at the door; this produced a considerable income for the Académie, for by the 1780s up to 20,000 copies might be sold at one Salon. In the middle decades of the century there would be between five hundred and a thousand visitors per day. In the *livret*, exhibits were listed and numbered in descending hierarchical order from the Premier Peintre du Roi and the Directeur of the Académie (often the same painter) down to the Agréés. Fig. 11 shows the title-page of the *livret* for 1761, where a contemporary has noted the opening and closing dates; we also see page 24, listing works by Parrocel and Greuze. This particular copy, in the Bibliothèque Nationale, has precious annotations by Gabriel-Jacques de Saint-Aubin in the form of tiny sketches after the principal works exhibited, including, on the right, a portrait of Greuze's father-in-law, *M. Babuti* (private collection, Paris) and, at the bottom, the picture now known as *L'Accordée de Village* (Col. Plate 5). Saint-Aubin's 'illustrated' *livrets* and catalogues of contemporary picture-sales are not only delightful masterpieces of observation and visual notation, but can also be valuable documents for the identification of works of art.

Leaving aside certain public commissions, works in churches, and private collections which were accessible, there were few opportunities for painters to exhibit their work in eighteenth-century Paris outside the official Salon. An annual exhibition, of remote and uncertain antiquity, was the Exposition de la Jeunesse. This was held for one day only (the Fête-Dieu or Corpus Christi), weather permitting, in the open air in the Place Dauphine and on the Pont-Neuf, and survived until 1789. Of the many artists, professional and amateur, who exhibited

Fig. 9. GABRIEL-JACQUES DE SAINT-AUBIN: *The Salon of* 1767. 1767. Watercolour and gouache. Private collection

Below, left and right:
Fig. 11. Title-page and page 24 from the catalogue of the Salon of 1761, the latter annotated with pencil sketches by Gabriel-Jacques de Saint-Aubin. Bibliothèque Nationale, Paris

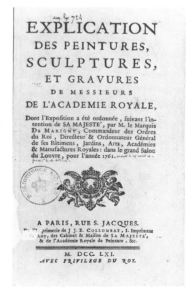

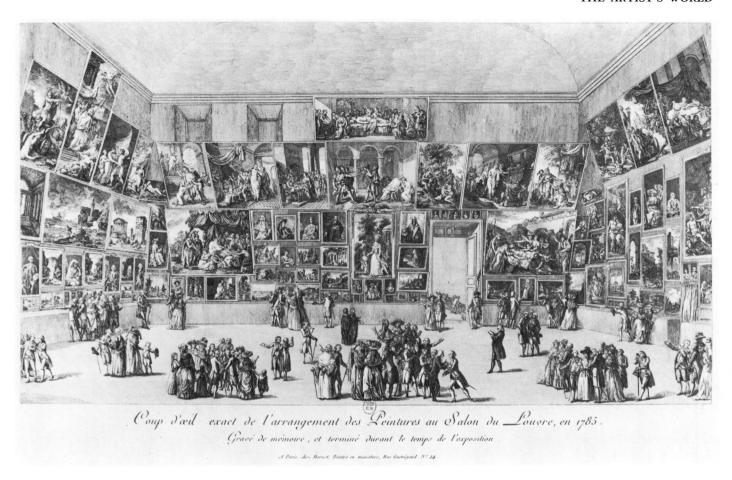

Coup d'œil exact de l'arrangement des Peintures au Salon du Louvre, en 1785.
Gravé de mémoire, et terminé durant le temps de l'exposition

A Paris, chez Bornet, Peintre en miniature, Rue Guénégaud N.º 24.

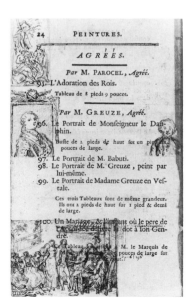

Fig. 10. PIETRO ANTONIO MARTINI:
The Salon of 1785. 1785. Engraving

there, few can be identified today, although an occasional famous name appears in its *livrets*: Chardin first exhibited there in 1728, and on occasion Desportes, Greuze, La Tour and Oudry showed works, but none of the history painters did so. The old Académie de Saint-Luc, once a guild and a rival to the original Académie Royale but finally abolished in 1777, organized seven exhibitions between 1751 and 1774; a single Exposition du Colisée (so named after the concert hall in which it took place) was held in 1776, but this exhibiting body was nipped in the bud and also suppressed by Act of Parliament in 1777. The Surintendants des Bâtiments were determined to maintain absolute control of artistic matters by means of the Académie Royale. The compartmentalized and hierarchical character of eighteenth-century society in general was mirrored in attitudes to art: d'Angiviller in the 1780s felt that absolute values were being dangerously undermined when an enlightened aristocrat and man of letters, Pahin de la Blancherie, promoted another rival exhibiting society, the Salon de la Correspondance. Pahin stated that he hoped to give encouragement to artists by exhibiting their work (which he did from 1779 to 1787), especially those underprivileged ones who did not pursue the *grand genre* of history painting. Indeed, it is significant that he should have chosen for the first ever one-man retrospective loan exhibition, in 1783, the landscape and marine painter Claude-Joseph Vernet. However, such subversion of d'Angiviller's cherished revival of the historical genre gained Pahin no favour in official circles. Thus, when in 1783 he asked for government approval to establish his society for

23

the encouragement of the arts on a semi-official basis in Paris, the project met with no success. Another proposition, for a 'Club des Arts' which would offer prizes for genres other than history, was also suppressed by d'Angiviller, who wrote to the King in 1785 that such a Club (which, moreover, would even include women!) might suit the English system, but in France it was a direct challenge to royal authority, and should be rigorously opposed 'at the present time, when many singular ideas are germinating in heated heads'.

The regular Salon exhibitions from 1737 onwards stimulated reports in the press, and gave rise to the development of art criticism in the form of pamphlets of various degrees of seriousness. Some of these would be lengthy affairs, including long descriptions of the major works exhibited, chiefly for the benefit of readers living outside Paris who could not visit the Salon. While many such reviews were of a comic, banal and ephemeral nature, some were written by highly articulate and intelligent men of letters and *amateurs*, who took a keen interest in the art of their day. The fact that these critics were not practising artists greatly irked the artists themselves, who considered them ill equipped to discuss such matters with any real insight—a point which has of course remained in perennial dispute. Some critics, such as La Font de Saint-Yenne, tended to keep their discussion on a level of general principle, but Denis Diderot, for example, cultivated friendship with a number of artists such as Chardin, Vernet, and the sculptor Falconet, which gave him a keen insight into specifically artistic problems. He was a man of literally encyclopaedic interests and knowledge, and he brought his lively curiosity to the study of art, as much as to the preparation of the great *Encyclopédie*, of which he was editor. His criticisms, however, while known in Paris, were not published in his lifetime, but were circulated in manuscript form to a small circle of subscribers to Baron Grimm's *Correspondance littéraire*, a bi-monthly report on all manner of intellectual affairs in Paris for readers resident abroad.

Most of the *salonniers*, as these critics were known, published anonymously, and often issued their works nominally in 'Amsterdam', or some other foreign city, to avoid the royal censor. Cochin, the influential Secrétaire of the Académie during the 1760s, on more than one occasion objected that while artists had to put their names to their works in public, the critics often did not do so. In 1767 he persuaded the censor, who issued permission for publication, that all pamphlets should be signed—with the result that none were published that year. Criticism was also felt to be unfair because the artists were not in a position to answer back, though some pamphlets were penned as replies to others. The artists' frustration is expressed in a published etching after Boucher (Fig. 12) showing a gagged figure of Painting (her work admired by several young genii), with an ass, an old man, a Bacchic drunkard, and the figure of Envy deriding her work. The critic was often caricatured as a senile and myopic old man who spent far more time talking and theorizing about art than looking at it; he can be seen in an etching attributed to Cochin (Fig. 13), waylaying a reluctant young man on the stairs leading up to the Salon Carré in 1753. Cochin's image forms the frontispiece to a Salon review of the more responsible kind, written by Jacques Lacombe, a lawyer and man of letters, who in the previous year had published a highly successful *Dictionnaire des Beaux-Arts*. His review opens in the form of a dialogue between an aged connoisseur who deplores the modern school in the light of the glories of the past, and a young man who defends the modern artists: this echoes the already time-honoured debate over the relative merits of ancient and modern art. Lacombe is on the side of the moderns, and describes the magnifying glass carried by the old man as 'the

instrument which these gentlemen seem to use only to enlarge the faults of our Académie, and which is essential, as you know, to those who wish to pass for connoisseurs'. Having escaped the clutches of the old pessimist, the young *amateur* is entranced, on entering the Salon, by the 'enchanting spectacle of this collection of marvels', and proceeds to admire the achievements of his contemporaries. Lacombe's praises should probably be interpreted as a constructive response to the stringent criticisms of the state of French art, and especially history painting, made in the late 1740s by La Font de Saint-Yenne, which are mentioned again in Chapter Three.

As well as numerous *Letters, Reflections, Sentiments,* and *Observations* on the Salons, some of the less earnest pamphlets appeared with comic or ironic titles, such as *A Glance at the Salon of 1775, by a Blind Man . . .*, or *Figaro at the Salon of Painting, an episodi-critical Play in Prose and Vaudeville . . . Rome, 1785* (Fig. 14). The etched frontispiece of the latter shows the servant Figaro, with David's *Oath of the Horatii* in the background. Figaro visits the exhibition with Count Almaviva, often pricking the bubble of the Count's pretentiousness, and that of some of the exhibits: before a neoclassical history painting by Brenet, the Count remarks, 'This picture is very

Left:
Fig. 12. *Painting mocked by Envy, Stupidity and Drunkenness.* Engraving after François Boucher by Soubeyran, 1747

Right:
Fig. 13. CHARLES-NICOLAS COCHIN(?): *A Critic at the Salon of 1753.* Engraving, 1753

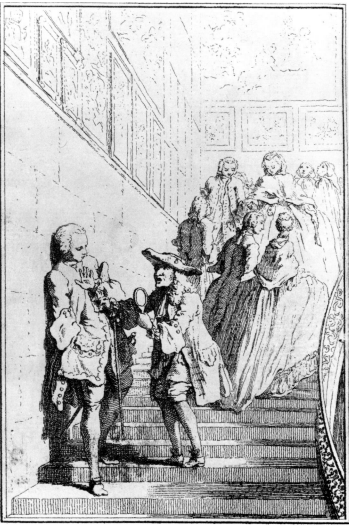

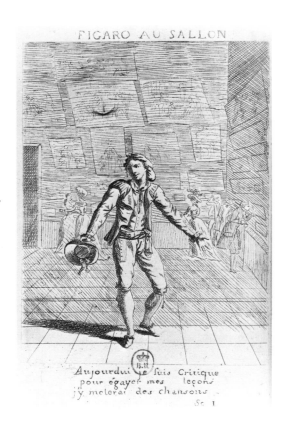

Fig. 14. *Figaro at the Salon*. 1785. Anonymous engraving

learned'; 'Too learned', retorts Figaro. However, although artists may have disliked certain published remarks about their efforts, the Salon was a valuable forum in which to test their abilities, and in which to show their wares to prospective patrons. Most of the exhibited works had been specially commissioned by Church, State, corporate body, or individual patron, but some smaller works were shown in the hope of attracting a purchaser or new commissions.

In addition to such French patrons, many Parisian artists enjoyed international reputations and worked for a European clientèle: the painters of *fêtes galantes* were eagerly sought by Frederick of Prussia; Vernet worked for all nationalities, but especially the English; Greuze was popular with Russian visitors to Paris. Numerous French painters lived abroad for some or most of their lives, exploiting another international market in Italy, or resident at European courts influenced by French manners, such as Berlin, Madrid or Dresden, which fall outside the scope of this short book. Painters could also supplement their incomes at home with various official appointments, such as academic teaching posts, administering the royal collections at the Louvre, Versailles and the Palais du Luxembourg, managing the royal parks and gardens, overseeing the Gobelins and Beauvais tapestry works, and so on. And there was more income to be had from the sale of engravings after their work, or sundry tasks such as valuing picture collections for probate.

French painters in the eighteenth century worked within a relatively secure framework of patronage, and most works were executed to order. A more speculative market did exist, however, and there would have been a fair chance that a visitor to the studio of, say, Boucher or Hubert Robert would find a few cabinet pictures for sale. Normally a client dealt directly with the artist, but sometimes a dealer might act as agent for a collector, or have a stock of modern works for sale.

The relationship between the dealer Gersaint and Watteau, like all aspects of Watteau's career, was unusual in the eighteenth century, with Gersaint supporting the artist for a time and in return having a monopoly on his work. More often, an artist would live in the household of a wealthy patron, at least early in his career. In other ways, however, Gersaint was a typical dealer of the first half of the century— not a specialist in paintings, but a general purveyor of 'curiosities' and luxurious extras for wealthy households, of which cabinet pictures were but a part. His shop-card of 1740 reads: 'At the Pagoda, Gersaint, merchant jeweller on the Pont Notre-Dame, selling all manner of new and tasteful ornaments, jewels, mirrors, cabinet pictures, pagodas, Japanese porcelain and lacquered ware, shells and other natural objects, stones, agates, and in general all curious and foreign goods.' The interior depicted by Boucher in Fig. 131, for example, could have been fitted out from Gersaint's shop. As well as supplying customers with such things, Gersaint and other dealers would dispose of collections by auction. Gersaint produced a number of scholarly catalogues for such sales, notably when he sold the collection of the *amateur* Quentin de Lorangère in 1744. This catalogue is embellished both with the first *catalogue raisonné* of the prints of Jacques Callot, the seventeenth-century etcher, and with Gersaint's important biography of Watteau; the collection contained mainly prints (especially by Callot) and drawings (especially by Watteau), paintings, maps and shells.

Cabinet pictures, lively oil sketches for larger works, and reduced copies after important works were eagerly collected. There was a marked increase in this sort of collecting during the eighteenth century: conservative estimates suggest that there were about a hundred and fifty private collections of pictures in Paris during the first twenty years of the century, while between about 1750 and the Revolution the number had risen to roughly five hundred. Most of these collections gave pride of place to old masters, but also contained modern works; some collectors, such as La Live de Jully (Fig. 93), made a conscious effort to purchase works by contemporary French painters, and La Live published a special catalogue of his French works in 1764. It is interesting to notice that La Live's collection did not include among its sizeable French holdings any large history paintings of the type increasingly encouraged by official doctrine in his day. But he had representative small-scale works or sketches by nearly all the artists active up to the 1760s mentioned in this book (including Largillière's *La Belle Strasbourgeoise*, Fig. 94). The modern French painters he most admired (and he also had many works of the Dutch, Flemish and French seventeenth-century schools) were Greuze, who painted his portrait, and Chardin. In the preface to his *Catalogue historique du cabinet de peinture et sculpture française de M. La Live de Jully* he gives his reasons for collecting French works, the main one being that he encountered relatively few in other Parisian collections: 'I was astonished to see that the taste of the French, lovers of art, had led them to make collections of foreign pictures, and above all of the Flemish School, and that French paintings had hardly entered their cabinets, or were found at the tail-end, as it were, to give an effect of completeness'. His collection could be visited on application, as could many others, and some were regularly open on certain days. From 1750 until 1779 part of the Palais du Luxembourg was opened to the public on two days a week, where about a hundred pictures from the royal collection could be seen, in addition to the Rubens *Marie de' Medici* cycle. Artists could gain admission at other times. In the late 1770s the opening of the Louvre as a museum was discussed, but this did not happen until the Revolution, in 1793. Apart from the royal collection, the greatest was that of Louis-Philippe-Joseph, the Duc

d'Orléans, housed in the Palais-Royal but dispersed during the Revolution.

A fine collection at the top of the second rank, as it were, was that of the Duc de Choiseul, and we can gain some idea of its appearance from a set of miniatures painted by Louis-Nicolas van Blarenberghe in the early 1770s. The images are on the sides and lid of Choiseul's famous gold snuffbox and show the principal rooms of his Paris house, where the best of his pictures were displayed. Choiseul's taste was principally for the fashionable and eagerly collected Dutch and Flemish 'little' masters of the seventeenth century, but among them we find notable French painters of his own century. In Fig. 15, taken from the lid of the snuffbox, Choiseul rises from the desk in his bedroom to address a guest, and we see on the walls, reading from right to left in the upper row of French pictures, the *Offering to Love* (Wallace Collection, London) and *Le Baiser Envoyé* (E. de Rothschild Collection) by Greuze, both shown at the Salon of 1769; Vien's *Greek Woman at her Bath*, a fashionably neoclassical work from the Salon of 1763 (private collection); a Jean Raoux *Sacrifice to Priapus* (1720; lost); and a rococo *mythologie galante* over the door. Among other contemporary French works in Choiseul's collection were paintings by Hubert Robert and Jean Houël (two artists he might be said to have launched on their careers; see Chapter Six), Vernet, Lacroix de Marseille, Watteau, Pater, Louis-Michel Van Loo, and a number of portraitists.

A more modest collector was Madame Geoffrin, who was especially keen on Hubert Robert and Vernet but also commissioned important cabinet pictures from masters such as Carle Van Loo (Fig. 132), Vien, and Lagrenée the Elder. During the 1760s and 1770s she held Wednesday *soirées* for artists at her Paris home, as a complement to her famous literary and philosophical evenings on Mondays.

The collection formed in the early 1770s by the Abbé Joseph-Marie Terray

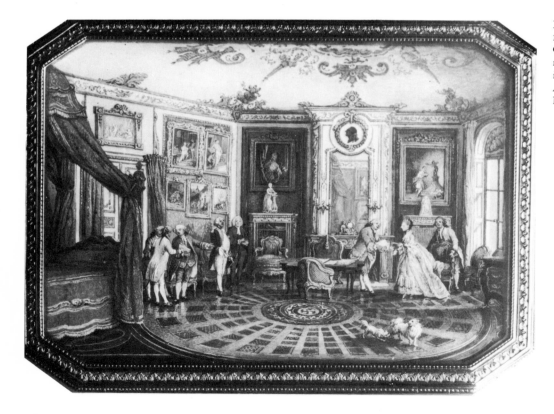

Fig. 15. LOUIS-NICOLAS VAN BLARENBERGHE: Lid of the Duc de Choiseul's snuffbox (enlarged), with miniature painting showing the interior of the Hôtel de Choiseul. About 1770–1. 5.55 × 8 cm. Private collection

(1715–78) is an interesting one because it has a strong didactic bias consistent with the 'serious' tastes of that decade. The collection may also reflect the important offices of state he held: he was appointed Contrôleur Général des Finances in 1769, and was also Directeur des Bâtiments from July 1773 until the death of Louis XV in May 1774. He had an important pair of pictures by Vernet, of interest to him as Contrôleur Général: *Constructing a Road* (Louvre, Paris), celebrating the achievements of Jean-Rodolphe Perronet (1708–94), the most famous civil engineer of the century; and *Approach to a Fair* (Musée Fabre, Montpellier), illustrating an important aspect of commercial life in the eighteenth century. He owned a sculpture by Pajou, *Mercury symbolizing Commerce*, a relief by Pigalle symbolizing *Agricultural Labour*, and two important paintings by Brenet: the Roman farmer *Caius Furius Cressinus* (Fig. 77), and *Cincinnatus made Dictator* (Salon, 1779), who was also busy at his plough. *The Market Place* (Fig. 145) by Nicolas-Bernard Lépicié, which had as a pendant an equally fascinating *Customs Yard*, was commissioned in 1775 and shows a thriving and abundant commercial life, which is presented with calm dignity and careful observation. Thus even as a private collector Terray seems to be assuming a role of public responsibility by encouraging art of a didactic nature. The relations between patrons and painters in eighteenth-century France, the history of taste and patterns of collecting are interesting subjects that still await a serious study.

Following the pattern of growth in collecting, the annual number of picture sales in Paris increased from very few before 1730 to about five during the 1750s, fifteen during the 1760s, and about forty during the 1770s and '80s, settling to thirty per annum by the end of that decade. About half of these sales would be of collections formed by an individual, the auction being organized by a dealer after a death or for private financial reasons. But dealers also formed collections of their own with a view to selling them by auction, and these accounted for roughly the remaining half of the sales. The number of art dealers also increased in the second part of the century, and the name of Gersaint is followed by those of Helle, Glomy, Paillet, Rémy, Lebrun (husband of Madame Vigée-Lebrun, the portrait painter), Joullain, and others. Works of art must have seemed a relatively sound investment, for the memories of the dramatic crash of John Law's financial system in 1720 remained fresh for many decades. But against this assumption we should note that it was a matter of surprise to Baron Grimm when, in 1772, Madame Geoffrin sold to Catherine the Great for 30,000 *livres* a pair of paintings by Van Loo which had cost her only 12,000 *livres* on commission a decade earlier; he remarked (as if it was unusual) that purchasing pictures to resell them was a sound way to invest money. Only in 1780 did Lebrun directly suggest this as a reason for buying works of art: 'By buying fine pictures one can be sure of agreeable and valuable possessions; and one can enjoy the advantage that the civilized person always seeks, of both taking pleasure in and increasing his wealth'. In 1783 Joullain published lists showing the increased value of certain pictures as they passed from collection to collection, sale to sale, through the century. These factors applied to works by old masters as well as contemporary paintings, and made the market in cabinet pictures a lively and interesting one.

When we look at eighteenth-century French works in a modern gallery, it is important to consider their original function. Cabinet pictures were both decorative in general effect and designed to be looked at closely in comfortable, habitable rooms. Satisfied by a sound investment in a unique object and by a sense of his own good taste, the private collector was interested in aesthetic experience of a different

29

order from that of, say, a cathedral chapter commissioning an altarpiece. He might admire the rich complexities of colour and brushwork in Watteau, for example, who could deftly touch-in the finest nuances of expression, of shot silk, or of fine-boned fingers; he would read off with comfortable horror the tribulations of the victims of a Vernet shipwreck, or the more lachrymose dramas of expression and symbol in the narratives of Greuze; he would surrender to the delicate fantasy of Robert's ruins, or the brilliant painterly improvisations of a Fragonard *tête d'expression*; he would savour the magic illusion in Chardin's impasto; he would return his own gaze, or that of his family, who had in turn been acutely observed in portraits by Aved, Roslin, or Duplessis, set among the reassuring stuff of material existence—a whole range of fabrics, woods, lacquers, and gilt. This is very much the aspect of French eighteenth-century art that appealed to the connoisseurs and collectors of the nineteenth and early twentieth centuries, who have done so much to form its popular image as one of elegance, luxury, and light tastefulness.

Most decorative works have, alas, been removed from their original, intended surroundings. They are now normally found in the hushed and somewhat didactic atmosphere of museums, but we should not approach them with the expectation that they might offer us a lesson about Life (except that art is to be enjoyed) or express the intellectual and moral struggles of their creators. It was quite accepted by eighteenth-century painters and their patrons that certain works of art were designed essentially to please the eye, as luxury objects which literally formed part of the framework of privileged existence, shaped to fit into the panelling of elegant rooms. Nicolas Lancret's decorative paintings on canvas set into carved wooden panels (Fig. 16), made around 1728 for the Hôtel de Boullogne in the Place Vendôme, are now dispersed, in the Musée des Arts Décoratifs and elsewhere. Out

Fig. 16. Hôtel de Boullogne, Paris: a view of the salon, with painted decorations by Nicolas Lancret (now dispersed). About 1728 (photographed about 1890)

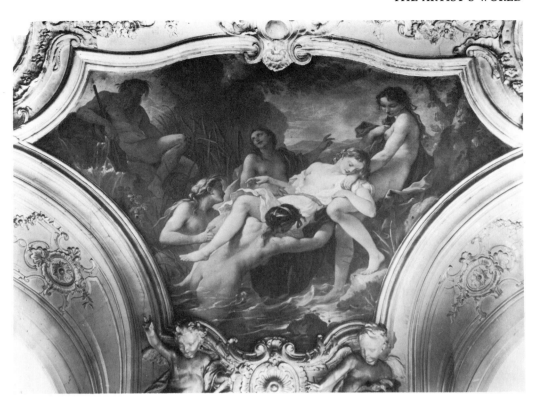

Fig. 17. CHARLES-JOSEPH NATOIRE:
Psyche saved from Drowning. 1738.
Oil on canvas, 180 × 266 cm. Hôtel
de Soubise, Paris

of context they lose their meaning, and it takes a combination of historical research and imagination to reconstruct this context. In the happier case of Charles-Joseph Natoire's *Psyche* paintings in the Salon de la Princesse of the Hôtel de Soubise (Col. Plate 1 and Fig. 17) we can see how such works would usually have been designed with attention to a specific location (though, in the absence of its original furniture and inhabitants, such a room still looks bare). The Prince de Rohan had this *hôtel* refurbished by the architect Germain Boffrand during the 1730s, and Natoire supplied paintings from the story of Cupid and Psyche for this exquisite oval room. The rhythms of *Psyche Saved from Drowning* (Fig. 17) echo the shapes of the canvas itself, and delicate pinks, blues and greens are picked up from the rest of the room; it is one of the happiest unions of architectural and painted decoration. Taken out of context such works would seem, especially to the already prejudiced eye, almost gratuitously decorative. These considerations of location weighed heavily with the painters; when Claude-Joseph Vernet made his *Four Times of Day* in 1762 for the Dauphin's library at Versailles (Fig. 18) he insisted that he should be allowed to put them in place himself, and to retouch them if necessary, so that they would correctly complement each other and their setting, and take account of the lighting of the room.

Similarly, huge altarpieces look out of place in museums. They were often designed to be seen at a distance, within the relative darkness of a chapel, perhaps, and surrounded by the emotive physical trappings of a religious place: a specific architectural setting, splendid altars and altar-furniture, candles, and at times the solemn movements of an officiating priest. It is important to understand that even where eighteenth-century altarpieces survive in their original settings, these are nowadays often too dark: in their day, clear window-glass was favoured, as in the

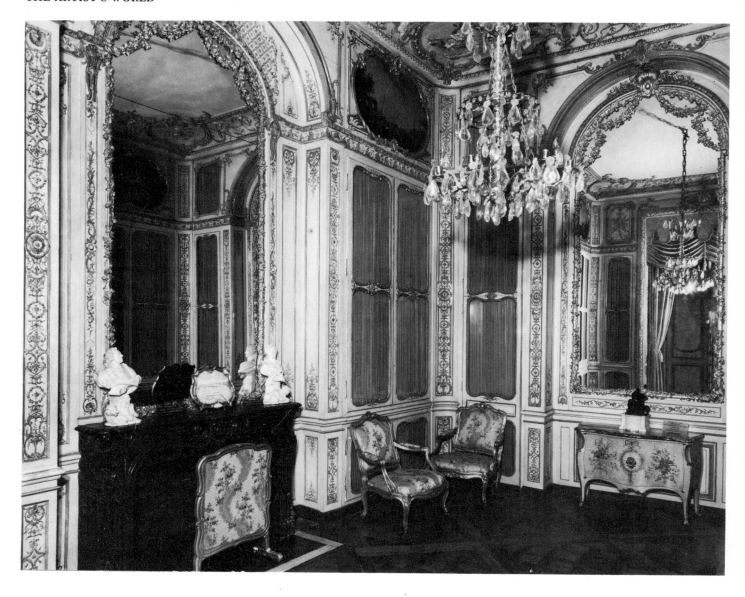

contemporary engraving of a proposed chapel for Saint-Sulpice (Fig. 20), with coloured glass only as a decorative border. But such chapels now often have dark, nineteenth-century glass, or are simply very dirty, or are overshadowed by later buildings, and may be cluttered with later furniture. In the Chapelle du Saint-Suaire (Holy Shroud) at Besançon Cathedral (Fig. 21), which contains major paintings by Van Loo (Fig. 19), Natoire, and de Troy, the sculpted angels round the cornice, holding instruments of the Passion, are related to the painted dramas of the Passion below. The prominence given to the Shroud in Van Loo's painting of the Resurrection would lose much of its meaning outside this shrine, for a fragment of the cloth was housed there. Alas, the chapel has lost its eighteenth-century iron grille, and its space is marred by modern chairs and two stark nineteenth-century monuments.

Fig. 18. View of the Dauphin's Library at Versailles, with overdoors by Claude-Joseph Vernet. 1762.

Opposite:
1. Hôtel de Soubise, Paris: a view of the Salon de la Princesse, with painted decorations by Charles-Joseph Natoire. 1736–9

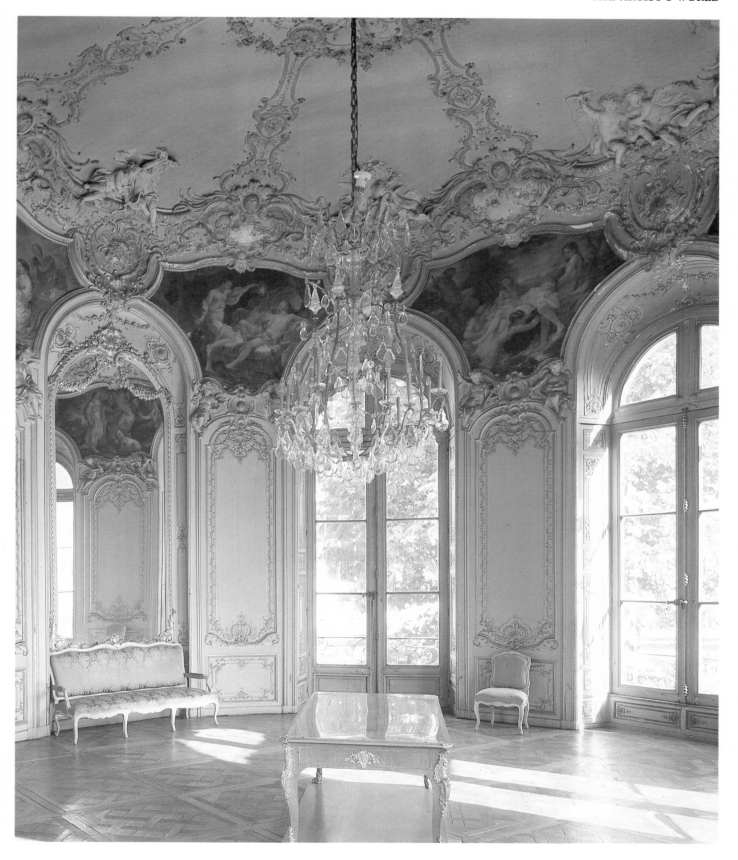

Fig. 19. CARLE VAN LOO: *The Resurrection*.
1750. Oil on canvas, 428 × 262 cm. Besançon
Cathedral

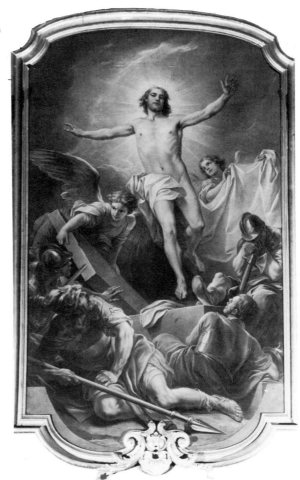

Below, left:
Fig. 20. Engraving of the proposed Chapelle
de Saint-Jean-Baptiste for the Eglise Saint-
Sulpice, Paris. About 1755

Below, right:
Fig. 21. Chapelle du Saint-Suaire, Besançon
Cathedral. 1740–50

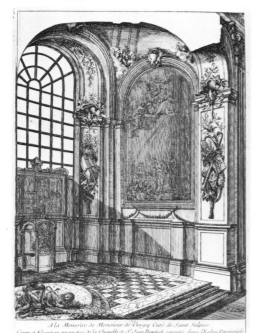

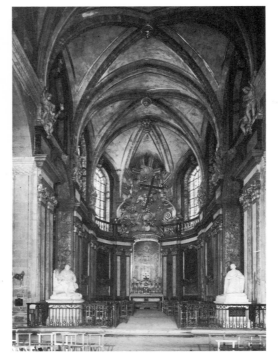

2 RELIGIOUS PAINTING

The popular concept of the eighteenth century as an 'age of reason' reflects the preoccupations of historians during the succeeding two centuries. Their attention has tended to focus on those aspects of the final century of the *ancien régime* which anticipate the Revolution and which form a basis for the subsequent history of ideas and events. Given the social and intellectual changes implied in the Revolution, and the growth of secularization in the last two hundred years, it is understandable that commentators should have been less interested in the features of culture and society during the *ancien régime* that were a survival of old orders than in those that heralded new ones. It is easily assumed that the 'Age of Reason' had little or no place for religion or religious art, or that if it had, they were not sincere or taken seriously. Only recently has attention begun to be focused adequately on the important role of religious painting in the eighteenth century. But even before the end of the century the achievements of religious painting were deliberately obscured by painters such as David and his followers, when they promoted their own art at the expense of earlier masters. The success of the Davidian revolution in history painting has tended to eclipse early eighteenth-century religious, and indeed secular, history painting.

It is broadly true that French religious painting of the eighteenth century tends to maintain a tradition derived from French and Italian art of the previous century. This fact can even deter the modern spectator, who is conditioned by the Romantic ideal of originality. Thus we tend to admire departure from tradition, as a sign that the artist is pushing back the frontiers of sensibility in the continuing process of art. Before the Romantic period, however, it was 'imitation' that was admired—the ability to make a new synthesis of established formulas—so that artistic stature tended to be measured in terms of the successful maintenance of tradition. This is particularly relevant in the case of religious painting, because Catholic ideology underwent no fundamental change in this period, and thus there is a sense of continuity with the late sixteenth and the seventeenth century.

As we noted at the end of the last chapter, it is important to take into consideration all the known circumstances surrounding a particular commission in order to approach the meaning a work had for the contemporary audience. The *Nativity* by François Boucher (Fig. 22) at first sight confirms the general conception many people still have of the decorously gallant and sweetly pastoral character of French art in the eighteenth century. While Boucher was indeed one of the most brilliant painters of decorations for secular settings, we should not allow that to prejudice our view of his few religious works. Although this altarpiece, painted for

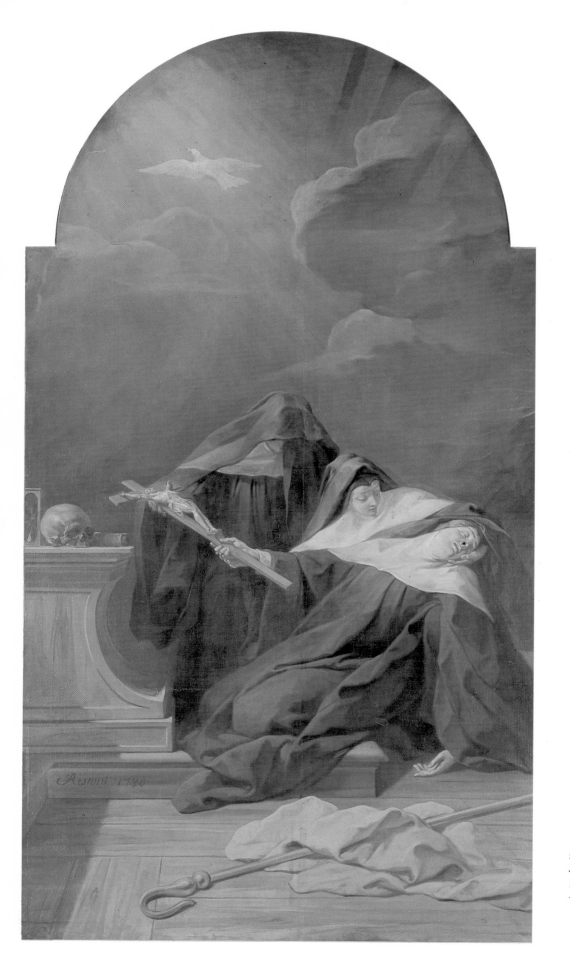

2. JEAN RESTOUT: *The Death of St Scholastica*. 1730. Oil on canvas, 338 × 190 cm. Musée des Beaux-Arts, Tours

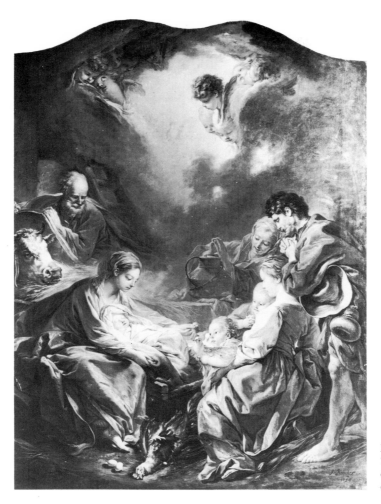

Fig. 22. FRANÇOIS BOUCHER: *The Nativity*. 1750. Oil on canvas, 175 × 130 cm. Musée des Beaux-Arts, Lyons

Madame de Pompadour, is very decorative, it is not mere decoration, but also expresses a sweet and precious piety, which we may easily mistake for insincerity. It was made for the chapel of Madame de Pompadour's Château de Bellevue and is entirely consistent with what we know of her taste. It was much admired at the Salon of 1750 for the way Mary tenderly shelters the sleeping Child from noise and intrusion. The Child seems to radiate light, which places this work in the tradition of Correggio, a painter Boucher certainly admired. It also reflects a type of devotional image often found in the work of Carlo Maratta (1625–1713) and his Settecento followers, whom Boucher would have keenly studied in Italy twenty years before painting this picture. But religious subjects are scarce in Boucher's work, and he is a mere tributary when measured against the mainstream of French religious art of his century.

The first decade of the eighteenth century saw the completion of two major cycles of ecclesiastical mural and ceiling decoration: the apse, nave-vault and tribune of the Royal Chapel at Versailles (Fig. 23), executed respectively by Charles de la Fosse, Antoine Coypel and Jean Jouvenet; and the various vaults inside the church of Saint-Louis-des-Invalides, commissioned from La Fosse, Jouvenet, Noël Coypel, Bon and Louis de Boullogne (cf. Fig. 42), and Michel Corneille (Corneille's St Gregory Chapel was later to have been repainted by Carle Van Loo in 1765, but

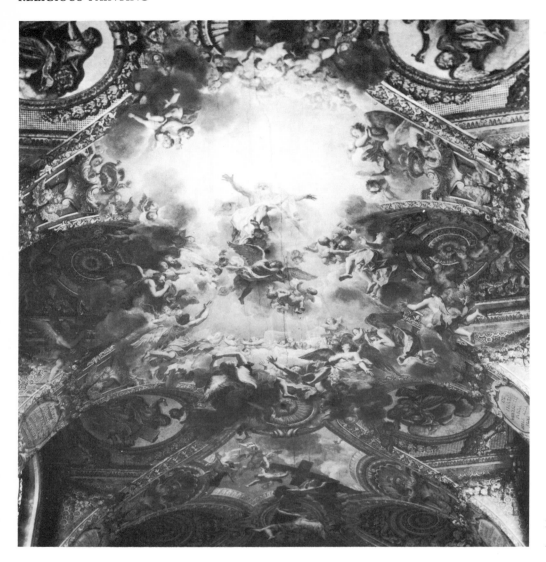

Fig. 23. Chapelle Royale, Versailles: vault paintings by Antoine Coypel, 1707–10

after his untimely death the repainting was done by Gabriel-François Doyen in 1772). These were the last major cycles of religious paintings on such a scale executed during the reign of Louis XIV, and they are the brilliant swan-song of baroque decoration in France. Nothing equivalent in scale or in dogmatic pretension was undertaken during the succeeding two reigns, when church decorations were nearly all limited to easel paintings (though often on a large scale), placed in relatively more modest architectural or sculptural settings than Versailles or the Invalides. Whereas these two lavish schemes were funded from the royal purse, nearly all the works discussed below were financed either by private individuals or by the Church. Indeed, the absence of comparable modern examples of the glorious patronage of the Sun King was increasingly commented upon by art critics and others as the century wore on.

In no other French church could the faithful of the eighteenth century have experienced, as they could at Versailles, an enormous golden vision such as the one painted by Antoine Coypel (Fig. 23) of God the Father descending through the roof to promise them the coming of the Messiah, witnessed by twelve patriarchs and

prophets of the Old Testament, the four evangelists, Charlemagne and St Louis, accompanied by floating angels bearing the implements of Christ's Passion. A scheme which more readily typifies the eighteenth century was that undertaken in the choir of Notre-Dame in Paris, begun at the very end of Louis XIV's life and completed in the first years of the Régence. The scheme has a long history, however, for it realized the celebrated vow of Louis XIII, made in 1638 in thanksgiving for his victories over the Spaniards, to dedicate his kingdom to the Virgin, a vow to be marked by the reconstruction of the high altar at Notre-Dame. At the same time as he undertook the works at the Invalides and the chapel at Versailles in 1699, Louis XIV decided to execute the wishes of his father; but the project was soon abandoned on grounds of cost. However, in 1708 the Canon of Notre-Dame, Antoine de la Porte, offered annual advances to the King for the construction of the altar and the refurbishing of the choir. In 1709 the Canon further offered to pay for six pictures relating the life of the Virgin, to be set in the marble framework north and south of the choir. By the time the structure was complete in 1714 it had been decided to accommodate eight paintings instead of six. Some of the architect Robert de Cotte's drawings survive, two of them showing alternative designs for three or four paintings on the south side (Fig. 24). The rhythm and proportion of the lower design, with four paintings, were found to be the more satisfactory; the subjects of the paintings have been written in on the drawings, together with the corresponding subjects for the north side. Jouvenet, La Fosse, Antoine Coypel, Claude-Guy Hallé and Louis de Boullogne executed the paintings, which were installed between 1715 and 1717. Boullogne's *Rest on the*

Fig. 24. ROBERT DE COTTE: designs for the choir of Notre-Dame, Paris. Pen and wash. Before 1714. Bibliothèque Nationale, Paris

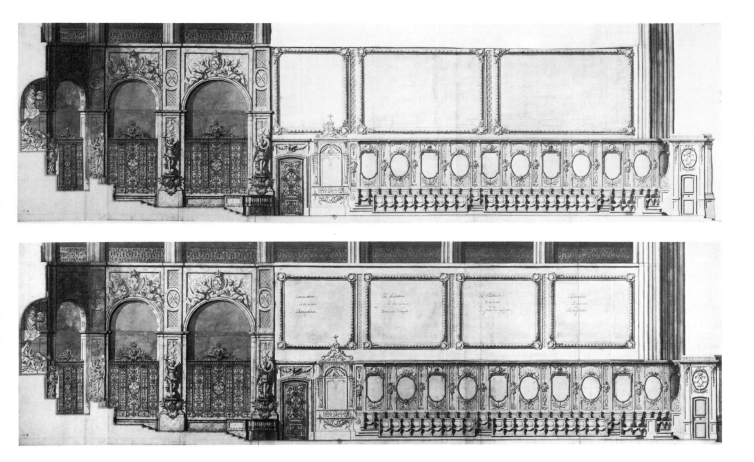

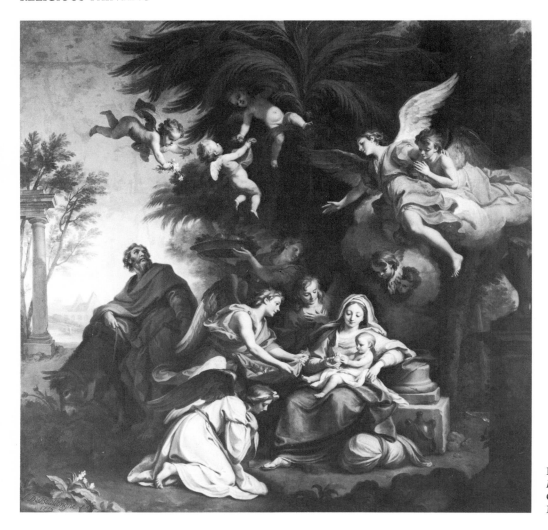

Fig. 25. LOUIS DE BOULLOGNE:
Rest on the Flight into Egypt. 1715.
Oil on canvas, 440 × 440 cm.
Musée des Beaux-Arts, Arras

Flight into Egypt (Fig. 25), with its supple and graceful forms, illustrates one of the characteristic styles of the close of Louis XIV's reign. Derived from the style of the Italian Francesco Albani, the *Rest on the Flight* can be compared with Boullogne's mythological paintings (Fig. 59) for its graceful manner, which was to be continued by the leading painters of the next generation, Lemoyne and de Troy.

One of the major painters to work at the Invalides and in the Royal Chapel at Versailles was Jean Jouvenet. The *Raising of the Nain Widow's Son* (Fig. 26), originally commissioned for a convent at Versailles, perfectly exemplifies the dominant tendencies in his art. It combines a precise realism of detail with a sense of nobility and of the ideal in the conception of the individual figures and in the way the composition is built upwards, giving the effect of towering above the spectator. The setting is grand and simple, and gestures and expressions are clear and eloquent, without excessive rhetoric. The firm pictorial structure expresses calm assurance and belief in the truth of the Scriptures, and is based upon a sound knowledge of the great ideal tradition in Western painting, from Raphael to the Carracci, Rubens, Poussin, and, more recently, Le Brun. A student especially of the latter two painters, Jouvenet shares their conception of the biblical characters as elevated types, acting out their inspired lives on a plane here literally above our

own. There is a range of different responses to the miraculous event; the actions, gestures and expressions of the two pall-bearers on the right, for example, make them a contrasting but not overstated pair.

Religious paintings were a major feature of Salon exhibitions throughout the eighteenth century, although during the two decades before the Revolution the proportion of secular history paintings greatly increased and drew more critical attention. This may have been due to renewed government programmes of support for history painting of that kind rather than to a decline in religious faith. However, the strength of history painting from the mid-1770s onwards was based on the maintenance of a tradition of large-scale narrative figure painting for religious commissions since the seventeenth century. Moreover, we must beware of forming an impression of French eighteenth-century art too readily from Salon *livrets* alone: a great many religious works produced in Paris studios during that century were never seen at the Salon, for they would be sent off directly to their destinations in churches and monasteries all over France.

Most artists were keen to execute commissions for churches because these provided a more or less permanent exhibition space—their paintings were before the public continuously rather than for a few fleeting weeks at the Salon, and some would be commended to public attention in guidebooks.

However, against the advantages of permanent exhibition (or perhaps because of them), religious works did not command good prices; it may be that it was

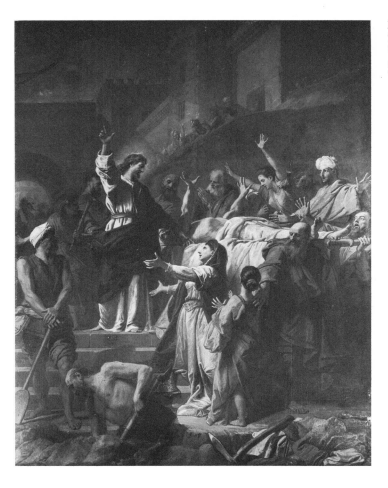

Fig. 26. JEAN JOUVENET: *The Raising of the Nain Widow's Son.* 1708. Oil on canvas, 450 × 340 cm. Versailles Cathedral

considered an honour, perhaps even an indirect means of redemption, to work in such exalted circumstances. The biography of the painter Louis Galloche, published in 1767, informs us that after losing his investments in the crash of John Law's financial system in 1720, 'Paintings for churches, which were the principal occupation of M. Galloche, hardly favoured the reparation of his losses. We cannot let it go unsaid, for the honour of artists and to the shame of those who order works for holy places, that this sort of work is always paid at a paltry rate in comparison with pictures of profane subjects. However, it is well known that painters make that much more effort to render them perfect because, being destined to remain for ever in the public eye, they offer the surest means to establish or affirm their reputation and to pass on their names to eternity.' To take an example, Carle Van Loo in 1750 was paid 2,250 *livres* for his large *Resurrection* at Besançon Cathedral (Fig. 19; 4.28 x 2.62 m), while only four years later he received 6,000 *livres* for the *Spanish Conversation Piece* (Fig. 132; 1.64 x 1.29 m) for Madame Geoffrin! In the early 1780s protracted negotiations were necessary to obtain a fair price from the Bureau de la Santé at Marseilles for Jacques-Louis David's *St Roch* altarpiece (Fig. 55).

The power and potential of the Church as a patron of painters was enormous. Even a cursory glance at the old guidebooks to Paris shows an astonishing number of churches and religious foundations of all kinds, for which hundreds of paintings were produced during the eighteenth century, to say nothing of the vast potential of provincial France. While the power to mystify and the material wealth of the Church were targets of the *philosophes* and some other *bons esprits*, we should nevertheless recognize the fundamentally religious framework of most people's lives at the time if we are to understand fully the character of eighteenth-century life and art.

The primary aim of religious painting was to expound the ideology of the Church. Within the confined walls of a religious community, paintings would serve as a stimulus to contemplation and meditation, as reminders of the exemplary lives of Christ and the Apostles or the saints, perhaps depicting the life and works of a particular saint or the history of a particular Order. In a more public context, pictures played a more simply didactic role. The eyes, hearts and minds of the faithful could be reached by means of an altarpiece, executed perhaps by a famous Parisian master, a painter of local repute in the provinces, or even a local hack; or they could be reached at a humbler level at the church door by a cheap plain or coloured woodcut, distributed by a travelling printseller or explained by a *montreur d'images* at a fairground.

Sometimes a popular print would be made after a well-known painting. In 1726 a crude engraving with explanatory text was made after the *ex voto* dedicated to St Geneviève (Fig. 27) which was painted in that year by Jean-François de Troy and originally placed with earlier *ex votos* over the tomb of the saint at the Abbey of Sainte-Geneviève near Paris. The painting was offered to the saint by the Provost of the Guilds and the aldermen of Paris in the name of their city as thanksgiving for saving Paris from the famine that resulted from flooding during the summer of 1725. The saint's reliquary had been carried in procession on 5 July in the hope of stopping the rains, just as it had on 10 August 1696 to bring an end to a drought. The legend on the print explains the events and gives the names of the grateful city fathers kneeling below the saint, who intercedes with Heaven on their behalf. Such an image functioned both as thanksgiving and as a public declaration of faith; the citizens of Paris could see the aldermen performing their duty on their behalf. De

Fig. 27. JEAN-FRANÇOIS DE TROY: *St Geneviève and the Aldermen of Paris.* 1726. Oil on canvas, 500 × 350 cm. Eglise Saint-Etienne-du-Mont, Paris

Troy is able in this work to display his considerable talents as a portrait painter and as a religious painter; the baroque visionary device of saint and angels borne on clouds, lit by a divine light, is cleverly integrated with, yet separated from, the more prosaic group below. De Troy had as a model the *ex voto* made by Largillière after the cessation of the drought in 1696, which now hangs in the same church.

Another example of a painting commissioned to commemorate a specific event, in this case to remind the congregation of the reason for a festival peculiar to their church, is that painted by Clément Belle in 1759, *The Discovery of the Profaned Host* (Fig. 28). The painting was commissioned by Pierre-Joseph Artaud, then Bishop of Cavaillon but formerly *curé* of the church of Saint-Merry in Paris. His predecessor at Saint-Merry had instituted an annual festival at the church as reparation for the profanation of the host when, on 15 April 1722, it had been discovered on the floor in one of the chapels, spilt from a broken ciborium which had been stolen from the church a few days before. Belle shows the *curé* and two horrified colleagues discovering the host, while a mother in the background points out to her child the figure of God restraining his Avenging Angel at the request of Religion, who demands mercy on the perpetrator of the crime. Such a unique subject needed explanation in the eighteenth century as much as it does today, and this was given

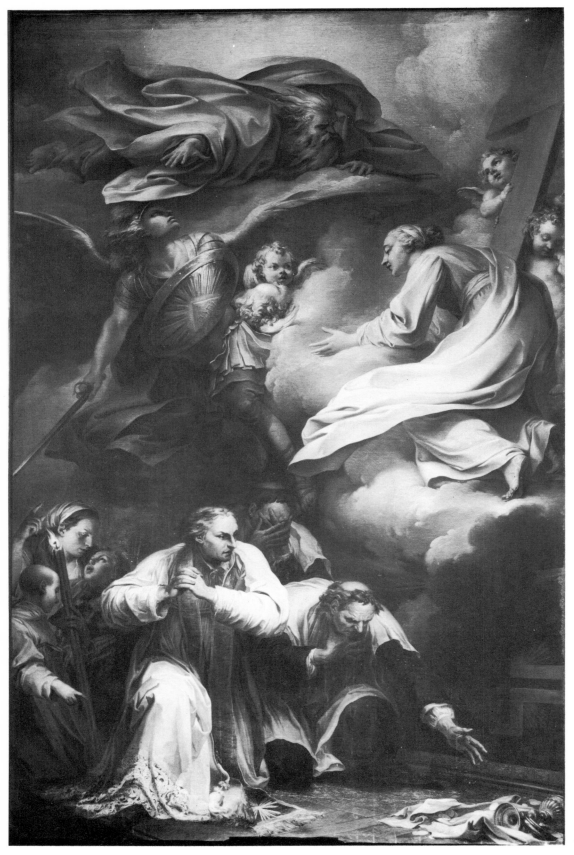

Fig. 28. CLÉMENT BELLE:
The Discovery of the Profanation of the Host. 1759. Oil
on canvas, 360 × 250 cm.
Eglise Saint-Merry, Paris

at length in the *livret* of the Salon of 1759, where the picture was exhibited.

Painters were conscious of their public and eager that their aims and intentions should be understood. The Salon, as we have seen in Chapter One, was the main arena of public debate about art, especially after the mid-1740s. Just as the Salon *livret* provided an opportunity to explain some of the more complex or unusual subjects represented, so painters would sometimes prepare independent pamphlets to explain their intentions. Such texts would also serve to publicize new works, particularly if they could not be shown at the Salon. Thus in 1729 Charles-Antoine Coypel published in the *Mercure de France* an open letter to the Father Superior of the Congregation of the Oratoire in Paris, discussing the huge *Ecce Homo* he had just completed for their much admired new church. The letter was also published as a separate pamphlet, and a simple engraving after the picture was made available to interested members of the public (Fig. 29).

Although Coypel's painting no longer exists, and we have only his description and the engraving, his discussion of it is interesting because it shows exactly how he expected the spectator to respond to his efforts. Born in 1694, Charles-Antoine was one of a generation of painters almost obsessed with Le Brun's *Traîté des passions*. For Coypel, the subject of Pilate presenting Christ to the people offered a whole range of conflicting emotions to be communicated by gesture and facial expression. The painting (about 12 x 10 m) had to fill a very large space, so a subject in a grand

Below, left:
Fig. 29. *Ecce Homo*. Engraving after Charles-Antoine Coypel by F. Joullain, 1729

Below, right:
Fig. 30. Chapelle des Enfants-Trouvés, Paris; painted decoration by Charles-Joseph Natoire and the Brunetti (destroyed). Engraving by E. Fessard, 1759

ECCE HOMO

Gravé par F. Joullain d'apres l'Esquisse du grand Tableau peint par Ch. Coypel pour l'Église des R.P. de l'Oratoire
le grand Tableau a 40 pieds de haut sur 32 de large.

Vue Perspective de la Chapelle des Enfans Trouvés de Paris

architectural setting seemed appropriate, and the artist would, by means of this painted architecture, be able to unite his pictorial space with the actual architecture of the church. An amphitheatre, with the tribune reached by steps, seemed suitable. Coypel studied Raphael in order to dispose his groups clearly, the better for us to see 'the different emotions that stir my actors'; thus would be combined 'magnificence of spectacle with pathos of action'. In addition to the expressions of compassion or indifference, the licence of including the grief-stricken holy women in this scene would introduce 'a pleasing contrast'; the soldier who genuflects in derision and 'low irony' would provide 'an apt opposition to the noble suffering which I have tried to depict in Christ'. The figures of Pilate and Christ were to form another contrast, the latter uniting 'nobility and humanity, divinity and suffering', his eyes rolled to heaven, 'at once priest and victim'. The gentleness, divinity and humiliation of Christ were to contrast with the anger of those around him. Overall, the picture was to attract the spectator by its unified effect, and then hold him with its details—details such as those already described, and the contrasts of Roman and Jewish types and costumes. The aim of depicting 'such a grand and touching event' was 'to move the spectator, and lead him to thoughts worthy of the place in which the picture is to be seen'. Moreover, if the body of Christ shows no signs of his physical suffering it is because Coypel is too well-mannered to present the painful spectacle of his flogged back: 'I hope it will not be found strange to see few marks on Christ's body; after all, I am dealing with an enlightened and delicate public. Should I have persuaded myself that weals were a resource to make this figure appear more moving?' Like nearly all eighteenth-century painters, Coypel observed a code of 'good taste', working as he was for a *public éclairé, délicat*.

Painting, architecture and fictive architecture were even more closely integrated in a chapel interior designed in the middle years of the century, although this type of illusionistic decoration is unusual in French art of the period (Fig. 30). At the new chapel of the Hôpital des Enfants-Trouvés the simple structure, designed by Boffrand, was but the support for an interior almost entirely covered in painted decoration by Charles-Joseph Natoire and his colleagues. According to a pamphlet issued at the time of the consecration of the chapel in 1751, it was Boffrand, himself an administrator of the Enfants-Trouvés, who suggested the Nativity as a suitable theme for mural decorations, with the Adoration of the Shepherds and the Kings. It was hoped, according to the pamphlet, that the extensive mural decorations of this interior would show the public just what was possible if only French painters were given sufficient opportunities to demonstrate their talents through this type of large-scale commission. Indeed, this was one of the most remarkable cycles of religious works undertaken anywhere during the eighteenth century; with his art, Natoire transformed the interior of the chapel into a sort of vast ruined antique barn, with characters acting out their roles in an illusionistic space 'outside' the chapel itself. In executing the illusionistic architecture (and it is difficult in Fessard's engravings to distinguish the real from the painted) Natoire was assisted by Italian specialists in illusionistic painting, Gaetano Brunetti (died 1748) and his son Paolo Antonio. The chapel was lit from the right-hand side by four large clear-glazed windows at first-floor level; below these were three large panels showing the procession of the Shepherds, and, facing these on the left side, corresponding panels with the procession of the Kings. These sequences culminated at the altar with three more panels, the largest of them the altarpiece in the centre, showing the Adoration of the Magi. Above this was a Glory, with angels on clouds. The vault of the chapel, continuing the decoration of the walls, was transformed

46

into a teetering ruin of broken coffering and old beams sprouting grass and lichens. In the choir there were further panels to left and right with grisaille paintings to simulate sculptured figures in niches, representing SS. Vincent de Paul and Geneviève, patron saints of the chapel. On the upper level on the left, facing the windows, nuns and children were painted as witnesses behind a rustic balustrade, 'characterizing admirably an establishment that unites piety and charity so perfectly'.

The seventeenth-century reforming saint, Vincent de Paul, was enormously popular and influential because of his promotion of pastoral care, which was one of the major preoccupations of the French church during the later seventeenth and the eighteenth century. He was the inspiration behind orphanages in Paris and elsewhere; hence his presence in Natoire's painting. He was beatified in 1729, and in consequence the congregation he had founded in 1625, the Prêtres de la Mission

Fig. 31. JEAN RESTOUT: *St Vincent de Paul with St François de Sales.* 1732. Oil on canvas, 382 × 228 cm. Eglise Sainte-Marguerite, Paris

(housed shortly afterwards at the Hôpital de Saint-Lazare and known as the Lazaristes), commissioned for their church a series of eleven paintings celebrating his life and works. Engravings were made of them after his canonization by Pope Clement XII in 1737. One of these paintings, by Louis Galloche, shows the saint instituting the Hôpital des Enfants-Trouvés; others—by Frère André, Jean-Baptiste Féret and Jean Restout respectively—show him preaching to the poor, encouraging his followers to care for wounded soldiers, and preaching to galley-slaves (the latter is known only through the engraving; the others mentioned here are in Sainte-Marguerite, Paris). The best preserved of this series (Fig. 31) shows St Vincent de Paul being presented as an almoner to the Dames de la Visitation (St Jeanne de Chantal and her nuns) by St François de Sales, who was another reforming saint of the seventeenth century. Restout has striven for historical accuracy in depicting the costumes of the previous century, and in this he anticipates the historicizing interests of painters during the 1770s; even his style—simple and monumental in the forms, a restrained essay in different greys—has a seventeenth-century feeling quite surprising in the 1730s. The movements and gestures of the characters are dignified and noble. The kindly and almost beatific expression of the saint, the sense of his presence, convey the degree to which he was still a living force for believers in the eighteenth century.

Among the most splendid and celebrated Parisian churches was Saint-Sulpice, whose astute *curé*, Languet de Gergy (1675–1750), had fully exploited his extensive, wealthy and highly fashionable parish to rebuild and embellish the church. Its visual effect was created for the most part by architecture, space, light, and architectural decoration, and the main painted decorations were in the Chapelle de la Vierge and what is now called the Chapelle de l'Assomption. We need eighteenth-century engravings to help us reconstruct their original appearance. François Lemoyne was commissioned to fresco the vault of the Chapelle de la Vierge (engraved section, Fig. 32), which he did in 1731–2. The lightness and elegance of his style, which we shall see also in his mythological paintings, must have been a perfect complement to the light and airy architecture of Servandoni's chapel and Edme Bouchardon's life-size silver statue of the Virgin. The narrow, shallow cornices of Servandoni's design and the number of windows, which were large in relation to the masonry, must have left the chapel very light and the vault quite visible—neither of which is so today. Lemoyne's painting shows the Virgin rising up on clouds; below, her presence is hailed by St Peter (on a cloud to the right) and St Sulpice (on a cloud to the left). In the preliminary oil sketch (Fig. 33) St Sulpice is looking down at St John the Baptist and other spectators; but in the fresco St John is joined by the Abbé Olier (a seventeenth-century *curé* at Saint-Sulpice and founder of the seminary there), who leads a crowd of parishioners to witness the Assumption overhead. The Virgin is accompanied by music-making angels, and witnessed also by the Fathers of the Church and others. Lemoyne's dashing and spirited sketch shows his knowledge of contemporary Venetian decorators, such as Gian'Antonio Pellegrini and Sebastiano Ricci. Damaged by fire in 1762, the vault at Saint-Sulpice was later heavily restored by Antoine-François Callet; in addition to Callet's overpainting, and later accretions of dirt, further obstructions in the course of the century caused the lightness of the Chapelle de la Vierge to be lost. In the early 1750s four of the bays were filled with paintings by Carle Van Loo, and the chapel was further transformed in the 1770s by Charles de Wailly, with much heavier and more grandiose architectural features. As so often with such schemes, if we are to understand the original intentions of the artist we have to supplement a

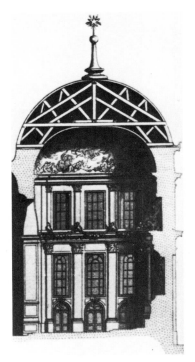

Fig. 32. Section of the Chapelle de la Vierge in the Eglise Saint-Sulpice, Paris. Engraving from J.F. Blondel, *Architecture françoise*, 1752

visit to the site with a reconstruction in our imagination, using engravings, sketches, and other works.

Tragic religious emotion hardly had a place at Saint-Sulpice in the eighteenth century, and the cult of the Virgin there may have been one of the reasons for this. The decoration of the Chapelle de l'Enfance de Jésus (now the Chapelle de l'Assomption) reflects the sweet and suave devotional tastes of Languet de Gergy and his congregation. Jean-Baptiste-Marie Pierre's *Flight into Egypt* (Fig. 34) and Noël Hallé's *Suffer the Children* (both exhibited at the 1751 Salon), in their supple rhythms and pale, refined colours, are the perfect pictorial equivalents of the elegant wood panelling in which they are set (Fig. 35). The original appearance of this chapel can be best understood from the contemporary engraving, which we might easily at first sight misread for the salon of some nearby *hôtel*! There is at the same time a striking simplicity about Pierre's white Virgin, placed in opposition to a luminous blue sky, which was remarked upon by contemporary critics.

If Pierre responded to a particular devotional atmosphere at Saint-Sulpice, he could at other times produce bold and even brutal images, which now seem more

Fig. 33. FRANCOIS LEMOYNE: *The Glorification of the Virgin* (sketch). About 1730–1. Oil on canvas, 91.5 × 119 cm. Musée du Louvre, Paris

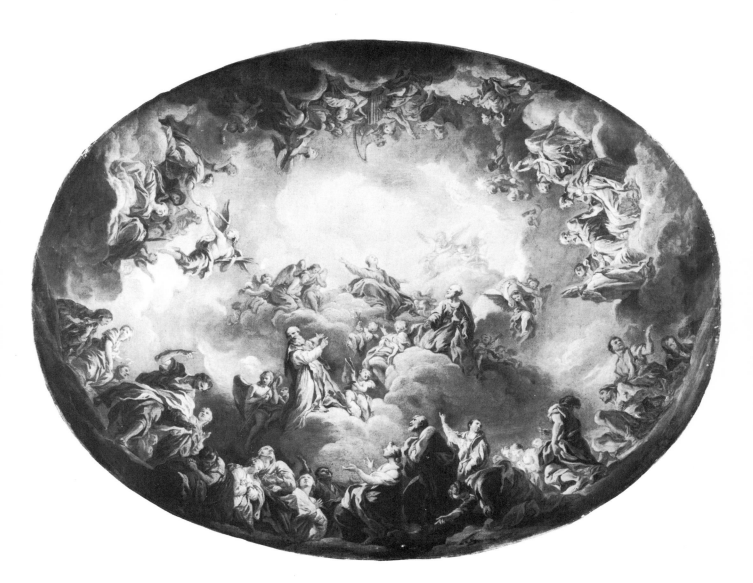

Fig. 34. JEAN-BAPTISTE-
MARIE PIERRE: *The Flight into
Egypt.* 1751. Oil on canvas,
310 × 190 cm. Eglise Saint-
Sulpice, Paris

redolent of 1790 than of the heyday of the *ancien régime*. His *Murder of Thomas à
Becket* (Fig. 36), shown at the Salon of 1748, is one of the most remarkable images
of the mid eighteenth century, and recalls the uncompromising works of Marco
Benefial, which Pierre would have admired during his time in Rome from 1735 to
1740. It was painted for Saint-Louis-du-Louvre, on the site of a medieval church
that had been dedicated to St Thomas à Becket. It was admired at the Salon for its
treatment of expression: the fury and rage of the soldier, the resignation of the
saint, the fear of the acolyte.

Pierre also contributed to a group of major works for the Cathedral of Saint-Louis
at Versailles an enormous *Lamentation at the Foot of the Cross* (Fig. 37), placed at the
end of the north transept, opposite an *Adoration of the Shepherds* by Restout on the
south side. The unusually prominent empty Cross in the background, with the
drapery flapping dramatically in the wind, helps to fill the very tall canvas; perhaps
a more active scene of Deposition would not have been a suitable pendant to the
contemplative *Adoration* opposite. Diderot was critical of the picture at the Salon of

1761, seeing the main figure-group as too reliant on Annibale Carracci's *Dead Christ Mourned* (National Gallery, London), and finding the body of Christ lacking in nobility and too much like a drowned corpse retrieved from the Seine. Perhaps this is what made another critic feel appalled by the work, arguing that the artist should offer his public only pleasing sensations, and only go so far as to fulfil the decent and proper requirements of the faithful. But the Christ, and his Cross illuminated against the bleak sky, are the features which make this work particularly striking: it is a novel interpretation of one of the great themes of Counter-Reformation painting. Probably Pierre was consciously placing himself in relation to that tradition in competition with Joseph-Marie Vien, who had triumphed at the Salons of the 1750s with his version of the Italianate grand manner. What in part led Diderot to misunderstand Pierre's work was his failure to realize the painter's debt to Jouvenet and to French tradition in such a picture.

The uncompromising character of Pierre's art may have been learnt in part from his master Jean Restout, who made a number of startlingly dramatic and emotional religious images but at the same time remained within the bounds of good taste.

Fig. 35. Engraving of the Chapelle de l'Enfance de Jésus, Eglise Saint-Sulpice, Paris

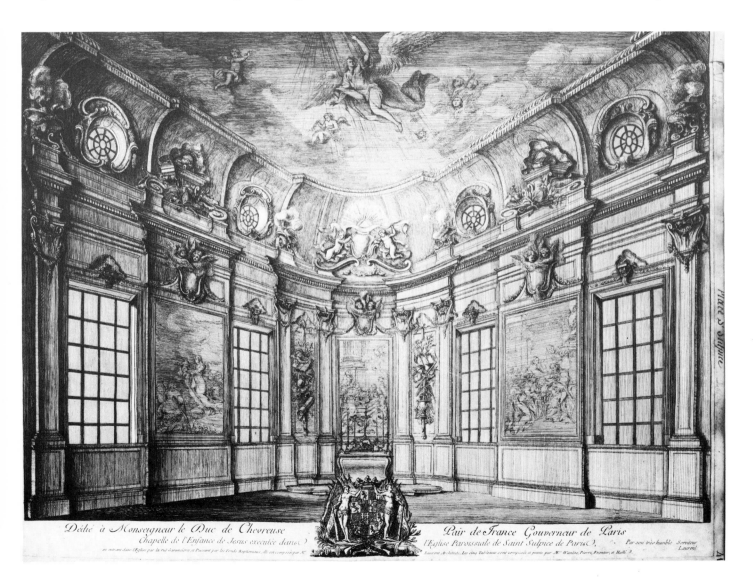

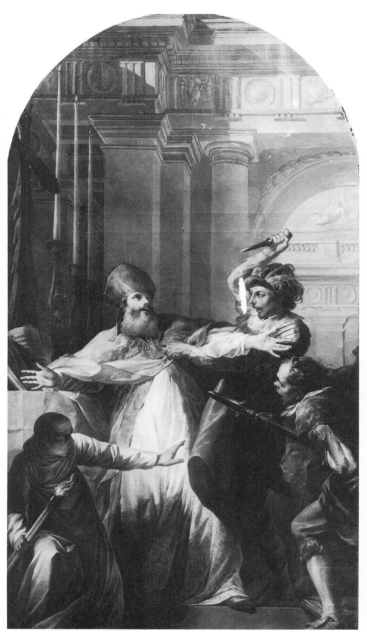

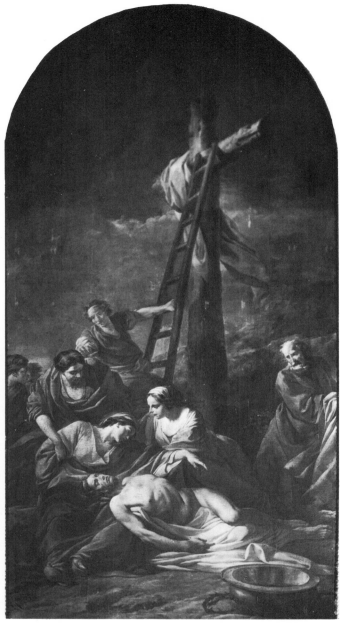

Restout's real début as the leading religious painter of the first half of the century was made in 1730 with his *Ecstasy of St Benedict* and *Death of St Scholastica* (Col. Plate 2). These two paintings, which form a pair, were almost certainly commissioned for the Benedictine monastery at Bourgueil near Chinon. There is a monastic austerity about them: the pale, bare, scrubbed boards of the cells, the economy of silhouette and colour (black and white only) in the figures. The saints' cells are furnished with the basic necessities of their lives of contemplation and devotion, and there is the rarefied atmosphere that characterizes such institutions. Two nuns in the first Benedictine convent, founded by St Scholastica, have entered her cell at the moment of her death: she has been contemplating a skull and an hourglass, and as she dies, one of the nuns, her face movingly covered by her habit, helps to support

Above, left:
Fig. 36. JEAN-BAPTISTE-MARIE PIERRE: *The Murder of St Thomas-à-Becket.* 1748. Oil on canvas, 300 × 140 cm. Eglise Notre-Dame-de-Bercy, Paris

Above, right:
Fig. 37. JEAN-BAPTISTE-MARIE PIERRE: *The Lamentation at the Foot of the Cross.* 1761. Oil on canvas, 750 × 300 cm. Versailles Cathedral

Scholastica's crucifix; the other nun tenderly supports the dying saint's head and hand. The stark simplicity of pictorial design is underlined by an almost hallucinatory vividness in the detail of such features as the woodwork of the cells.

Together with the bold presentation of his images, this attention to vivid details is a feature Restout owes to his master Jean Jouvenet. Restout's *Martyrdom of St Andrew* (Fig. 38), originally painted for the church of Sainte-André at Grenoble, shows the continuity of French religious art from the time of Jouvenet early in the century through to the work of Restout's own pupil Jean-Baptiste Deshays in the 1760s (Fig. 43). The *repoussoir* device of tools and garments scattered in the foreground can be found in Jouvenet's *Raising of the Nain Widow's Son* of 1708 (Fig. 26), as can the method of building up the composition of monumental figures behind, and some of the muscular figure-types are also comparable. The arrangement of Jouvenet's figures tends to be more staccato and their gestures more declamatory; with Restout, the compositions usually have longer, more curving rhythms, with elongated, bending or twisting bodies, such as those of the executioners on the ladder at the left or the figure supporting the saint's legs, who has more than a hint of mannerism in his pose. Rigour is perhaps the best word to

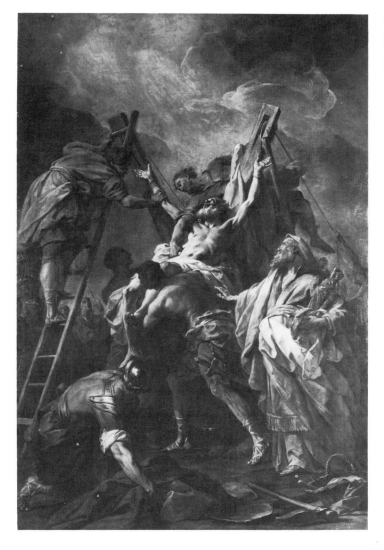

Fig. 38. JEAN RESTOUT: *The Martyrdom of St Andrew.* 1749. Oil on canvas, 360 × 235 cm. Musée de Peinture et de Sculpture, Grenoble

apply to the finest of Restout's religious compositions, such as *The Martyrdom of St Andrew*. This painting has a potent concentration of mood, counterpointing the strenuous efforts of the executioners (who are oblivious to all but the task in hand) with the expression of the saint, who perceives the divine light breaking through the overcast sky; the priest on the right, holding a pagan image which Andrew has refused to recognize, is not aware of the significance of the event he witnesses. The forms lead our eyes to the grateful face of the saint, and then upwards to the source of light in the sky. This main movement of the composition can also be compared with Jouvenet's *Raising of the Nain Widow's Son*, except that the latter has more additional incident and less concentration than the *Martyrdom*.

A different and more Italianate tradition in religious painting is found in the work of Carle Van Loo, who spent his formative years south of the Alps. He made one of the major cycles of religious paintings commissioned in Paris at the mid-century, illustrating scenes from the life of St Augustine, which are still to be found in Notre-Dame-des-Victoires, the church of the Augustinian Petits-Pères, together with a painting executed in 1746 to illustrate the supposed vow of Louis XIII at La Rochelle to found the church. With the upright *Vow* at the end of the choir, flanked by the square *Death of St Augustine* and the *Translation of the Relics of St Augustine*, the four enormous principal scenes—two each side of the choir—show *The Baptism of St Augustine*, *The Preaching of St Augustine before Bishop Valerius* (Fig. 39), *The Consecration of St Augustine as Successor to Valerius* and *The Dispute of St Augustine with the Donatists* (Fig. 40).

Van Loo was one of the most revered painters of his day, and yet painting did not come easily to him. On more than one occasion he destroyed works he or his critics found unsatisfactory; one of these was a *Consecration of Augustine*, shown at the Salon of 1750. A completely new version was exhibited in 1751, but it underwent further modifications before being signed and dated in 1754. Van Loo worked within a respected tradition, and his *Preaching of Augustine* is derived from Louis de Boullogne's treatment of the same theme in the St Augustine Chapel at Saint-Louis-des-Invalides at the beginning of the century (sketch, Fig. 42). There is more variety of type, character and expression in Van Loo's painting, perhaps because it was intended to be more closely visible than Boullogne's distant vault, but the general designs are very similar and in turn derive from Le Sueur's *St Bruno listening to Raymond Diocrès* (Louvre); his maintenance of this classical tradition in French painting goes far to explain eighteenth-century admiration for Van Loo. The scale of Van Loo's picture is very grand, the looming figures echoed by the architecture, and it shows him to have been indeed the exemplary student of the Italian grand manner described by his biographer Dandré-Bardon, as well as of more recent French prototypes such as Boullogne. The saint is not shown in the mythical miraculous setting popular in the imagery associated with him from the Middle Ages to the seventeenth century; rather, the historic facts of his life are stressed, in accordance with the rationalized editions of his biography published in the late seventeenth and the eighteenth century. Augustine is already a stern figure of authority in the *Preaching*, and the power of his oratory is conveyed by his elevated position and silhouetted gesture, as he enjoys the privilege, unique for his day, of addressing a bishop; his dominating figure is effectively supported by the foreground spectators and the scribe, who attentively records his words, watched by an intrigued youth. The effect of having light shining from directly behind Augustine onto his audience, which is used by both Boullogne and Van Loo, symbolizes the illumination of his listeners.

Opposite, above:
Fig. 39. CARLE VAN LOO: *St Augustine Preaching before Bishop Valerius*. 1755. Oil on canvas, 400 × 550 cm. Eglise Notre-Dame-des-Victoires, Paris

Opposite, below:
Fig. 40. CARLE VAN LOO: *St Augustine Disputing with the Donatists*. 1753. Oil on canvas, 400 × 550 cm. Eglise Notre-Dame-des-Victoires, Paris

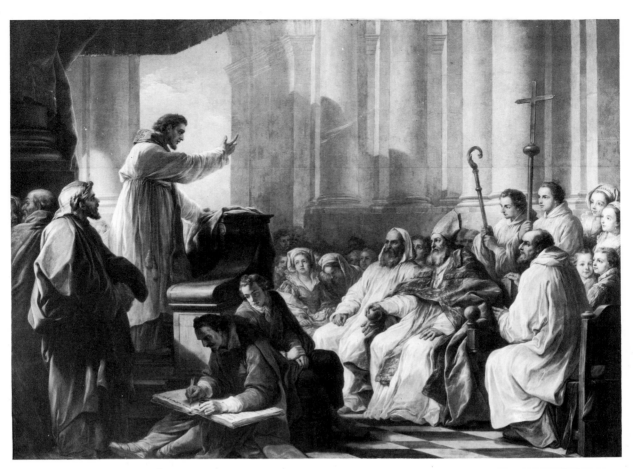
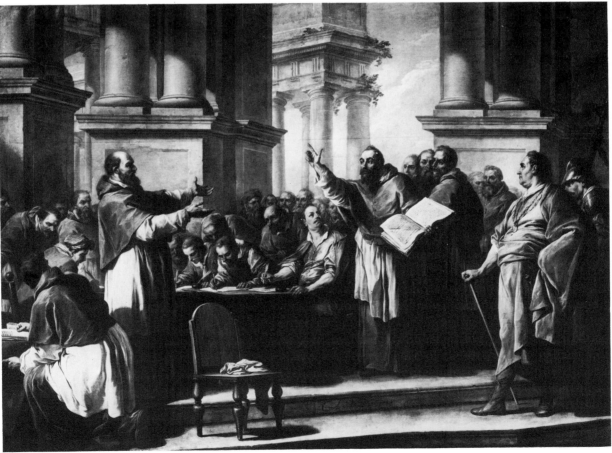

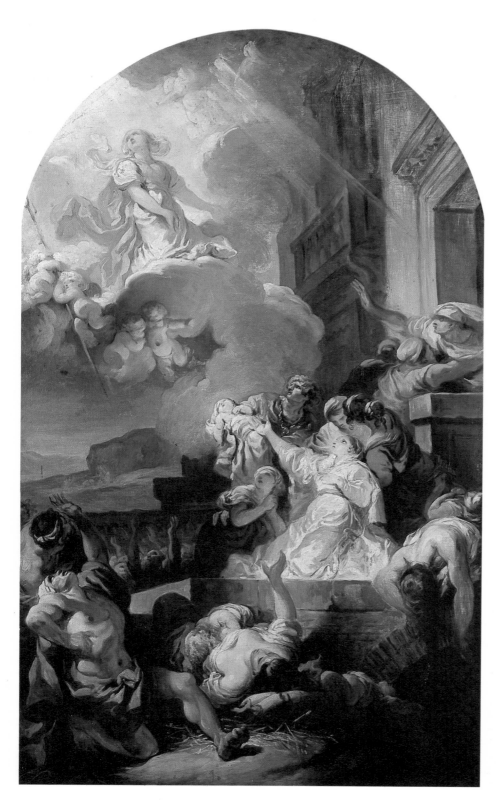

3. GABRIEL-FRANÇOIS DOYEN: *St Geneviève interceding for Victims of the Plague* (sketch; cf. Fig. 44). 1767. Oil on canvas, 100 × 61 cm. Musée Bonnat, Bayonne

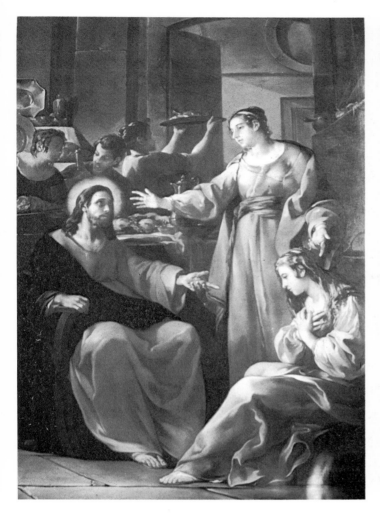

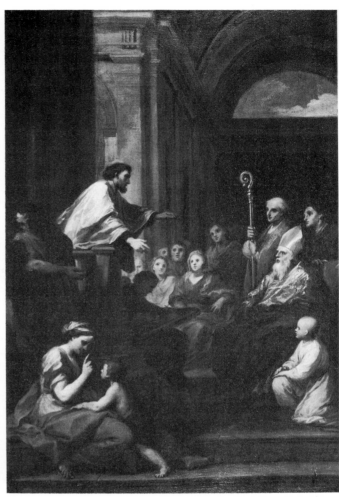

Fig. 41. JOSEPH-MARIE VIEN: *Christ in the House of Martha and Mary*. 1747. Oil on canvas, 312 × 215 cm. Collégiale Royale de Sainte-Marthe, Tarascon

Fig. 42. LOUIS DE BOULLOGNE: *St Augustine Preaching* (sketch). About 1705. Oil on canvas, 70.5 × 47 cm. The Snite Museum of Art, University of Notre Dame, Indiana (Gift of Dr Hans Rosenwald)

One of the most admired paintings of this cycle, *The Dispute of Augustine with the Donatists*, shows Augustine at one of the triumphant moments of his life. The Emperor Honorius had summoned a conference of Catholic and schismatic Donatist bishops in 411, to substantiate their respective claims to represent the true Church. The debate, led by delegations of seven bishops from each side, took place before the tribune Flavius Marcellinus in the great hall of a Roman bath at Carthage, and the full proceedings were recorded verbatim by stenographers. One anonymous Salon critic in 1753 (possibly Jacques Lacombe) devoted some six pages to a discussion of this picture, describing it in detail and observing how well the architecture expressed the grandeur of Roman baths. To the right of centre stands Augustine, declaiming with confidence and pointing heavenwards, while attentive scribes take down what he says. To the left, the chief Donatist adopts a more defensive pose and gesture, while on the right the stout tribune presides, looking with admiration at Augustine, whom at heart he supported. As the critic observed, no person seems superfluous, and the protagonists are so disposed that the essence of the action is clear: 'M. Vanloo has grasped the moment when the dispute is most animated, and where St Augustine is at grips with the chief of the Donatists. This moment is without doubt the most propitious of the whole action. Everything consists in opposing the zeal and the superior reasoning of the defender of truth to

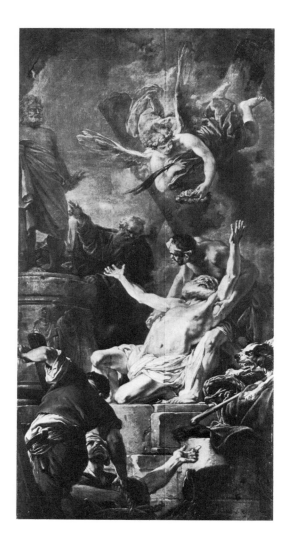

Fig. 43. JEAN-BAPTISTE DESHAYS: *The Martyrdom
of St Andrew*. 1758. Oil on canvas, 420 × 220 cm.
Musée des Beaux-Arts, Rouen

the bad faith and spirit of chicanery of his adversary, and in making all those
present seem attentive and engaged, according to their different interests in the
dispute.' The scene is intended to show Augustine's powers in learned discourse,
perhaps as a pendant to the scene where he preaches before Valerius. Some critics
picked on the fact that Van Loo was not always historically accurate in his treatment
of costume, or in the manner of baptism, for example. But Dandré-Bardon, in his
Life of Carle Van Loo, defended this lack of historicism, arguing that the invention
of persuasive and attractive images through artistic genius was more important than
historical accuracy; moreover, 'church pictures are the books of the people, and we
are excused for conforming to their ideas. To cross them or clash directly with them
would make those we hold up as models of virtuous action and objects of veneration
unrecognizable in the eyes of the common people'. So for didactic reasons it was
considered important that the ordinary eighteenth-century spectator could readily
recognize, say, a bishop by his cope, mitre and crozier, although these might not be
consistent with the practice of early periods of Christianity.

A visit to Notre-Dame-des-Victoires is one of the best ways to understand why
the reputation of Van Loo stood so high during the eighteenth century. The
paintings there are clearly disposed and legible, with gesture and expression

directed to specific ends, and in their eclecticism they sum up the classical tradition of Franco-Italian art of the preceding two hundred years. Van Loo's eclecticism and the consequent stylistic variety across the whole of his work were greatly admired by Dandré-Bardon, who gives us an estimation of Van Loo as the eighteenth century saw him: as a master who made positive, intelligent use of a respectable academic tradition and yet created 'an original manner, which belonged to himself alone'. Paintings such as the St Augustine cycle express the highest ideals of mid-eighteenth-century French art, and they are just as representative of their age—though of different aspirations of that age—as the pastorals and mythologies of Boucher, which have dominated nineteenth- and twentieth-century views of its character.

The rising star of French religious painting during the early 1760s was that of Jean-Baptiste Deshays. The quiet austerity of his *Last Communion of St Benedict* (now in the church of Saint-Paterne, Orléans, but in too poor a condition to reproduce) was the sensation of the Salon of 1761. But in the next few years he developed a much more baroque style, full of movement and expressing more visionary subjects. His reputation was based upon three huge paintings showing *The Flagellation of St Andrew* (Salon of 1761), *The Martyrdom of St Andrew* (Fig. 43; Salon of 1759) and *The Burial of St Andrew*, commissioned by the town of Rouen for the church of Saint-André de la Porte aux Fèvres. In December 1761 Deshays was able to write to the mayor of Rouen: 'I am delighted that in general you are satisfied with the paintings I made for Saint-André; they made a good part of my reputation in Paris, and have earned me the name of "Painter of St Andrew".' Deshays was born near Rouen, and this important commission was probably already promised to him before he set off from Paris for Rome in 1754. He had an impeccable pedigree as a religious painter: a pupil of Restout, he had been at the Académie in Paris, then at the Ecole des Elèves Protégés, after which he had some four years in which to contemplate and absorb the great examples of Renaissance and seventeenth-century painting in Italy. These sources—Restout (Fig. 38), Jouvenet (Fig. 26), Caravaggio, Domenichino, Vouet—are assimilated into his *Martyrdom of St Andrew*, which received almost universal critical acclaim; these works particularly caught the imagination of Diderot, who recognized in them the revival of seventeenth-century standards.

The death of Deshays and Van Loo in 1765 and of Restout in 1768, and Pierre's withdrawal into academic administration in the late 1760s, left the young Gabriel-François Doyen in the position of their successor, and of leader of a young generation of religious painters. He successfully completed Van Loo's St Gregory Chapel at the Invalides in 1772, and established his reputation with the enormous *St Geneviève* altarpiece in the church of Saint-Roch. Nearly a century in its construction, Saint-Roch was only completed in the mid-1740s. Inspired by and wishing to rival the building and decoration of Saint-Sulpice on the other side of the Seine, the *curé* of Saint-Roch, Jean-Baptiste Marduel, encouraged elaborate works and scenic effects, which were supervised by the sculptor Falconet, the architect Boullée, and the painter Pierre. For example, the latter painted a huge cupola with an *Assumption of the Virgin*, as a more classicizing rival to that of Lemoyne at Saint-Sulpice. Marduel's relatively stern taste is reflected in the transept chapels, which were remodelled by Boullée in false-perspective coffering and completed in 1767 with the enormous altarpieces by Doyen (*St Geneviève interceding for Victims of the Plague*; Fig. 44) and Vien (*St Denis Preaching to the Gauls*; Fig.45). These altarpieces form a contrasting pair, showing the acts of the two saints most favoured by the

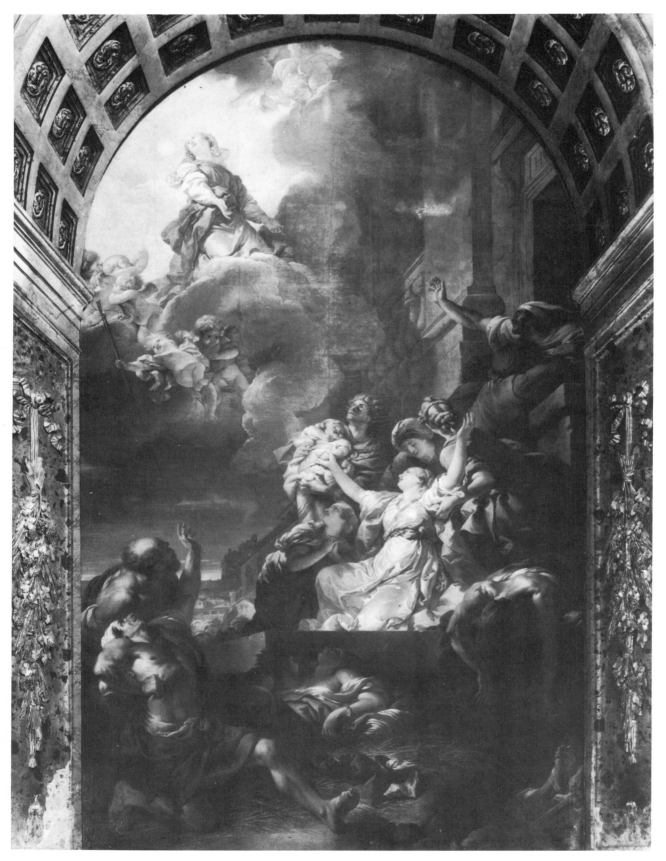

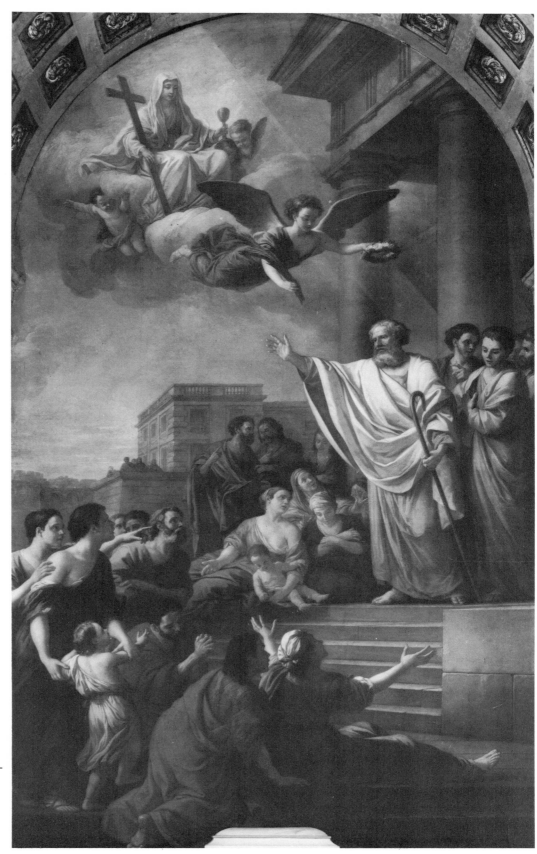

Opposite:
Fig. 44. GABRIEL-FRANÇOIS
DOYEN: *St Geneviève interceding for
Victims of the Plague*. 1767. Oil on
canvas, 665 × 400 cm. Eglise Saint-
Roch, Paris

Fig. 45. JOSEPH-MARIE VIEN: *St
Denis preaching to the Gauls*. 1767.
Oil on canvas, 665 × 400 cm.
Eglise Saint-Roch, Paris

61

Gallican church—St Geneviève invoking divine assistance, St Denis imparting the truths of religion by reasoned argument. In the south transept Doyen's St Geneviève implores the cloud-borne Virgin to end the plague which was ravaging Paris in 1129. The foreground is filled with corpses and tormented bodies, which act as *repoussoir* figures to the dramatic diagonal movement back and up into the picture, following the gaze of the saint towards the Virgin, who in turn looks up to heaven for respite. The bold movement, the painterly surface, and the visionary nature of the subject recall the dynamic art of Rubens (tempered by Le Brun and Jouvenet), and offer an alternative to the classicism of Vien. Early biographers hint that Doyen may have made a trip to the Low Countries to study works by Rubens—though he could have done that in Paris, at the Palais du Luxembourg—but in any case his attempt to revitalize French art in this painterly way was not really followed seriously until the early decades of the nineteenth century, with the work of Gros and then of the young Delacroix. From the late 1760s onwards, it was the Franco-Italian classical tradition that dominated the work of French painters, especially because of the support it had in the official teaching of the Académie.

A total contrast to Doyen's *St Geneviève* is provided by Vien's altarpiece, which shows St Denis, who was credited with bringing Christianity to the Gauls, preaching in a calm and authoritative manner. This commission had originally gone to the ill-fated Deshays, who would have introduced rather more movement (oil sketch in the Musée des Beaux-Arts, Nîmes); but Vien adopts a more classicizing style, derived from Le Sueur, Andrea Sacchi, and ultimately Raphael, which perfectly expresses the didactic manner of his saint, as opposed to the miraculous deed of St Geneviève. The figures, with their carefully measured gestures, are set in a space clearly articulated by the classical architecture. However, *St Denis Preaching* represents a mature phase of Vien's development, when in the 1760s he was a pioneer of the neoclassical revival of restraint in French painting, which is discussed in the next chapter.

It was in Rome, twenty years before, that as a *pensionnaire* (1744–50) Vien had first been inspired to a passion of reforming zeal, by the work of early Seicento masters. In Rome he was struck by the bold contrasts of light and shade, the richly saturated palette, and the large figure-scale of painters such as the Carracci, Guercino, Saraceni and Reni. This is nowhere more apparent than in his cycle of seven paintings illustrating the life of St Martha, made for the Cloisters of the Capuchin church at Tarascon. Begun in 1746, they were admired by de Troy, who was then Directeur of the Académie in Rome; but when Vien presented one of the series as a reception piece to the Académie in Paris, he was initially rejected, for 'it had too much of the Italian masters'. In *Christ in the House of Martha and Mary*, for example (Fig. 41), the large scale of the figures (which are life-size), the full modelling of their solid forms, their bold colour and clear gestures, all reveal his sources. In this strong and natural style, Vien was breaking with the conventional routines of academic training: he said in his own memoirs of these years that he deliberately went back to early seventeenth-century sources because through them he felt more in contact with nature and with the mainstream of Renaissance tradition than he could through his immediate teachers. So in spite of the rather limp neoclassical style that he had himself developed by the late 1770s, the Italian Seicento masters were the models Vien recommended his young pupil David to study in Rome, with dramatic results for the course of French history painting in the following years. In any case, by the end of the 1760s the painters newly admired by the young Vien were quite the accepted models—the *pensionnaires* in Rome

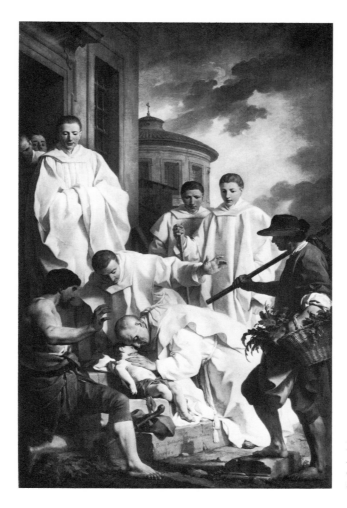

Fig. 46. PIERRE SUBLEYRAS: *The Miracle of St Benedict*. 1747. Oil on canvas, 325 × 215 cm. Church of S. Francesca Romana, Rome

might copy such masters, and the influential theorist Charles-Nicolas Cochin recommended in 1774 that the young French painters there should study other tenebrists as well, and the painterly effects of Guercino.

The strong influence of Italian painting on the French is hardly surprising, for of course one of the reasons why the *pensionnaires* were sent to Rome was to study the example of revered masters. But the French painters naturally enough made their own contributions to such traditions, and were also much influenced by the most recent artistic developments in Rome. Painters such as Claude-Joseph Vernet and Pierre Subleyras, who spent an important part of their working lives in Italy, can with justification be classed with the school of Rome during their sojourn there. Subleyras was a *pensionnaire* who, through the protection of the Duchesse d'Uzès, the Duc de Saint-Aignan and Pope Benedict XIV, managed to stay on in Rome instead of returning to Paris as was normally expected. He pursued a brilliant career in Rome during the 1730s and 1740s, sharing only with Poussin and Le Valentin among French painters the honour of a commission for an altarpiece in St Peter's. Next to the bold contrasts and vigorous modelling of Vien, his younger contemporary in Rome, Subleyras, with his clear, pale colour and flat technique of fine brushwork, can be seen as continuing the mainstream of Roman classicism, looking back to the work of Carlo Maratta and Andrea Sacchi. We may feel that the destination of Subleyras's *Miracle of St Benedict* (Fig. 46)—the church of the

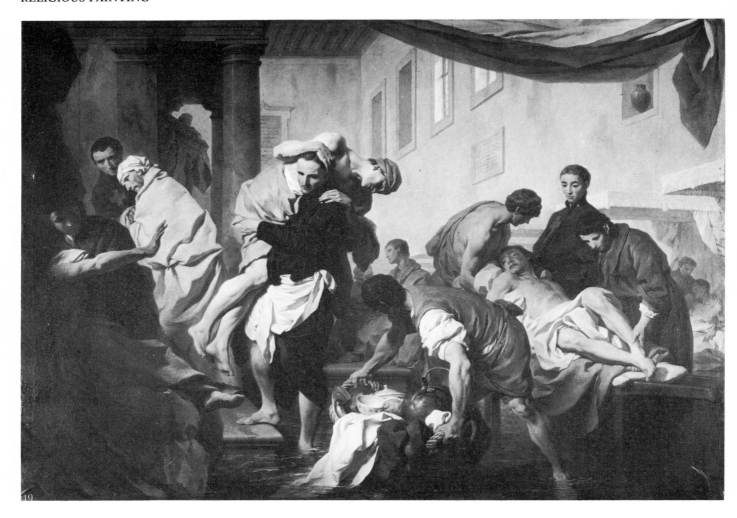

Fig. 47. PIERRE SUBLEYRAS: *St Camillo de Lellis*. 1746. Oil on canvas, 205 × 280 cm. Museo di Roma, Rome

Olivetan Benedictine monks at Perugia—partly accounts for its noble simplicity. Yet this painting, in which the saint revives a dead child, is typical of Subleyras's religious works, with its profound economy and sobriety of form, colour, gesture, and expression. The tonal character of his paintings and his love of a subtly impasted surface, combined with the ordered stillness of his pictorial world, have led many commentators to compare his work with that of Chardin. Indeed, had Chardin ever painted a gardener, he would surely have looked rather like the figure on the right of this altarpiece.

Though Subleyras was an upholder of the classical tradition in Roman painting, he was original in blending this tradition with a more sharply observed realism. To his *St Camillo de Lellis saving Patients of the Ospedale di Santo Spirito from a Flood of the Tiber in 1598* (Fig. 47) Subleyras lends a sober human dignity. The picture was commissioned by the Order of the Camillans on the occasion of the Saint's canonization in June 1746, and presented as a gift to Pope Benedict XIV. This is almost an elevated genre-painting, for he gives as much emphasis to the interior of the hospital and its artefacts and inmates as to the quiet heroism of the saint. French painters in Rome seem to have been particularly drawn towards realism in the middle decades of the century. This was perhaps partly because they were at a distance from the rather doctrinaire idealism promoted by the Académie in Paris,

64

and also because they were made more strongly aware by their exposure to Italian art (as in the case of Vien, mentioned above) that their tradition of history painting, stretching back to the example of Annibale Carracci at the beginning of the seventeenth century, had a firm basis in the first-hand study of nature. Italian painters working in Rome in the later 1730s and 1740s, such as Marco Benefial (1684–1764) and the younger Pompeo Batoni (1708–87) had initiated a reform of the art by looking back to this earlier period. Frenchmen such as Pierre, Subleyras and Vien were responding to the reforms of their Italian peers, though Subleyras in a sense tempered Benefial's vigorous and often eccentric realism with a measure of French good taste.

To return to our survey of painting in France, the major religious commission of the 1770s was a suite of large works illustrating the life of St Louis, commissioned by the Ministry of War for the Royal Chapel at the recently completed Ecole Militaire and shown at the Salon of 1773. The commission brought together a generation of history painters, and, as the *Mercure de France* pointed out in a review of the Salon, provided a sort of competition in which the painters could attempt to outshine one another. The serious purpose of the pictures and their grandiose disposition led the critic to remark that such works seemed 'far removed from those rose-tinted compositions which many artists have been willing to paint in order to please the eye and decorate the boudoir'. This is a critical comment typical of the decade, which, while approving official State patronage of 'high' art, accuses the earlier generation of triviality and ignores the fact that an unbroken tradition of serious history painting had been maintained through ecclesiastical patronage. The programme at the Ecole Militaire is particularly interesting for its fundamentally nationalist character, and it was no coincidence that the first sculptors' maquettes produced for d'Angiviller's 'Grands Hommes de la France', a commission which had been designed to stimulate morally elevating nationalist sculpture, were exhibited at the same Salon. Moreover, the Ecole Militaire canvases, with their subjects drawn from nationalistic medieval and Renaissance history, in this respect anticipate history painting later in the decade. Louis-Jacques Durameau's *St Louis washing the Feet of the Poor* (Fig. 48) and Doyen's *Last Communion of St Louis* for the high altar (Fig. 49), with their large rhythms, bulky masses, bold movement, and play of light and shade, are very much in an idiom derived from the study of the baroque masters of Bologna and Rome, where these two painters had recently studied. Just as Doyen had proved his abilities with the Saint-Roch altarpiece (Fig. 44), so Durameau had shown his power as a religious painter with two altarpieces executed in 1767 for the church of the Dames de Saint-Cyr near Versailles, *The Last Sacrament of St François de Sales* and *The Martyrdom of St Cyricus and St Julitta* (now in the church of Saint-Nicolas-du-Chardonnet, Paris).

In contrast to the painterly, neo-baroque electicism of artists such as Doyen, Durameau, and others trained during the 1760s, those formed in the following decade developed a style more austere and more realist, in line with the European movement of neoclassicism, which centred on Rome. Painters completing their training during the 1770s began to move away from the often sumptuous painterliness characteristic of the close of Louis XV's reign and the opening of that of Louis XVI. This was the result of a reassessment of the classical tradition, looking back to its sources in Raphael and in antique art, which will be discussed further in the following chapter, and also to the early Seicento realism of Caravaggio. The influence of Caravaggio on *pensionnaires* in Rome was strong during the last three decades of the century. His works were frequently copied, and his *St*

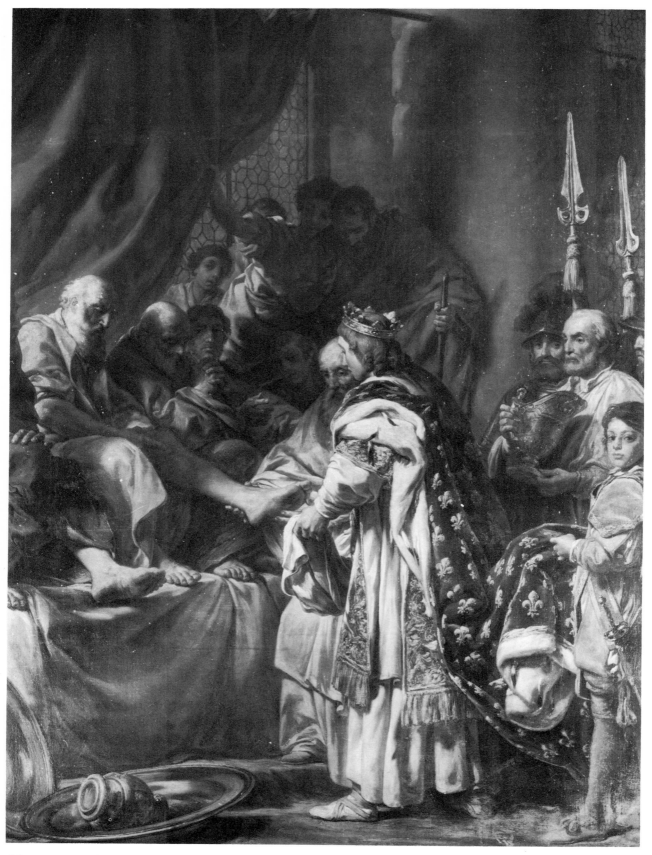

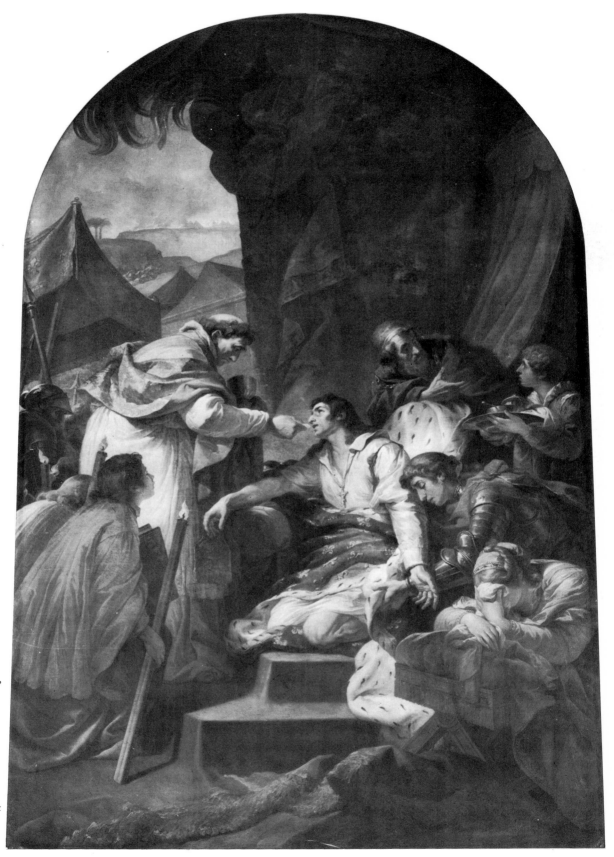

Opposite:
Fig. 48. LOUIS-
JOSEPH DURAMEAU:
*St Louis washing the
Feet of the Poor.*
1773. Oil on canvas,
about
300 × 200 cm.
Chapelle de l'Ecole
Militaire, Paris

Fig. 49. GABRIEL-
FRANÇOIS DOYEN:
*The Last Communion
of St Louis.* 1773.
Oil on canvas, about
600 × 300 cm.
Chapelle de l'Ecole
Militaire, Paris

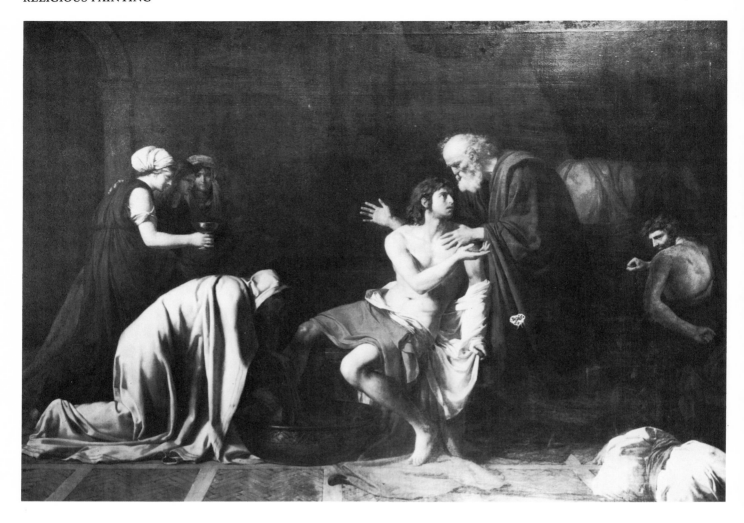

Fig. 50. JEAN-GERMAIN DROUAIS:
The Return of the Prodigal Son. 1782.
Oil on canvas, 144 × 200 cm.
Eglise Saint-Roch, Paris

Matthew cycle in the French church of S. Luigi dei Francesi was a continuing reminder of his powers. French admiration of his art is reflected in Cochin's praise of his Franco-Roman follower Le Valentin, in a lecture of 1777. Two aspects of his art seem to have appealed to painters who were seeking a more vivid approach to figure painting: firstly, the lighting up of the main figures against a dark background, which emphasized the narrative; and secondly, the careful depiction of everyday objects in order to lend a sharp sense of actuality to historical events (a device which can also be seen in certain works of Jouvenet's, as Cochin observed). One of the first works in which these features can be seen is *The Return of the Prodigal Son* (Fig. 50) by Jean-Germain Drouais, a pupil of Brenet (who precociously copied a Caravaggio in 1758) and David. If the idealism and disposition of the figures owe something to a rethinking of Poussin, the way they are picked out against the dark background suggests Caravaggio, as do certain details, such as the bundle of clothing on the right or the brickwork of the floor. They provide realistic touches with which we can identify, and which form a transition between our world and the ideal world of the picture. This painting was probably conceived as a trial run for the Prix de Rome competition, which Drouais failed in 1783 but won the following year. He has perhaps considered Caravaggio here through the eyes of his master David, and the overall pictorial design is very close to that of Peyron's *Funeral of Miltiades* (Fig.

82), which was painted in the same year and is discussed further in Chapter Three. Here we can observe that religious painting followed the same direction of stylistic development as history painting in general, towards neo-Poussinism and a re-evaluation of seventeenth-century realism.

Jean-Charles-Nicaise Perrin's *Death of the Virgin* (Fig. 51), painted for the chapter-house of the Carthusians in Paris in 1788, makes an extreme stylistic contrast with Jean-Jacques Lagrenée's *Presentation of Jesus in the Temple* of 1771 (Fig. 52), commissioned by the same patrons. Perrin was evidently striving to create an austere, monumental and sculptural style to rival the contemporary examples of David, Drouais and Peyron, notably in the figure-groups on the right; already a copyist of Caravaggio and Guercino as a student in Italy, he further studied Caravaggio's treatment of the same theme, which he could at the time admire in the royal collection in Paris. While the contrast with Lagrenée's soft and painterly picture is an instructive one, we should not too readily see in it a linear development towards a more severe style. While it is true that Perrin's generation was more concerned with the Poussinesque ideal than were Lagrenée and his contemporaries, we must allow that each artist is responding to the theme in hand. The earlier painting conveys an appropriate mood of maternal concern and tenderness. This type of atmosphere is also found in the work of an artist of Perrin's generation, a great admirer of Poussin and Le Sueur, Joseph-Benoît Suvée, in his *Birth of the Virgin* (Fig. 53), shown at the Salon of 1779. In the foreground a group of women attend to the infant Virgin with Greuzian expressions of sentiment, while in the background St Anne reclines on the child-bed as her attendant women come

Fig. 51. JEAN-CHARLES-NICAISE PERRIN: *The Death of the Virgin*. 1788. Oil on canvas, 216 × 366 cm. Musée National du Château de Versailles

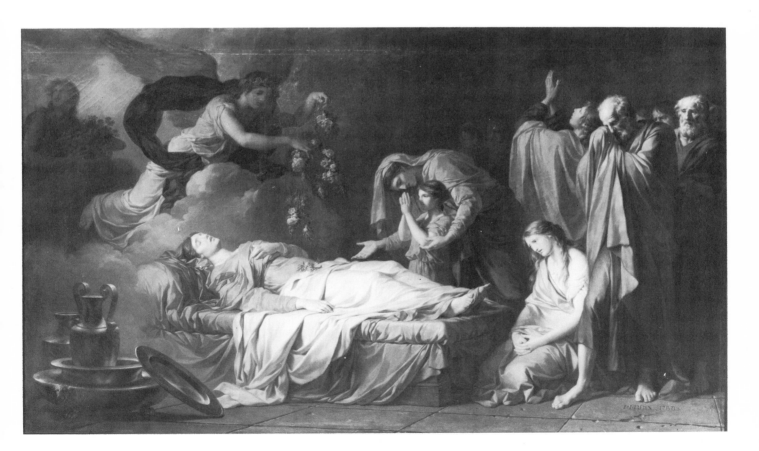

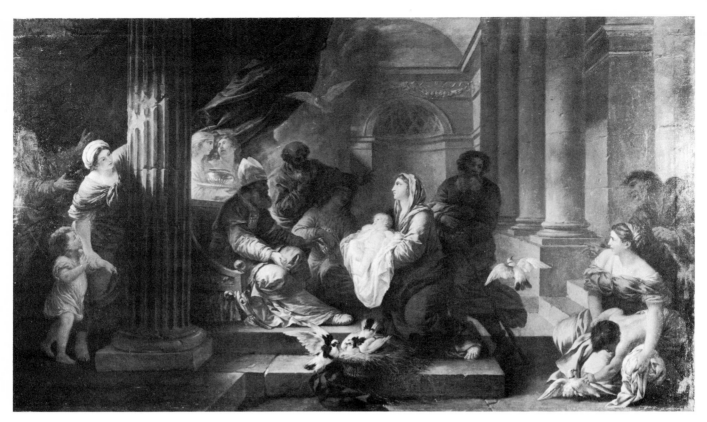

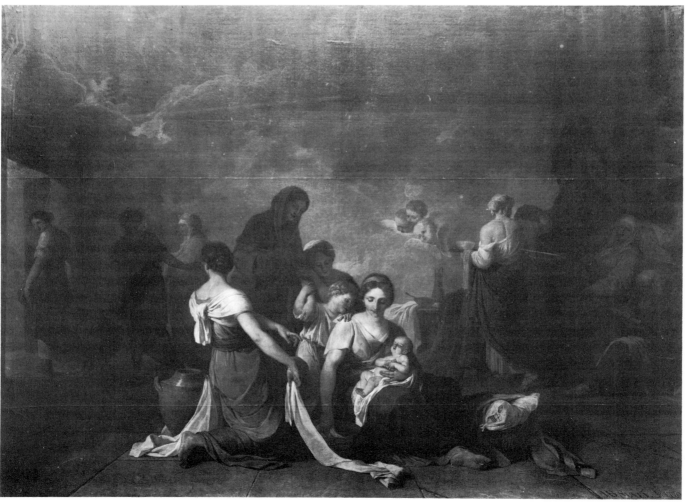

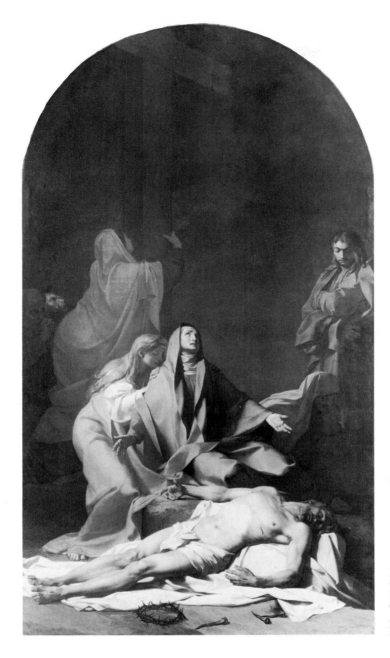

Fig. 54. JEAN-BAPTISTE REGNAULT: *The Descent from the Cross*. 1789. Oil on canvas, 425 × 233 cm. Musée du Louvre, Paris

Opposite, above:
Fig. 52. JEAN-JACQUES LAGRENÉE THE YOUNGER: *The Presentation of Jesus in the Temple*. 1771. Oil on canvas, 215 × 360 cm. Musée National du Château de Versailles

Opposite, below:
Fig. 53. JOSEPH-BENOÎT SUVÉE: *The Birth of the Virgin*. 1779. Oil on canvas, 310 × 423 cm. Eglise de l'Assomption, Paris

and go; infant angels float in on shafts of light and luminous clouds, which mingle with the steam from hot water. There seems to be a wilful naïvety in the virginal grace of Suvée's drawing and his restrained pastel colours in a work which continues the tradition of the sweeter Raphael and Le Sueur.

In contrast with Suvée, but to be compared with Perrin, is the remarkable *Descent from the Cross* by Jean-Baptiste Regnault, shown at the same Salon as Perrin's *Death of the Virgin*, where it was a sensational success (Fig. 54). It was commissioned by d'Angiviller for the Chapel of the Trinity at Fontainebleau, to replace a decaying work of the seventeenth century. Critics in 1789 compared Regnault's efforts with those of the Carracci and Guido Reni. But the more immediate source of the prominent, very dead-looking, indeed ugly corpse in the foreground, and of the

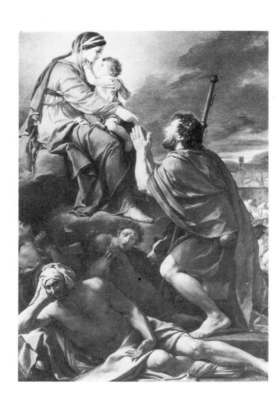

Fig. 55. JACQUES-LOUIS DAVID: *St Roch imploring the intercession of the Virgin for Victims of the Plague.* 1780. Oil on canvas, 259 × 193 cm. Musée des Beaux-Arts, Marseilles

Cross isolated against the bleak sky, is Pierre's picture of the same subject (Fig. 37). However, the polished forms, the exotic, even *recherché* colour, and the rolling eyes of the Virgin all certainly suggest Reni and his Seicento followers. It is salutary to consider that in the Salon of the first year of the Revolution two of the most admired pictures were traditionally religious works.

The important role of religious painting in the formation of history painters can finally be illustrated by the example of David, who first manifested his artistic independence in an altarpiece, *St Roch imploring the Intercession of the Virgin for Victims of the Plague* (Fig. 55), completed in Rome in 1780 for the Chapelle du Lazaret (chapel of the plague hospital) at Marseilles. The picture was to commemorate the infamous plague that had ravaged Marseilles in 1720, and was commissioned by the health administration of the city, which contacted Vien, Directeur of the Académie in Rome, asking for the name of a suitable pupil. David was selected, and the picture, much admired in Rome in 1780, was exhibited at the Salon of 1781, after it had failed to win him the title of *agréé* at the Académie. Again, the realism of the work, especially of St Roch with a sore on his leg, his pilgrim's staff, knapsack and homespun clothes, and the frightening plague victim so daringly placed across the front of the picture, suggests Caravaggio, while the more idealized Madonna and Child are derived from Guercino. In fact, the recumbent figure in the foreground is adapted from a work by Le Brun, and his head comes from Poussin's *Plague of Ashdod*—altogether an eclectic range of sources, which David has cast into a combination of impressive originality. This painting illustrates perfectly the eighteenth-century attitude to the art of the past, which it regarded as a rich vocabulary, available to all, from which to construct new statements. Within a few years, however, David would challenge this comfortable eclecticism with the stark and uncompromising image of *The Oath of the Horatii* (Col. Plate 6), which is a radical work in the development of French history painting.

3 HISTORY PAINTING

A sense of continuity with the *grand siècle* marks history painting at the opening of the eighteenth century. The leading masters of the early decades, whose careers were all over by about 1720, had already firmly established their reputations in the 1680s. Indeed, history painting was felt to be in something of a crisis after the deaths of La Fosse (1716), Jouvenet and Bon Boullogne (1717), and Antoine Coypel (1722), and with the unproductive last years of François Verdier and Louis de Boullogne. Most of these painters had collaborated on one or all of the final great decorative schemes of Louis XIV in the Royal Chapel at Versailles, at Notre-Dame de Paris, and at the Château-Neuf de Meudon, but by the mid-1720s conscious efforts were needed to give new stimulus to the genre. However, French history painting in the age too easily thought of merely as that of Watteau was rich and various. We have seen the major religious cycles of these years in Chapter Two, and the same artists also produced important secular works.

The secular counterpart to Antoine Coypel's vault in the Royal Chapel at Versailles was the suite of decorations for the King's nephew, the Duc d'Orléans (later regent, from 1715 until the majority of Louis XV in 1723), in the gallery of his official residence, the Palais-Royal (Figs. 56 and 57). Such decorated galleries have a long history in French art, beginning with Fontainebleau, and several important examples were executed in Paris early in the eighteenth century: La Fosse decorated a new gallery for the collector Pierre Crozat in 1705–7; the Neapolitan Paolo de Matteis painted galleries at three *hôtels* between 1702 and 1704; and the Venetian Gian'Antonio Pellegrini decorated the gallery of the Banque Royale in 1720 (to the chagrin of his rival for the commission, Lemoyne). However, the artistic establishment looked askance at the dextrous speed of execution in which the Italian painters took such pride. The French versions of such schemes were usually more 'correct', clearly compartmentalized, and derived from Roman-Bolognese tradition. The vault of the Palais-Royal gallery was complete by 1706, with a central compartment showing an *Assembly of the Gods* (sketch, Fig. 56), flanked by four subsidiary scenes showing the roles played by the gods in the events of the *Aeneid*. Between 1714 and 1718 a series of large easel paintings were placed along the walls of the gallery, their themes also taken from the *Aeneid*. The scheme was destroyed during the early 1780s, but some of the lateral canvases survive, together with the sketch for the ceiling. To the right of the central opening, the unclad Venus, just above Mars and Hercules, appeals to Jupiter, who with outstretched arm reveals the future of Aeneas's line to her and the assembled gods and goddesses (some of whom are flattering portraits of ladies of the regent's court).

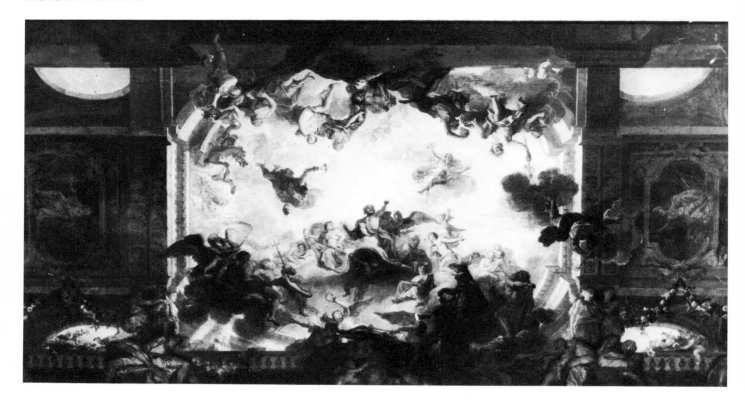

Fig. 56. ANTOINE COYPEL: *The Assembly of the Gods* (sketch). About 1702. Oil on canvas, 95 × 195 cm. Musée des Beaux-Arts, Angers

Coypel's scheme in general owes debts to several seventeenth-century precedents in France, but his combination of an illusionistically pierced vault and *quadri riportati* (one of them can be seen to each side of the sketch) derives from the ceiling of the Hercules Gallery by Charles Le Brun at the Hôtel Lambert, and the naked figures and caryatids recall Annibale Carracci's Farnese Gallery in Rome. Thus Coypel's vault consolidates an established tradition, just as the later canvases on the walls below would have seemed to contemporary eyes exemplary expositions of the academic manner. Where Aeneas appears to Dido (Fig. 57), the clear and measured space and the figure-types, gestures and groupings are reminiscent of Raphael, Domenichino, Poussin, and Le Brun, while a certain grace and softness of line show Coypel's admiration for Correggio. Painting of this sort may seem to lack the verve, originality and individuality of spirit which a post-Romantic audience seeks in works of art. Yet in Coypel's day originality would have been seen in his particular combination of recognizable sources. He could imitate—that is, interpret, develop, vary, and recast—an admired tradition, and thus add a link to the chain of that tradition, as indeed we have seen done in the majority of religious works mentioned in Chapter Two.

A more colouristic eclecticism is found in the work of Charles de la Fosse, who had spent over half of his six years in Italy (1658–63) in Venice. The *Bacchus and Ariadne* or *Autumn* (Fig. 58; one of a set of *Four Seasons* to decorate the main salon of the royal Château de Marly, the others by Antoine Coypel, Louis de Boullogne and Jouvenet) is consciously Titianesque in its sensuous contrasts of flesh, shimmering fabrics, and fur; its warm autumnal tones and conspicuously supple brushwork recall the great Venetian's late works. This poetic, neo-Venetian aspect of La Fosse's style became an important source for the more painterly artists of a younger

generation, such as Lemoyne and Watteau. As well as working on other official commissions, such as those at Versailles and the Invalides, La Fosse was protected by Pierre Crozat, in whose house he met the young Watteau in a company altogether sympathetic to the colourism of Rubens and the Venetians.

Another major source for early eighteenth-century painters was the style developed by Domenichino (1581–1641) and his contemporary Francesco Albani (1578–1660) in their delicate and graceful mythological paintings, which enjoyed a vogue in France during the latter part of Louis XIV's reign. This style was rendered into the French idiom by Louis de Boullogne (also an admirer of Raphael, Correggio and Carracci). His *Diana Resting* (Fig. 59) was painted in 1707 as part of a decorative scheme for a room in the King's suite at the Château de Rambouillet, a property of the Comte de Toulouse. Such a work, with its curving, languid rhythms and pretty nymphs displaying their charms in pleasing sylvan surroundings, sets the tone for what is almost a sub-genre in its own right (the *mythologie galante* it has been called), later perfected by Boucher in the middle of the century.

In line with academic doctrine, the State normally attempted to support history painting above the other genres. The various Directeurs des Bâtiments would regulate the prices paid for royal commissions in favour of history, as opposed to portraiture and lesser genres, especially during the second half of the century. As

Fig. 57. ANTOINE COYPEL: *Aeneas appearing to Dido*. About 1715. Oil on canvas, 385 × 570 cm. Musée des Beaux-Arts, Arras

Opposite:
Fig. 58. CHARLES DE LA FOSSE:
Bacchus and Ariadne (or *Autumn*).
1699. Oil on canvas,
242 × 185 cm. Musée des Beaux-
Arts, Dijon

Fig, 59. LOUIS DE BOULLOGNE:
Diana Resting. 1707. Oil on canvas,
105.5 × 163.5 cm. Musée des
Beaux-Arts, Tours

early as 1747 the reforming Directeur Le Normand de Tournehem adjusted the price paid for histories according to their size, and reduced the tariff for portraits. This discrimination of course drew bitter complaints from portrait painters, as we shall see in the discussion of portraiture in Chapter Four. Commissions were sometimes made with a specific view to encouraging history painters. This was especially so from the 1740s onwards, when, with the establishment of more frequent Salons, the state of contemporary painting came under regular critical scrutiny.

Before regular Salons were instituted in 1737 only two such exhibitions had been seen since the beginning of the century, in 1704 and 1725. One of the principal motives behind the exhibition of 1725, instigated by the Duc d'Antin, had been to encourage history painters. However, the leading masters of the closing years of Louis XIV's reign had all disappeared from the artistic scene, and it was felt that their places had yet to be filled. D'Antin thus instituted a competition in 1727, offering a prize of 5,000 *livres*, to be divided between the two artists of the Académie who produced the finest history paintings. All entries were to be put on public display in the Galerie d'Apollon at the Louvre for about two months, after which the Académiciens were to select the two best works, which would receive, as well as a prize, the honour of being purchased by the King. A dozen painters executed works to a prescribed size, with subjects of their own choice. The opinions of *amateurs*, the public and the court were divided, but it was finally decided to

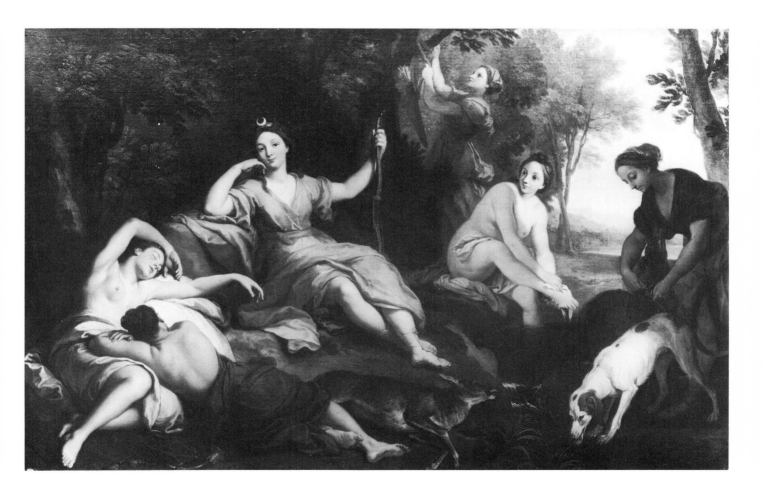

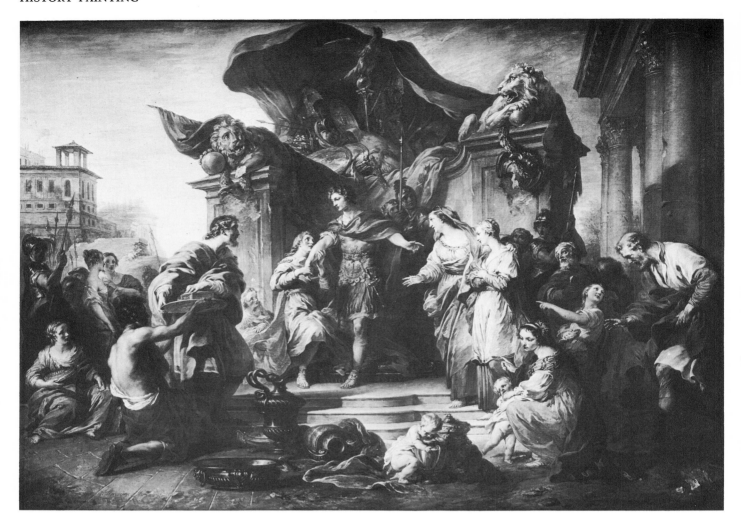

share the prize equally between Lemoyne (Fig. 60) and de Troy (Fig. 61), and the King also purchased the entry of Charles-Antoine Coypel, a work awarded almost equal merit (Fig. 62). Noël-Nicolas Coypel's very suave *Rape of Europa* (Fig. 63) was also greatly admired, and by way of compensation was purchased by the Comte de Morville for 1,500 *livres* (500 less than the royal purchases). The whole competition was surrounded by intrigue, arising mainly from the rival aspirations of Lemoyne (d'Antin's favourite) and de Troy for the first place in French painting of the day. De Troy felt piqued by the judges' decision and was 'indisposed' on the day of the presentation. In the following year Lemoyne was favoured with the coveted commission to decorate the ceiling of the Salon d'Hercule at Versailles, and it is probable that the Concours of 1727 was originally engineered to show his suitability for this task. However, it was not until the following decade that he became Premier Peintre, and de Troy had to be content with directing the Académie in Rome. With a few exceptions (for example Jean Restout), the paintings entered for the 1727 competition share a lightness of spirit and a desire to please, by means of displaying female charms to advantage. None of the four most highly ranking works shows much of the revered moral seriousness of Poussin, Le Brun or Le Sueur. Charles-Antoine Coypel's Rubensian *Perseus and Andromeda* (Fig.

Fig. 60. FRANÇOIS LEMOYNE: *The Continence of Scipio*. 1727. Oil on canvas, 147 × 207 cm. Musée des Beaux-Arts, Nancy

Opposite, above:
Fig. 61. JEAN-FRANÇOIS DE TROY: *Diana Resting*. 1726. Oil on canvas, 130 × 196 cm. Musée des Beaux-Arts, Nancy

Opposite, below:
Fig. 62. CHARLES-ANTOINE COYPEL: *Perseus and Andromeda*. 1727. Oil on canvas, 131 × 196 cm. Musée du Louvre, Paris

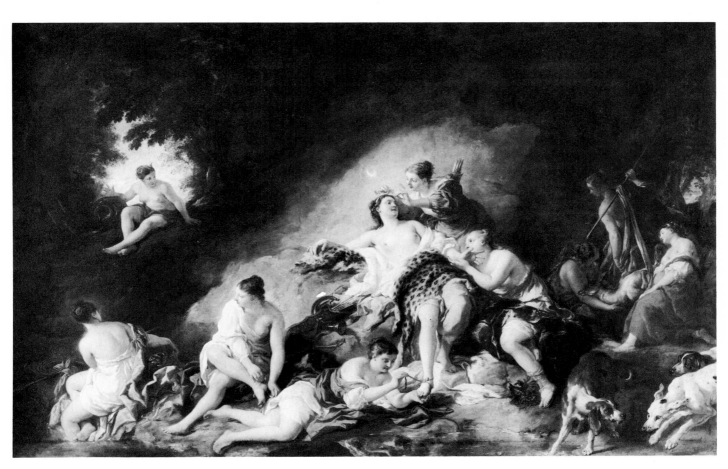

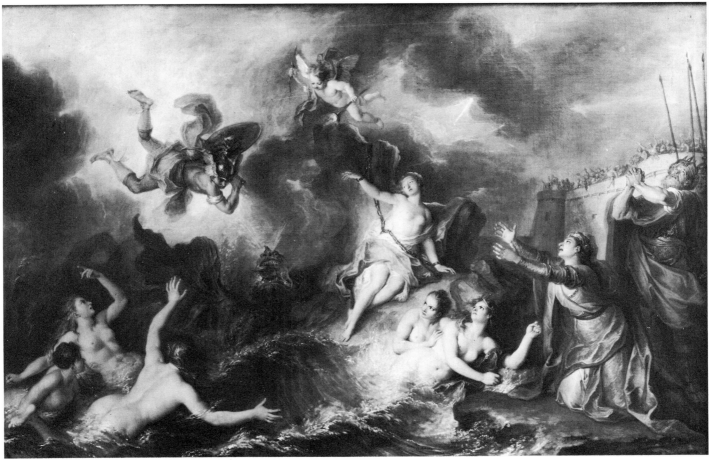

62), his first masterpiece, is a spectacular artifice, consciously theatrical in its effects, with histrionic actors and shrill colours. Noël-Nicolas Coypel (half-brother of Antoine but of the same generation as Charles-Antoine), who died in 1734 at the age of forty-four, might have rivalled Boucher in his brilliant, translucent, porcelain-like colour, polished finish, and curving rhythms (Fig. 63). Neither de Troy's *Diana Resting* nor Lemoyne's *Continence of Scipio* aroused very much critical interest, and such commentaries as survive lean more towards the two Coypels and other competitors such as Pierre-Jacques Cazès.

This attempt to focus attention on history painting and rejuvenate the genre can hardly be said to have greatly affected the course of French art. It was rather the younger artists who were in Rome at this time and in the 1730s—such as Van Loo and Subleyras, or Boucher and Natoire in the field of decoration—who were to have that effect. Twenty years later, in 1747, Le Normand launched another competition for history painters, which was the beginning of a more successful campaign to revive the standards of the *grand siècle*.

Lemoyne's *Apotheosis of Hercules* (Fig. 64), unveiled before Louis XV in 1736, was the largest cycle of secular ceiling decoration to be undertaken since the completion of Coypel's gallery at the Palais-Royal. In the room adjacent to the Royal Chapel at Versailles, whose ceiling was also by Coypel, and leading from there to the Grands Appartements, Lemoyne's *Apotheosis* carries to its extreme in French art the

Opposite:
Fig. 64. FRANÇOIS LEMOYNE:
The Apotheosis of Hercules. Ceiling vault in the Salon d'Hercule, Versailles. Completed 1736

Fig. 63. NOËL-NICOLAS COYPEL:
The Rape of Europa. 1727. Oil on canvas, 129.5 × 194.5 cm. Philadelphia Museum of Art (Gift of John Cadwalder)

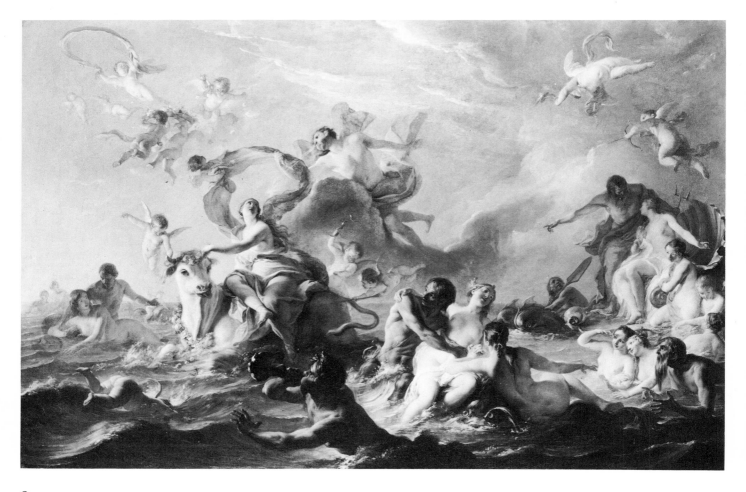

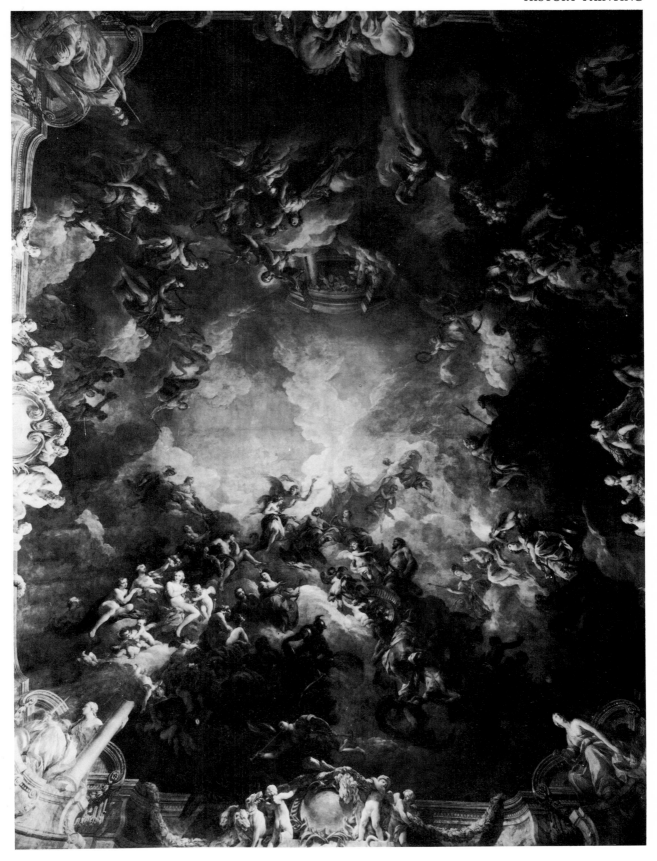

illusionistic ceiling opened up to the sky. It was originally to have been compartmentalized, with an opening in the centre only (drawing in the Musée Atger, Montpellier), in line with earlier French practice, of Coypel and Le Brun for example. But Lemoyne, like La Fosse before him, was a great admirer of Venetian painting, and decided on a fully illusionistic system, such as he had already tried in the *Transfiguration* in the Chapelle Saint-Louis of the church of Saint-Thomas d'Aquin in Paris and in his unsuccessful competition with Pellegrini for the gallery of the Banque Royale. Moreover, the light and decorative colour of the Versailles ceiling derives from a pair of important paintings by Veronese set into the walls at each end of the room below. The principal aspect of the painting, to be seen by the King on his way to the Chapel, shows Hercules in a chariot, presented to Jupiter and Juno by Virtue; Jupiter offers him the hand of Hebe, goddess of youth, who is led by Hymen. The brilliant blue sky with ethereal clouds is peopled by genii and a host of other gods, goddesses, and personifications. Lemoyne published a pamphlet to explain the meaning of his allegory in detail, which is summed up in the following passage:

> 'The love of virtue raises man above himself, and makes him overcome dangerous and difficult tasks: obstacles vanish at the sight of his king and his country. Sustained by Honour and Fidelity, he attains immortality by his actions. *The Apotheosis of Hercules* suggests this thought: the hero, in the course of his life, immortalized himself by means of virtuous and heroic deeds. Jupiter, whose image he had been on earth, crowns his achievement in heaven by imparting to him the gift of divinity'.

Lemoyne worked at the ceiling from May 1733 to September 1736 and was rewarded not only with 30,000 *livres* but also with the post of Premier Peintre du Roi. But alas, for this ambitious and troubled painter official recognition came too late, and within a few months he lost the balance of his mind and committed suicide. Lemoyne's ceiling had no progeny, and indeed for economic and aesthetic reasons such grandiose, baroque ideas were replaced by a more intimate and less illusionistic approach to decoration.

The light and airy *Hercules* ceiling and the lush, curvaceous forms and silvery tones of *Perseus and Andromeda*, which is derived from works by Titian and more particularly Veronese, give us some idea of how light and delicate Lemoyne's ceiling in Saint-Sulpice must have been (Fig. 64 and Col. Plate 4). The figure-type of Andromeda was later adapted by Boucher, who was briefly Lemoyne's pupil about 1720, and we see a similarly erotic and humorous juxtaposition of armed man and supple woman in Boucher's *Venus and Vulcan* (Fig. 65), one of a pair of decorative *mythologies galantes* executed for an unknown patron ten years after Lemoyne's picture. These paintings by Lemoyne and Boucher most likely formed integral parts of decorative schemes, as is usually the case with secular history paintings executed during the first half of the century. Cabinet pictures might also fall within the genre of history, but a delightful and again neo-Venetian work such as *The Abduction of Helen* by Nicolas Vleughels (Fig. 66), for all that it was painted by a future Directeur of the Académie in Rome, is closer in spirit to the *galanterie* of Watteau than to the *grand genre*.

With the exception of the 1727 competition entries, nearly all the easel paintings so far discussed in this chapter were executed for incorporation into specific architectural settings, and the lightness of their themes underlines their essentially decorative function. While the history of interior decoration is a subject

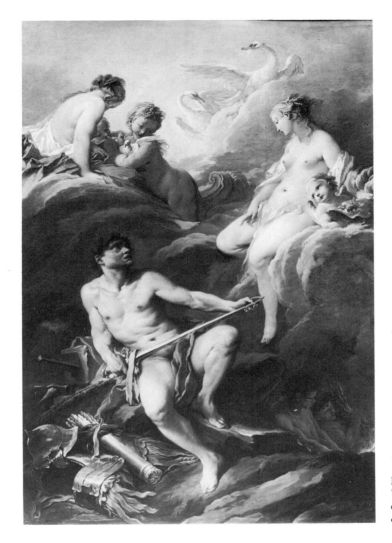

Fig. 65. FRANÇOIS BOUCHER: *Venus and Vulcan*. 1732. Oil on canvas, 252 × 175 cm. Musée du Louvre, Paris

in itself, it can be said here that the development of more elaborate and refined carved panelling and the increasing use of mirrors during these decades gave a more subsidiary role to painting, and also threatened the production of large tapestries, which derived from painted cartoons. Large decorative works, such as Natoire's *Siege of Bordeaux by Clovis* (Fig. 71), successfully reconcile decorative and more serious, didactic functions. But throughout the century, and from the 1740s against a background of rising academic criticism, brilliant decorators such as Boucher continued to produce charming *tableaux de place*, such as the four ovals painted for the Hôtel de Toulouse (Fig. 67). The theme is from Tasso's *Aminta*, and the oval reproduced here shows Sylvia fleeing from a wolf she has wounded, dropping her shawl in a prominent place as she runs (it is later discovered by her lover Aminta, who thinks she has been devoured by the beast). The rhythms of the running girl echo the oval shape of the canvas itself, and the creams, golds and pinks of her figure would probably have been in accord with the gilding and paintwork of the room in which the picture was originally set.

Venus and Vulcan and *Sylvia fleeing the Wolf* typify Boucher's sensitive discernment as the most impressive decorative painter in a society where such painters had every

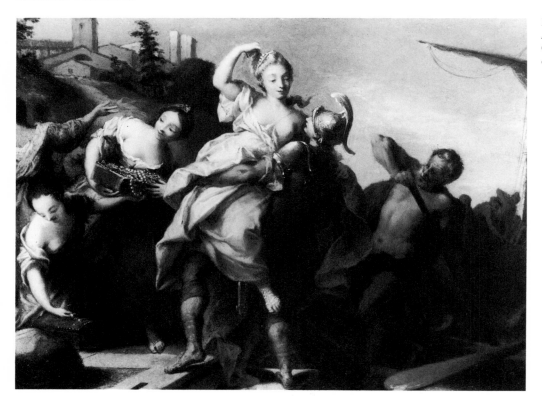

Fig. 66. NICOLAS VLEUGHELS: *The Abduction of Helen*. About 1716. Oil on copper, 19 × 26 cm. Private collection, New York

encouragement to excel. He benefited especially from the protection of Madame de Pompadour and her circle, which ensured him a prominent and profitable place in the intermingled world of the court and financiers during the 1740s and 1750s. But these connections did nothing to endear him to the more radical critics, such as La Font de Saint-Yenne in the late 1740s and, later, Diderot. His sure sense of design, be it in linear rhythm, the play of high-keyed colours, the variety of brushwork, or the telling juxtaposition of the textures of flesh, fabrics and other surfaces, is carried over into his treatment of different genres, which are discussed in their separate places in this book. He tackled all the genres except the extremes of morally elevated history and the lowly still life, and brought to each the same decorative sense and a joy in depicting all that was pleasing and undisturbing in the physical world, be it the realm of playful mythology and pastoral literature, a bourgeois refreshment (Fig. 131), a portrait of the King's mistress (Col. Plate 8), his own pretty wife (Fig. 106), or a never-never land of rosy-cheeked milkmaids in pastel parklands (Col. Plate 14). Thus for many he seems to reflect in his art all that was most attractive about the *ancien régime*: sophisticated, none too earnest, delighting in material luxury, and sparkling with the lightness, brilliancy and wit of a repartee exchanged in the gilded cage of an elegant Parisian drawing-room.

Since the end of the seventeenth century interiors had become progressively lighter and less formal in style. The proportions of panelling and mouldings became more slender and graceful, and the corners of mirrors and panels were rounded, or elaborated with scroll-shapes (Col. Plate 1 and Fig. 131). We have seen in Chapter One how this type of interior provided the context for Natoire's decorative style, the rococo style that finds perfect expression in his *Psyche Saved from Drowning* (Fig. 17). The rococo style is light, elegant, and intimate, with graceful, rhythmic

S-curves. It has its roots in Watteau (Fig. 121), who for a time worked with the leading decorators of his day, and was continued by his followers, such as Lancret (Figs. 16 and 129). Throughout the 1720s, '30s and '40s it emerges in the decorative works of many painters, including de Troy (Col. Plate 11), Van Loo (Fig. 134), Oudry (Fig. 137), Lajoue (Fig. 150), Boucher, and Natoire. These developments in interior decoration also help to explain the growing popularity of cabinet pictures from the second decade of the century onwards. With the diminishing of grander painted schemes, the relegation of fixed decorative paintings to the spaces above doors and windows, and the division of wall surfaces by panelling, only small and movable works could be accommodated. Thus the cabinet pictures in a fine collection such as that of the Duc de Choiseul would play

Fig. 67. FRANÇOIS BOUCHER:
Sylvia fleeing the Wolf she has wounded.
1756. Oil on canvas,
123.5 × 134 cm. Musée des Beaux-
Arts, Tours

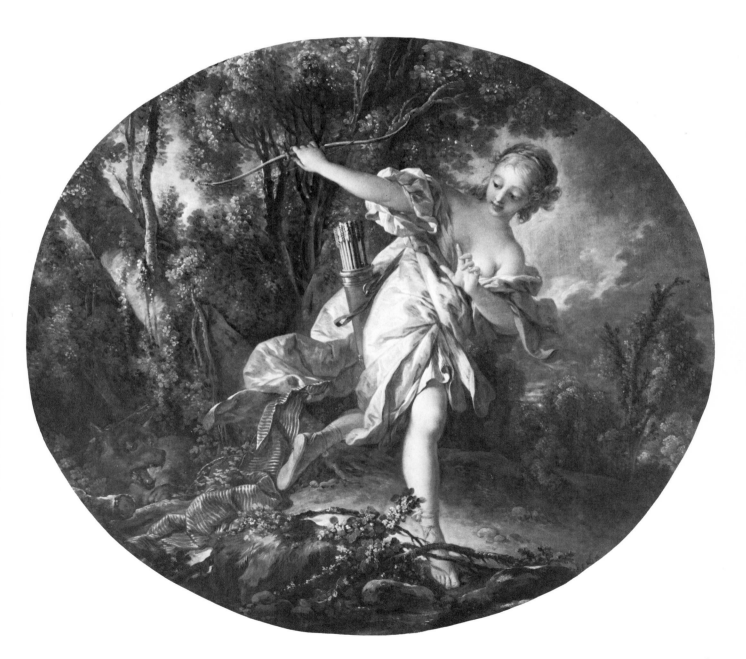

Fig. 68. JEAN-FRANÇOIS DE
TROY: *The Continence of Scipio*.
1728. Oil on canvas,
270 × 204 cm. Musée d'Art et
d'Histoire, Neuchâtel

an important part in the overall decoration of the rooms, as we can see in Blarenberghe's view of Choiseul's bedroom (Fig. 15). The taste for cabinet pictures was not only satisfied by contemporary painters like Vleughels and many others, working especially in the lesser genres, but also by old masters, notably Dutch and Flemish 'little' masters of the seventeenth century, whose works enjoyed a tremendous vogue from the second decade onwards.

With a few exceptions, the chief support for secular history painting during the 1720s and 1730s came from private rather than royal sources. If the royal purse-strings were drawn tight during those years, financiers and others who made their fortunes by profiteering through war or otherwise supplying funds to the King were lavish in their patronage. The banker Samuel Bernard, who subsidized the finances of Louis XIV in his last years, commissioned several sets of paintings from de Troy for his Paris residence, including four large scenes from Roman history: *The Discovery of Romulus and Remus*; *The Rape of the Sabine Women*; *Coriolanus and his Mother*; and *The Continence of Scipio* (Fig 68). It is interesting to compare the *Scipio* of de Troy, executed just after the 1727 competition, with that of Lemoyne (Fig. 60). De Troy invests his scene with a noble simplicity and a sense of Roman *gravitas*, in a monumental rendering of the ancient world seen through the eyes of Rubens and Jordaens, while the gesture and expression recall the French tradition of Le Brun and Jouvenet. It is almost as if de Troy were showing that he belonged to a less

ornamental tradition than Lemoyne. And, when compared with the rest of his own varied work, it shows that de Troy was the more subtle painter, more adaptable to particular subjects or commissions.

Natoire received commissions from private patrons for two major cycles of history paintings—one a set of tapestry cartoons, the other a painted decoration for a château. The commission for tapestry cartoons was exceptional in that only a single set of tapestries was woven from them, at the Beauvais works between 1735 and 1744; the client was Pierre Grimod Dufort, a financier and Intendant Général des Ports for the King. The tapestries were hung in the reception rooms of his Paris *hôtel*, and the cartoons were let into the panelling of his château in the country. The commission may have been a piece of enlightened self-interest, because it also helped to lift the Beauvais works out of the doldrums in the later 1730s. The theme is that of Don Quixote; this character was seen in eighteenth-century France simply as a grotesque buffoon, and it is difficult to understand the patron's desire to have his story depicted on such a large scale. But the element of the marvellous in the tale makes a splendid pretext for decorative painting. This is no more so than in *Sancho Panza on the Island of Barataria* (Fig. 69), where, during a lavish feast, a quack doctor forbids Sancho to eat. Servants clear away the food and dishes on the doctor's orders, and Sancho is about to explode with rage. There is a picturesque mixture of Renaissance and medieval architecture, a swirl of baroque drapery, and a gathering of all types—musicians, servants, courtiers—wearing sixteenth- and seventeenth-century costumes. And deficiencies in scale or perspective are compen-

Fig. 69. CHARLES-JOSEPH NATOIRE: *Sancho Panza on the Island of Barataria*. 1735. Oil on canvas, 180 × 325 cm. Musée National du Palais de Compiègne

Fig. 70. Copy after CHARLES-ANTOINE COYPEL: *Sancho Panza on the Island of Barataria*. 1719. Oil on canvas, 149 × 180 cm. Musée du Louvre, Paris

sated for by the rich and lively play of colour and brushwork, which is reminiscent, like the mixture of architecture and costume, of Veronese, and of the contemporary Venetian painter Sebastiano Ricci, whom Natoire knew and admired. It is his successful adaptation of the full decorative panoply of Venetian art that distinguishes Natoire's treatment of this theme from that of Charles-Antoine Coypel (copy, Fig. 70), executed in 1719 as one of a series of small scenes to serve as cartoons for the central medallions of Gobelins tapestries. Coypel's pictorial space and overstressed characterization recall his obsession with the theatre and his not very successful aspirations as a dramatist.

Another major private commission given to Natoire was for decorative mythological and historical paintings for the Château de la Chapelle-Godefroy, family home of Philibert Orry, which he executed between 1731 and 1740. After holding a number of important military and Crown posts, Orry was Contrôleur Général des Finances from 1730 to 1745, and Directeur des Bâtiments from 1737 to 1745. *The Four Seasons* and six episodes from *The Story of Telemachus* anticipate the *Psyche* series at the Hôtel de Soubise discussed in Chapter One, and have much in common with the decorative cycles of Boucher and others in these years. The six historical works are more unusual, however, in that they treat the history of early medieval France, celebrating the reign of Clovis at the end of the fifth century. Such an unusual theme must have been chosen by the patron, and the exploits of Clovis should probably be read as allusions to the achievements of Louis XV when, in 1735, the Peace of Vienna brought to an end, to French advantage, the War of Polish Succession. *The Siege of Bordeaux by Clovis* (Fig. 71) recalls the late-

Opposite:
4. FRANÇOIS LEMOYNE: *Perseus and Andromeda*. 1723. Oil on canvas, 184 × 151 cm. Wallace Collection, London

Fig. 71. CHARLES-JOSEPH
NATOIRE: *The Siege of Bordeaux by
Clovis*. 1737. Oil on canvas,
266 × 300 cm. Musée des Beaux-
Arts, Troyes

seventeenth-century battle paintings by Van der Meulen, but the large scale of the
figures shows Natoire to be looking at the more monumental tradition of Italian
baroque art, notably in the work of Pietro da Cortona (*Battle of Arbela*, Palazzo dei
Conservatori, Rome). Natoire's design and his disposition of light and shade have
the clarity of the best academic art, and the different stages of siege and battle are
carefully laid out, with proper emphasis on the commanding role of the King.

During his time as Directeur des Bâtiments, Orry also did his best in his official
capacity to encourage history painters, and perhaps his greatest service was to
institute more or less regular Salons in 1737. Apart from d'Antin's competition of
1727, history painters had little new stimulus during the Régence (1715–23) or
the next twenty years. The Beauvais and Gobelins tapestry workshops provided a
fairly constant source of patronage, and this was given more impetus when Jean-

Baptiste Oudry was nominated painter to the Beauvais works in 1726 (Director in 1734) and Inspector to the Gobelins in 1738 (chief inspector, 1748). Genre and hunting scenes were popular in tapestry, as were *fêtes galantes*, light mythologies, and tales from La Fontaine. But Oudry also saw to it that the more earnest seventeenth-century traditions were maintained, and a number of important commissions went to history painters, among the most significant being de Troy's seven-part *Story of Esther* (1738–42; cartoons in the Louvre and the Musée des Arts Décoratifs in Paris) and his *Jason and Medea* (1743–6; cartoons in the museums of Angers, Brest, Clermont-Ferrand, Le Puy and Toulouse).

The establishment of more regular Salons, where a large public could see the latest works by contemporary painters, stimulated critical comment in the press and in pamphlets, as described in Chapter One. Critics also considered the achievements of modern artists in relation to antique art and to the work of old masters, especially the most eminent representatives of the French school in the preceding century: Poussin, Le Sueur, Le Brun, and Jouvenet. Such critiques written during the late 1740s and the 1750s take their place in a broader range of critical opinion which sometimes compared the political, cultural and historical achievements of contemporary France unfavourably with those of a more glorious national past. This was the message of Voltaire's *Le siècle de Louis XIV* (1751), in which the *grand siècle* under the Sun King is depicted as a heroic and dynamic age for France, in contrast to the effete France of Louis XV. In a prize-winning essay submitted to the Dijon Academy in 1750 (*Si le rétablissement des sciences et des arts a contribué à épurer les moeurs*) Jean-Jacques Rousseau concluded that modern art contributed little to the elevation of either personal morality or public virtue. Instead of extolling the heroism and virtue of great national figures such as the ancients knew, modern art was devoted to depicting pleasure and encouraging hedonism. Rousseau's criticisms formed part of the intellectual background to the programmes of national moral exemplars commissioned from painters and sculptors by the Direction des Bâtiments twenty years later. Other critics more closely associated with the world of art, such as La Font de Saint-Yenne, the most incisive, were quick to point out how the modern taste in interior decoration, which we have discussed above, was detrimental to the continuation of the grand manner in the early decades of the century. In a Salon review published in 1747 (*Réflexions sur quelques causes de l'état présent de la peinture en France*) La Font was already saying that the history painter ought to create moral paradigms for posterity by 'presenting to our eyes the great deeds and virtues of famous men'. His reviews were severe criticisms of painters such as Boucher and Natoire, and of the type of decorative painting encouraged by patrons like Madame de Pompadour and her circle.

Critics and artists alike realized that the State had failed to give the necessary lead in patronage and artistic training; artists needed specific opportunities to tackle elevated themes from literature and history, and they needed the knowledge and expertise for such undertakings too. Mention has already been made of the various reforms carried out within the academic system from the 1740s onwards to raise the standards of practical and intellectual training for young painters. In this spirit Le Normand de Tournehem made an effort to reanimate interest in history painting with a competition in 1747, in imitation of the one held in 1727, 'to revive the art, which seems to have fallen not only in France, but even in countries where painters formerly excelled in this genre'. Académiciens were invited in January to prepare a characteristic work (only the dimensions were specified) in time for the autumn Salon; the winners, to be chosen by the public and by other artists, would be

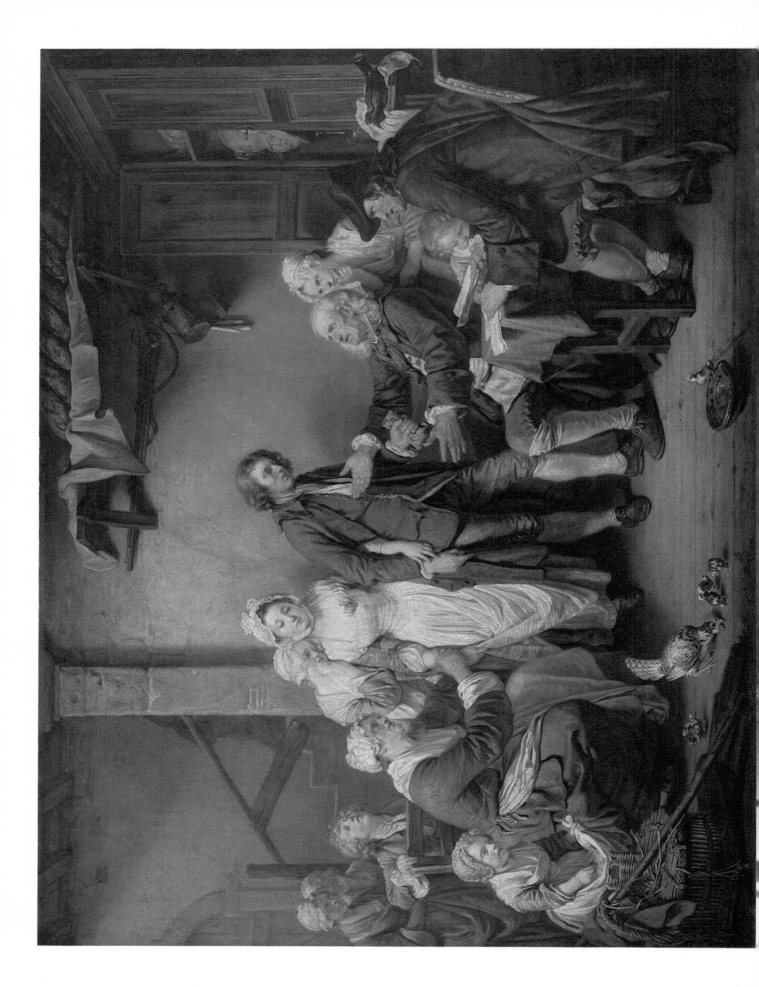

favoured with commissions for royal residences. Eleven painters finally showed works, which were exhibited in the Galerie d'Apollon at the Louvre during the period of the Salon. Boucher, for example, showed a typically graceful mythology, *The Rape of Europa* (Fig. 72), with plump nymphs, dashing putti scattering flowers, a playfully fluttering drapery. By contrast, Jacques Dumont 'le Romain' in his *Mucius Scaevola* (Fig. 73) seems not only to have looked back to a painting of the same subject by Le Brun (now at Mâcon), but also to the muscle-bound heroes of the Second School of Fontainebleau at the end of the sixteenth century. His lumbering figures have a robust, if heavy and lumpish, monumentality, which suits the bold heroism of Mucius, as he thrusts his fist into the hot coals at Porsenna's camp. It was probably on the strength of this picture that Dumont was placed in charge of the Ecole Royale des Elèves Protégés in 1748. This work and Restout's *Alexander with his Doctor* (Amiens) were the most admired works of the 1747 competition, evoking as they did the serious traditions of French history painting, and marking the official revival of the elevated academic manner for the second half of the century.

The example of Rome was also very important from the 1740s onwards, as is shown by the fact that in 1749 Le Normand de Tournehem organized a two-year trip to Italy for his successor as Directeur des Bâtiments, specifically to train him into the good and elevated taste that the post was felt to require. The young Marquis de Vandières, later Marquis de Marigny, was taken to Rome in order to absorb at first hand the beginnings of a new classicizing and antiquarian spirit that was to gain momentum during the next two decades. Numerous publications relating to the rediscovery and reinterpretation of ancient art and to the theory of imitation appeared during the 1750s, such as Johann Joachim Winckelmann's *Gedanken über die Nachahmung der griechischen Werke* in 1755, scholarly works like the Comte de Caylus's *Recueil d'Antiquités* in 1752, Piranesi's *Le Antichità Romane* in 1756 and, stimulated by the recent excavations at the ancient town of Herculaneum near Naples, the Accademia Ercolanese's *Le Pitture Antiche d'Ercolano e Contorni*, begun in 1757. However, it was not until the 1760s that the new antiquarian interests were asserted in European painting. In France, Vien's painting *The Seller of Cupids* (Château de Fontainebleau), shown at the Salon of 1763, was adapted from an engraving in the 1762 volume of the latter publication. Encouraged by the Comte de Caylus, Vien set a fashion for such classicizing works in the Paris of the 1760s, a vogue he continued into the next decade (Fig. 76). But it was especially in Rome that this neoclassical revival was concentrated, although it did not make itself fully felt in painting there until the decade after Marigny's visit, in the work of the German Anton Raphael Mengs (1728–99) and the Scot Gavin Hamilton (1723–98). Both these artists had strong antiquarian leanings, the former a close friend and disciple of Winckelmann, who insisted in his art theories on the superiority of the purity of ancient Greek art over all later schools; Hamilton, in addition to being a painter, was an archaeologist and a leading dealer in antiquities. Mengs's *Parnassus* ceiling painting of 1761 in the Villa Albani, Rome, and Hamilton's huge Homeric scenes and ancient Roman subjects such as *The Oath of Brutus to Avenge the Death of Lucretia* (1763–4; engraved by Cunego, 1768) were admired and influential works, which to contemporaries seemed to imbue the tradition of sixteenth and seventeenth-century classicism with a new nobility, grandeur and purity, based on the study of antique sources.

On his visit to Italy of 1750–1 Marigny was accompanied by Charles-Nicolas Cochin, who later became his closest adviser in matters of art, the Abbé Le Blanc, a

Fig. 72. FRANÇOIS BOUCHER: *The Rape of Europa*. 1747. Oil on canvas, 160.5 × 193.5 cm. Musée du Louvre, Paris

leading critic with conservative and eclectic taste, and the architect Germain Soufflot (1713–80). These three mentors were, in their different ways, opposed to all that was light and florid in all the arts of the early eighteenth century, and by precept and example wished to encourage a return to the grand manner by invoking antiquity, the Renaissance, and the seventeenth century. While his private tastes for pretty cabinet pictures and drawings were comparable with those of any *amateur* of his day, the advice of these experts had some effect on Marigny's official policies in the arts from 1751 to 1773. In general, he continued and intensified the reforms begun by his uncle Le Normand in the 1740s. But with the exception of seven large tapestry cartoons of *The Story of Mark Antony* commissioned from Natoire (only three of which were executed), the first decade of Marigny's directorship did little for serious history painting. Apart from the painters of numerous relatively minor decorations in royal palaces, the chief beneficiary of Marigny's protection was Claude-Joseph Vernet, whose important topographical *Ports of France* some contemporary observers in any case rated as highly as history paintings. Finance for the arts was very limited during the Seven Years War (1756–63), and Vernet benefited from a lucky combination of Marigny's personal taste (he had visited Vernet's studio in Rome) and the propaganda value of his own celebrations of the seaports of France. However, after Cochin became Secretary to the Académie and Marigny's chief adviser in 1755, the latter continued Le Normand's policy of raising the price of large history paintings, while reducing the prices for portraits again by at least a quarter. Natoire's *Mark Antony* cartoons, for example, were raised from 16,000 to 24,500 *livres*; but war caused the suspension of the series in 1757.

Among numerous commissions for decorations, the most interesting was for four large paintings for the Grande Galerie at the Château de Choisy, a scheme planned by Cochin. Thinking first of themes such as the four seasons or the four elements, and then of more lofty subjects taken from the *Iliad*, Cochin settled on the paradigmatic lives of Roman emperors, 'that the King, seeing celebrations of their virtues, may recognize some of those which render him so dear to his people'. Given the existing military style of architectural decoration in the gallery, Cochin thought that scenes of a military character would suit. But, with the Seven Years War recently over, he saw that such themes would best be interpreted in a spirit of clemency, generosity and humanity. Thus Noël Hallé was commissioned to paint a *Justice of Trajan* (Fig. 74) in which the Emperor, setting off on a campaign, finds the time to stop and listen to the petition of a luckless widow. Such a theme does not demand the tough style of Dumont's *Mucius Scaevola* (Fig. 73); Hallé works with

Fig. 73. JACQUES DUMONT 'LE ROMAIN': *Mucius Scaevola*. 1747. Oil on canvas, 165 × 192 cm. Musée des Beaux-Arts, Besançon

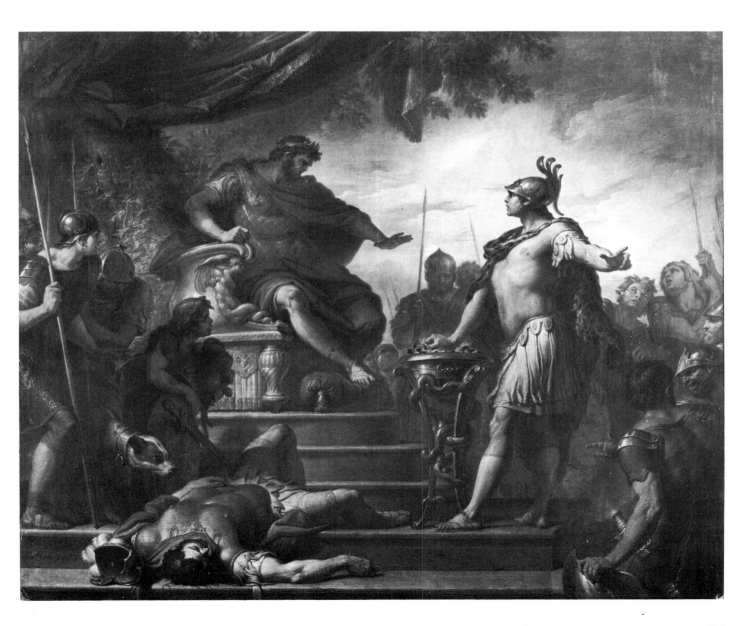

Fig. 74. NOËL HALLÉ: *The Justice of Trajan*. 1765. Oil on canvas, 265 × 302 cm. Musée des Beaux-Arts, Marseilles

more delicacy in his colour and his pictorial rhythms. Nevertheless, the King quickly tired of these exemplars of virtue at Choisy, and after a couple of years the paintings were removed and replaced with lighter tapestries. Subjects such as the hunting scenes of the 1730s in the Petits Appartements at Versailles (Figs. 133 and 134), Oudry's *Royal Hunt* tapestries (Fig. 136), and Boucher's nymphs were much more to his personal taste. The Choisy scheme, however, anticipates by a decade the practice of royal patronage under Louis XVI, whose Directeur des Bâtiments promoted history painting (and sculpture) of high moral earnestness in a more authoritative way than Marigny.

Before turning to the programmatic revival of history painting in the 1770s, it should be noted that the hierarchy of the genres did come into question during the 1750s and 1760s. Although he was a staunch advocate of didactic history painting, the prominent critic La Font de Saint-Yenne nevertheless admired the high quality of observation and execution in the work of painters such as Oudry, Chardin, and Vernet. These painters offered a realist alternative to rococo fancy. Such arguments were brought in to defend the academic respectability of landscape and genre painting, which were becoming increasingly popular, and even Diderot could exclaim in 1765: 'I protest that the *Bible-Reading*, the *Ungrateful Son* and the *Village Betrothal* of Greuze, and the marines of Vernet, which offer me all sorts of incidents and scenes, are as much history paintings to me as Poussin's *Seven Sacraments*, Le Brun's *Family of Darius*, or Van Loo's *Susanna*'. Vernet's elevation of landscape is

discussed below, but the elevated genre subjects of Greuze must be noted here in the context of history painting. With his first success at the Salon of 1755, *Reading the Bible* (private collection, Paris), Greuze exploited the popular taste for Dutch and Flemish genre painting, in a design based on low-life scenes by Teniers; but in his own painting he seeks to show the moral benefits of Bible-reading on a humble and innocent Protestant household, which is depicted in detail. This homespun realism is found again in *The Village Betrothal* (Col. Plate 5), a major sensation at the Salon of 1761, which was commissioned, on the basis of Greuze's earlier successes, for Marigny's private collection, at 39,000 *livres* (compare 4,000 *livres* for each of the Choisy history paintings, which were twice the size, or 6,000 for Vernet's *Ports of France*!). Greuze, in a narrative of his own invention, shows us the moment when a marriage contract is drawn up by a notary, with the young man receiving a dowry, a pretty wench, and the blessing of her aged father. The simple, rustic setting and costumes are described with loving care; there is a variety of ages, types, expressions and emotions; and the force of the moral and the very clear narrative are underlined with details such as the mother hen with her chicks. To a public accustomed to reading a picture and susceptible to the emotional tenor of the contemporary sentimental novel, such a 'novel in paint' had an appeal which was both immediate and sustained. Moreover, Greuze presented his audience with *new* stories, devised by himself and expressed with all the clarity—and at times the declamation—of the theatre: but a theatre far more relaxed and natural than the stiff and formal conventions of Charles-Antoine Coypel and most other contemporary painters. Greuze, although he has his own stereotypes, did much to extend the emotional range of painting, in an age that was increasingly interested in exploring the expression of new areas of feeling. This is partly what made his scenes seem relatively realistic, and the sense of actuality was also helped by settings and costumes that were recognizably modern.

Like most painters of his day, Greuze wanted academic recognition as a history painter. The genre painter Jeaurat and the portraitist Nattier, for example, had both originally been received into the Académie as history painters, although they subsequently pursued careers in their lesser genres. But Greuze's *morceau de réception*, an unfamiliar subject from Roman history (*Septimius Severus and Caracalla*; Louvre) was turned down in 1769 for reasons which are not absolutely clear. In reply to academic and public criticism at the Salon, Greuze justifiably defended himself by pointing out his impeccable references to Poussin and the antique. The picture is indeed a tribute to Poussin's celebrated *Death of Germanicus*, but in the severity of his theme and the way in which he chose to represent it Greuze was unfortunately a decade ahead of his time. Piqued at being left in the category of mere genre painter, he did not exhibit again at the Salon until 1800, but showed in his studio. He continued a highly successful career, with a European reputation, as a portraitist and painter of elevated genre. In later years his works became more and more dark and dramatic in mood, more monumental in conception, and more emotional in subject, in line with the general development of history painting in the 1770s. *The Ungrateful Son* (Fig. 75) and *The Punished Son* form a two-part tragic drama. In the former, during a terrible family scene, the eldest son, cursed by his enraged father but implored by the womenfolk, leaves his rustic home for the army. The even more lachrymose sequel shows the return of the fatigued prodigal, to find his father mourned on his deathbed by the rest of the family, in a group that again makes heavy reference to Poussin's famous deathbed scene. By casting such venerable Poussinesque designs in modern dress and modern settings Greuze made them all

the more immediate and moving to the contemporary public, depicting, as he did, recognizable emotional dramas involving important human dilemmas. Such frank and heightened feeling was soon adopted by history painters.

While Greuze's references to the classical tradition were covert, an overt classicizing manner was well established by the 1760s, notably in the work of Vien. We have seen his 1767 *St Denis Preaching* (Fig. 45) as representing the Roman-Bolognese tradition, which he had assimilated in Italy in the late 1740s. He also took account of the revived interest in the ancient world in the decades after 1750 by adapting the shallow pictorial space, the rather effete figure-style, and the accessory details of paintings unearthed earlier in the century at Herculaneum and Pompeii, which he studied principally through engravings. His *Girls adorning sleeping Cupid with Flowers* (Fig. 76) has the fashionable Graeco-Roman trappings and limp style associated with such sources, but lacks the moral weight with which Greuze succeeded in infusing his own art by ancient reference. Vien's painting,

however, was originally conceived as part of a decoration on the theme of love, for Madame du Barry's lodge at Louveciennes, where it replaced highly rococo, but no longer fashionable, works by Fragonard (Figs. 127 and 128). A fresh look at antique sources, an unearthing of new ones, an attempt at historical accuracy in costume and setting, and a profound reassessment of the classical tradition in painting and sculpture are all part of the broader European movement of neo-classicism, as is the general academic revival of these decades.

With the reign of Louis XVI, which began in 1774, official patronage came under the direction of the Comte d'Angiviller, who was advised by Pierre, the Premier Peintre. Together they devised the most programmatic series of State commissions for works of art since the days of Colbert and Le Brun. The commissioned works were given pride of place at the Salons, thus increasing the

Fig. 76. JOSEPH-MARIE VIEN: *Girls Adorning sleeping Cupid with Flowers.* 1773. Oil on canvas, 335 × 194 cm. Musée du Louvre, Paris

importance of these exhibitions, and pictures were now carefully vetted in order to exclude, as far as possible, any nudes or mythological subjects that were not morally exemplary. The result was that the majority of history paintings were devoted to weighty themes. At the Salon of 1777 d'Angiviller hoped to see works which would 'revitalize virtue and patriotic sentiments', and at the same time 'maintain the grand style'. Typical paintings that year were two by Brenet, one encouraging agricultural industriousness, the other, respect for virtue. The former (Fig. 77), from ancient Roman history, shows the farmer Caius Furius Cressinus, whose superabundant crops had brought a charge of sorcery, defending before an aedile the hard work of his family and the careful maintenance of his equipment. The other (Fig. 78), taken from medieval French history, shows the honours rendered in 1380 at the deathbed of the French constable Bertrand du Guesclin by the English occupiers of Châteauneuf-de-Randon, which he had under siege. The English symbolically and respectfully return the keys of the town, which they had promised to surrender by a certain date. This is one of a series of works commissioned from various artists to celebrate French history, and the idea of such a theme may have been suggested by the cycle of works dedicated to the life of St Louis in the chapel of the Ecole Militaire in 1773. Such paintings in general reflect an increasing interest in past periods other than antiquity, and the development of historical relativism in

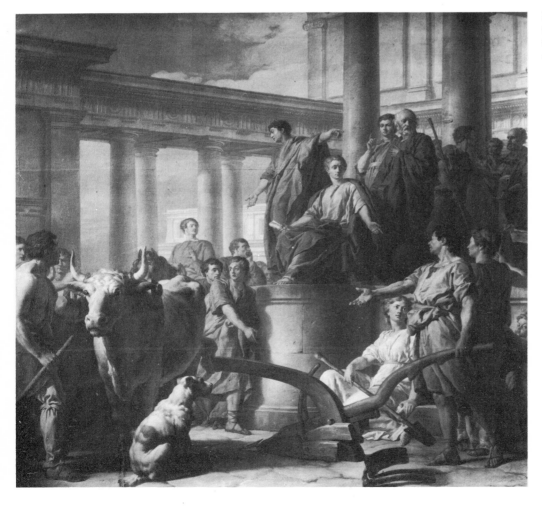

Fig. 77. NICOLAS-GUY BRENET: *Caius Furius Cressinus*. 1777. Oil on canvas, 324 × 326 cm. Musée des Augustins, Toulouse

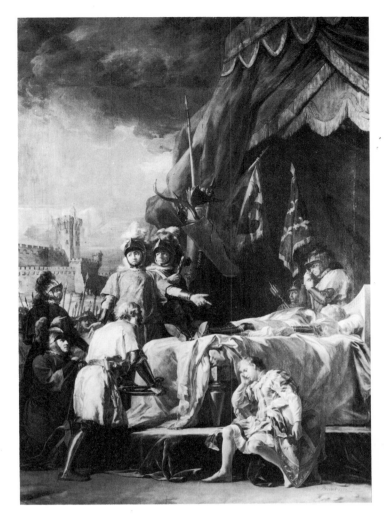

Fig. 78. NICOLAS-GUY
BRENET: *The Death of du
Guesclin*. 1777. Oil on canvas,
317 × 224 cm. Musée
National du Château de
Versailles

the later eighteenth century. Just as when treating a theme from the ancient world, so here too, in the medieval *Du Guesclin*, Brenet strove for the greatest possible accuracy in the topographical rendering and in the treatment of such details as costume and armour. In their style, however, the 'History of France' commissions were to be neither classicizing nor medieval, but an eclectic combination of Renaissance and baroque sources, with complex compositions and rich, nuanced colour. It was not until the taste for primitive art developed, in the early nineteenth century, that French artists were to treat medieval subjects in a deliberately archaic style, with stiff forms and heraldic colours.

History paintings of the 1770s often betray signs of Greuzian sentiment: the seated youth in Brenet's *Du Guesclin*, for example, might have been recast from one of Greuze's morality pictures. Altogether, the strong emotions of these works and the lofty import of their themes form the greatest possible contrast with the history paintings discussed in the first half of this chapter. A pendant to *Du Guesclin* was Durameau's *Continence of Chevalier Bayard* of 1777 (Fig. 79), whose subject is the early-sixteenth-century soldier *sans peur et sans reproche*, seen generously giving a dowry to a girl, of whom he might have taken advantage. One critic pointed out that Greuze would have chosen a more dramatic moment and shown the moral

Fig. 79. LOUIS-JOSEPH DURAMEAU: *The Continence of Chevalier Bayard*. 1777. Oil on canvas, 320 × 152 cm. Musée de Peinture et de Sculpture, Grenoble

conflict rather than the virtuous decision. Although the costumes in fact owe more to the eighteenth-century theatre's idea of the Renaissance, we know that the artist studied publications by antiquarians in order to render the the François Ier period with the greatest possible accuracy. The style, too, shows Durameau's roots in his own century, with his delight in painting certain passages of the fabrics, for example; but the intimate and domestic nature of his treatment anticipates the so-called 'troubadour' painters of the early nineteenth century.

Paintings relating the lives of medieval and Renaissance French kings were used by d'Angiviller to stimulate patriotic feeling. One which reflects well both on artists and kings shows the death of Leonardo (Fig. 80), which was supposed to have taken place in the arms of François Ier at Fontainebleau; it is the masterpiece of François-Guillaume Ménageot. The painting is rich in cream, gold and red at the centre, and has all the narrative ingredients for a success at the Salon: a carefully reconstructed historical atmosphere, exotic costumes, royalty, and a tender gesture as François supports the aged and dying artist, which would appeal to the sentimentalism of the age. D'Angiviller also drew on seventeenth-century history, as in his choice of subject for a painting commissioned from François-André Vincent entitled *President Molé stopped by Insurgents during the Fronde* (Fig. 81). The

calm bravery and moral rectitude of the elderly magistrate is contrasted with the hectoring mob, in a work which imaginatively conveys a vivid sense of actuality and extends the traditional range of history painting.

Wishing to gain his associateship of the Académie in 1781, David naturally submitted a work of high seriousness and forceful emotion, *Belisarius* (Fig. 82). According to the story, already popular in eighteenth-century literature and art, Belisarius, an eminent general under Justinian, was wrongly disgraced and was reduced to begging for alms. In David's painting a woman approaches the blind old general and drops a coin into his helmet, which is proffered by a child; in the background a soldier is shocked to recognize his former leader, a victim of the inconstancy of fortune. David's image is very powerful, a genuine rethinking of Poussin, and created a sensation at the Salon: he has purged every trace of mid-eighteenth-century grace with sombre colour, a few monumental figures (which loom large in relation to the canvas), an overshadowing triumphal arch, and a city wall enclosing the simple stage. This work established his reputation as a reformer of painting, and young artists rallied around him to begin a Davidian School.

While he had been slow to win the Prix de Rome, once in Italy with his master Vien (1775–80) David became an assiduous student of all the proper academic sources, which by this time also included Caravaggio and his followers. In *Belisarius* and succeeding works of the 1780s David consolidated this experience into a powerful, personal neo-Poussinism, but with a radical simplicity of design that was a departure from the dominant styles of the 1770s. However, beside David's star rose that of Jean-François-Pierre Peyron, who contended with him for the leadership of new French painting during the early 1780s. Peyron too had an exemplary academic career and was in Rome with David, returning in 1782. His *Funeral of Miltiades* of that year (Fig. 83) is no less impressive in its lugubrious

Fig. 80. FRANÇOIS-GUILLAUME MÉNAGEOT: *The Death of Leonardo da Vinci*. 1781. Oil on canvas, 298 × 352 cm. Hôtel de Ville, Amboise

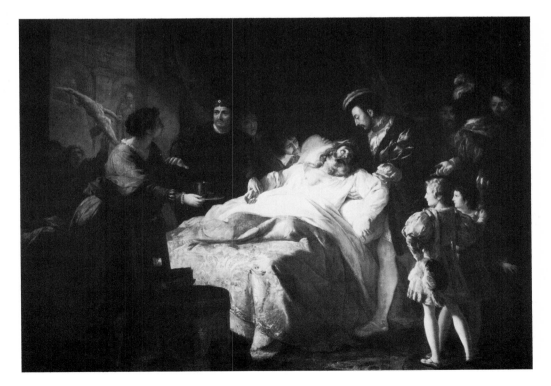

Fig. 81. FRANÇOIS-ANDRÉ
VINCENT: *President Molé stopped by
Insurgents during the Fronde.* 1779.
Oil on canvas, about 305 × 305 cm.
Chambre des Députés, Paris

theme than David's *Belisarius*. The rotting corpse of the Athenian general Miltiades is removed from a dungeon, while his dutiful son Cimon takes his place, so that the body, neglected by the ungrateful people, can be decently buried. Peyron, too, draws heavily on Roman sources, especially Caravaggio, for the lighting of the figures in their gloomy prison, and their simplified poses. The composition has a novel openness and planar simplicity quite different from the complex designs of Brenet or Vincent, with their *repoussoirs* building upwards from the sides of the picture. Peyron was developing this simplified type of design in the 1770s, and it had its effect on David.

Peyron presented his masterpiece, *The Death of Alcestis* (Louvre), at the Salon of 1785, but lacking dramatic unity and pictorial cohesion, like all his work, it was eclipsed by David's *Oath of the Horatii* (Col. Plate 6). This is still one of the most famous and arresting images in eighteenth-century art. Its force lies partly in its large scale (well over three by four metres), and in the simple but decisive placing of a few actors on a bare stage. The architectural setting is minimal, but disposed in such a way as to reinforce the main figure-groups. It was commissioned by d'Angiviller, and although David defiantly chose a different part of the story, his theme remained the primacy of patriotic duty over the bonds of family and love.

Fig. 82. JACQUES-LOUIS
DAVID: *Belisarius begging
Alms.* 1781. Oil on
canvas, 288 × 312 cm.
Musée des Beaux-Arts,
Lille

Fig. 83. JEAN-
FRANÇOIS-PIERRE
PEYRON: *The Funeral of
Miltiades.* 1782. Oil on
canvas, 98 × 136 cm.
Musée du Louvre, Paris

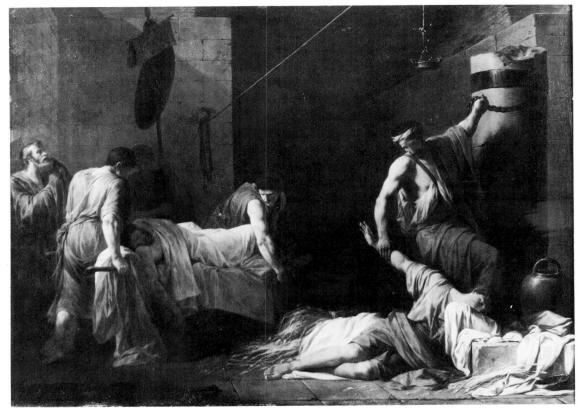

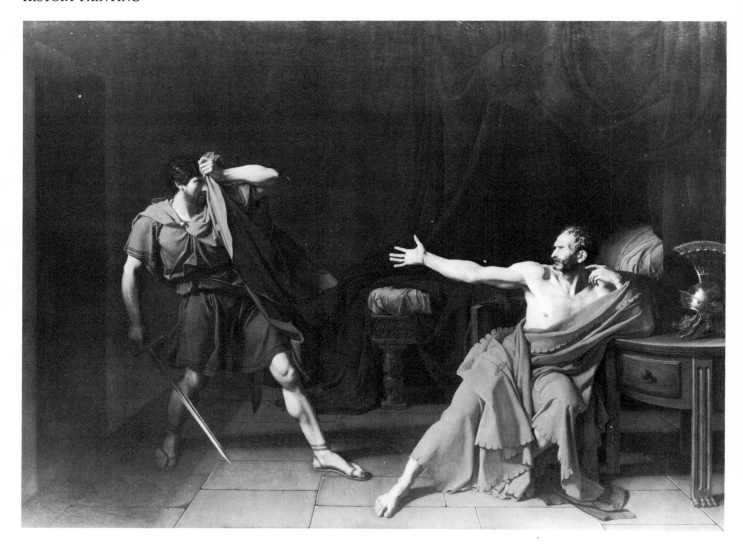

The Horatii, three Roman brothers, are to settle a dispute by combat with three Alban brothers, the Curatii; their sister, however, is betrothed to one of the latter, while one of the Horatii is married to a sister of the Curatii. Collapsing with grief over their certain loss, the women form a contrast with the 'male' side of the picture, in which the father holds aloft three swords on which the young men swear an oath. This image is the ultimate expression of uncompromising moral fervour, by starkly reduced pictorial means—the drawing is tense, the colour predominantly cold (but often subtle in its effects, especially in the female group), and the light hard as it picks out vivid details, which make the overall design seem the more austere. David withdrew to Rome for a year to make the necessary studies and to paint the work, which created equal excitement there when it was exhibited in 1784. He returned to this idea of oath-swearing in more specifically political works during the Revolution and Empire; but we should not underestimate the possible radical political implications of the *Horatii* in France. While in subject it conforms to a long tradition of royal commissions of patriotically virtuous themes, paradoxically its spare style and direct presentation, its simplicity, were indeed radical. It is a stark visual denial of the complex neo-baroque eclecticism inculcated

Fig. 84. JEAN-GERMAIN DROUAIS: *Marius at Minturnae.* 1786. Oil on canvas, 271 × 365 cm. Musée du Louvre, Paris

into history painting by the teachings of the Académie over the previous forty years. As some contemporary critics implied, this could be seen as a potential undermining of the whole order of established values.

David's influence can be seen throughout French painting of the later 1780s and the 1790s, and nowhere more strongly than in Jean-Germain Drouais's *Marius at Minturnae* (Fig. 84). The twenty-one-year-old Drouais had been in Rome when David painted the *Horatii*, and the older painter advised the younger on the disposition of his picture. A soldier has been sent to execute Marius, imprisoned at Minturnae, but quails before the moral stature of the great and terrible general and consul. The design is even more spare than in David's picture, and the colours predominantly dark, except for the brilliant red of Marius's cloak. The premature death of Drouais in 1788 removed from David his greatest potential rival. His other rival, Peyron, was effectively eclipsed, not only by the *Horatii* in 1785 but also at the Salon of 1787, when both painters exhibited a *Death of Socrates* (Fig. 85; Peyron's version is now in a Danish private collection). Peyron soon virtually gave up painting, but David's *Socrates* was admired across Europe and confirmed his position in French art. Socrates is about to drink the hemlock, surrounded by his disciples, including Plato, who is seated in silent contemplation at the foot of the bed. The setting is cold and stony, but with hard, strong colours in the draperies; the heads are carefully studied from antique prototypes, and the shallow composition and the disposition of the figures are derived from Poussin's most

Fig. 85. JACQUES-LOUIS DAVID: *The Death of Socrates*. 1787. Oil on canvas, 130 × 196 cm. The Metropolitan Museum of Art, New York (Wolfe Fund, 1931)

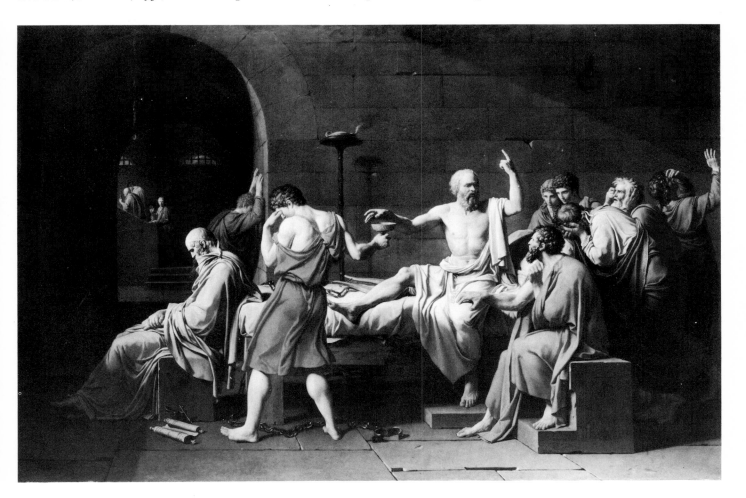

austere works. A perfect neoclassical work, it is the culmination of representations of the subject in the eighteenth century; this severe Stoic moral alternative to Christianity had been commended to artists by the *philosophe* Diderot in 1758. Throughout the second half of the century the number of religious works listed in a Salon *livret* varies from about ten to thirty-five; only in the mid-1790s is there a marked decline in religious art. However, from the mid-1770s the proportion of history paintings greatly increases—from about ten serious subjects in 1775 to nearly sixty in 1789. The increasing numbers of works drawing on the ancient world for morally exemplary subjects during the 1770s and '80s may indicate the degree to which the educated public was responding to Enlightenment ideas, in a gradual secularization of Christian belief. But we should also bear in mind that the State was commissioning works to encourage or confirm belief in its own *status quo*; this had no bearing on religious sentiment, but it did affect the ideological bias of works exhibited at the Salon in certain years.

David's next exhibition picture, *The Lictors returning to Brutus the Bodies of his Sons* (Fig. 86), shown at the Salon of 1789, was commissioned by the Crown on the strength of the *Horatii*, but David had again asserted his artistic independence by radically altering the proposed subject, and by completing the work two years late. He depicts the terrible story of Lucius Junius Brutus, who overthrew King Tarquin to found the Roman Republic. His own sons having conspired against the Republic, Brutus has ordered and witnessed their execution, and now sits in the shadow of a statue of Roma as their corpses are carried home. It is a case—even more brutal than that of the *Horatii*—of placing interests of state before family feeling: the conflict is expressed in the pose and expression of Brutus himself, with the grief and rent family affection conveyed by placing the weeping and collapsing women far to the other side of the picture. The emotional drama is tensely played out across the gulf of a shadowy room, punctuated with stabs of light, or a vivid detail such as the ironically homely still life on the table. In the ensuing years the painting became closely identified with the French Republican cause, and indeed it was exhibited at the Salon only six weeks after the storming of the Bastille. In these troubled months the presence of Brutus in Paris was seen by the royal authorities as a potentially disturbing one, and David, who generally had a good idea of the sort of impact his works would make, must have seen this consciously republican image as at least a timely warning, even though he could not have foreseen what was to come. Cuvillier, a royal official acting on behalf of d'Angiviller in the organization of the Salon that year, wrote to Vien (Directeur of the Académie) in August that he was relieved to hear that the *Brutus* was still not yet finished. But David did submit the picture, and was able to write to a friend: 'It seems to me that of all my paintings it is the one which up to now has caused the most fuss'.

Secular history painting was progressively ascendant over religious art at the Salons of the 1770s and 1780s, mostly as a result of the lead given by the Direction des Bâtiments with commissions designed to affirm patriotic belief and civic virtue. This concentration on a didactic art dealing with important human issues and decisions, both public and private, although its subjects were taken from historically remote periods, profoundly affected the orientation of artistic effort, and had far-reaching consequences in the following decades. With the rapid development of political events during the 1790s, David, fervently committed to the Revolution, produced a number of bold and original works, devoted now to contemporary issues and reflecting his beliefs and commitments. Works which

Opposite:
6. JACQUES-LOUIS DAVID: *The Oath of the Horatii*. 1784. Oil on canvas, 330 × 425 cm. Musée du Louvre, Paris

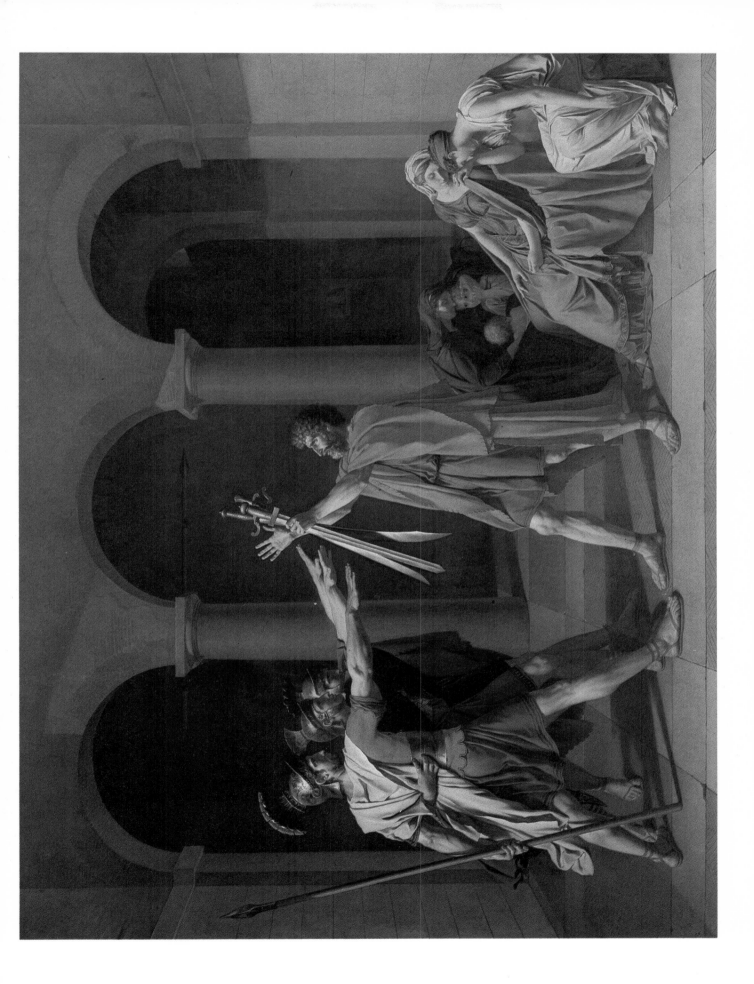

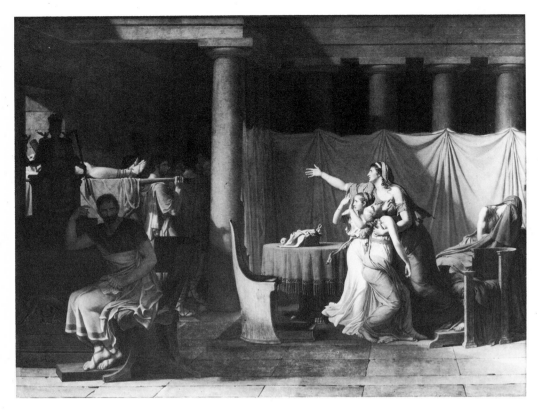

Fig. 86. JACQUES-LOUIS DAVID: *The Lictors Returning to Brutus the Bodies of his Sons*. 1789. Oil on canvas, 325 × 425 cm. Musée du Louvre, Paris

reconcile portraiture and monumental history painting, such as his commemorative icons of *The Dead Marat* (1793; Musées Royaux, Brussels), *Le Pelletier de Saint-Fargeau* (1793; lost), and the *Tennis Court Oath* (unfinished; drawing exhibited 1791), are a new and vivid type of ideological picture. But they celebrate a new, not an *ancien* régime, and opened another chapter of the history of painting in France.

4 PORTRAITURE

Eighteenth-century France was remarkable for the richness and variety of its portraiture, which embodies a wide range of meanings and ideologies. Even the most elevated history painters—and increasingly so during the course of the century, from Jouvenet to David—were attracted to this genre, although it stood below history in the academic hierarchy, and some, such as Rigaud and Nattier, preferred to devote themselves to it almost entirely. It was partly a matter of economics. Portrait painting was lucrative, and in demand from patrons of a much larger and wealthier middle class than in any previous period, eager to have their status confirmed through art. Moreover, Parisian society was intimate and exceptionally sophisticated, articulate, critical, and self-aware; these qualities are reflected in the brilliant and perspicacious letters of Madame du Deffand (1697–1780) for example, or in the sharp characterizations of his contemporaries found in the *Mémoires* of Jean-François Marmontel (1723–99), and the ultimate product of this self-concern was Jean-Jacques Rousseau's great autobiographical *Confessions* (1765–70). Individual psychology was a matter of great interest, and the portrait painter could play his part by exploring and expressing the character of his sitters. The intimate and psychologically penetrating type of portrait flourished especially from the early 1740s onwards. In more general terms, more than in any previous era it was felt that man, as Diderot put it, was 'the centre around which everything revolves', that it was man who gave interest and meaning to the world, and hence we find repeated throughout the century the notion that the proper study of man is mankind itself. In painting, this is reflected in the importance accorded to the human figure: primarily, in history painting, to man seen in ideal terms, 'as he ought to be'; secondarily, in portraiture, to man seen more 'as he is', in a contemporary costume and context that the public would understand and with a character that his intimates would recognize.

Certainly portrait painting was good business. A critic at the Salon of 1755 complained that the demand for portraits was injurious to the development of 'imaginative' painting (he meant history painting). But this demand meant that the portrait painter could be sure of a good living. Jean-Marc Nattier, for example, after losing money heavily with the collapse of John Law's financial system in 1720, apparently turned from history painting (he was *reçu* in this genre in 1718) to portraiture in order to recoup his losses. We have already observed how successive Directeurs des Bâtiments tried to discourage the popularity of the portrait by lowering the official prices paid in relation to history painting. In 1763 the pastellist La Tour wrote a long letter to Marigny pointing out the injustice of a

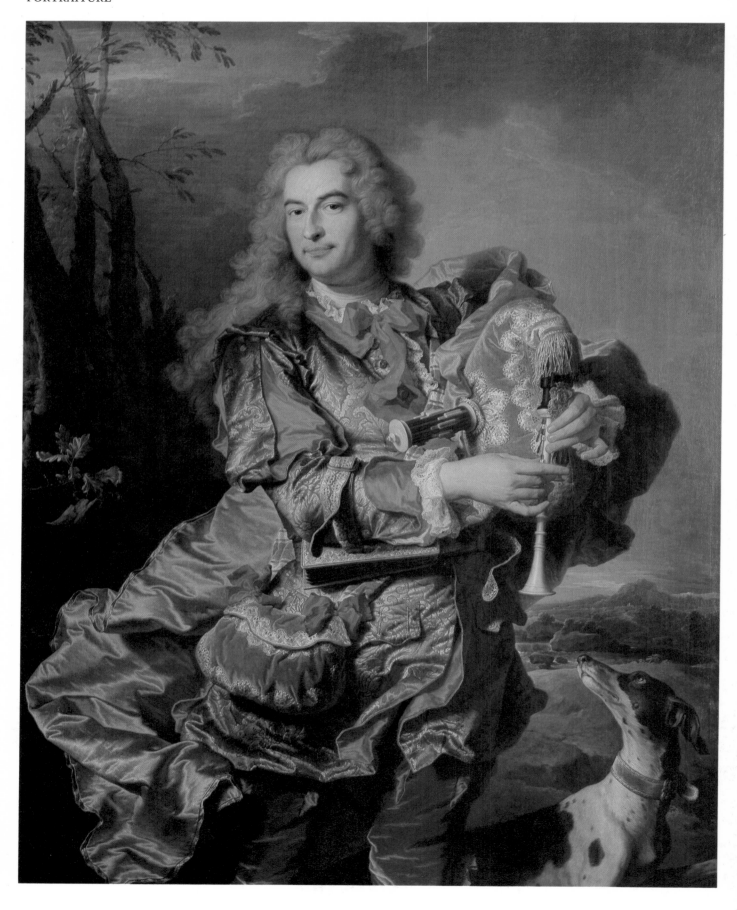

standard scale of payments for portraits according to size: some artists could dash off ten portraits in a routine manner, in the time that a conscientious and meticulous master would devote to one work, allowing as he would for all the adjustments and revisions of mood, expression and lighting during sittings.

There was now a larger market for portraits than before: in the early decades of the century a sizeable and wealthy class of people, not of noble origin, made fortunes of different magnitudes on the complex finance markets of the day. These financiers and their families, in the royal service and outside it, were the chief private patrons of artists. A collection of art was an outward sign of wealth and taste—two attributes which were more easily acquired than the coveted noble ancestry (though the social and financial advantages of the latter could be, and were, acquired by marriage). If an art collection was the ultimate embellishment of the sophisticated *hôtel*, then a collection of modern portraits could serve as a substitute for ancestral ones. Social and financial security brought with them vanity and a sense of self-satisfaction, and these were implied in the desire and ability to commission a portrait, and in the patron's pleasure in looking at images of himself and his family. 'The portraitist', it was observed in 1728, 'manages easily to keep his pot boiling, because there is not a single mildly coquettish bourgeois lady, comfortably off, who does not want her portrait painted . . . and one can easily recognize the most coquettish ones by the number of copies they have made. . . .' Whether designed for a private or a public context, the portrait was an ideological statement, promoting an image of high society to itself and to those outside its narrow confines. A perusal of the Salon reviews shows that the contemporary public not only read the gestures, expressions and occupation of a sitter, but also enjoyed the rendering of costume, which was an important indication of wealth and rank.

The pretexts for public portraiture were legion, from multifarious reproductions of the King to group portraits of corporations and institutions, the works expressing one kind of allegiance or another. Such public statements were more or less bound by tradition, and their sumptuous, baroque manner changed little between the late seventeenth century and the Revolution—and was revived by David under the Empire. The private portrait, on the other hand—in line with fashions in dress, social attitudes and behaviour—became more simple in presentation, more natural, less affected or flattering, more open, direct and penetrating in its exploration of character. But otherwise there were few dominant trends in portraiture; a variety of different types, with different functions, existed side by side throughout the century, creating an overall pattern of some complexity; the examples discussed below are to illustrate this variety.

Quite often a portrait would be combined with history or allegory to commemorate some important event. We have seen in Chapter Two how the aldermen of Paris, following seventeenth-century precedents, commissioned from de Troy an *ex voto* which combined altarpiece and group portrait (Fig. 27). Similarly, a series of allegorical portrait groups was commissioned for the Hôtel de Ville (all but one destroyed by fire in 1871), linking the fortunes of the city of Paris with major events of the reign of Louis XV. Good relations between the King and the city traditionally needed confirmation since the Fronde in the previous century. For example, Roslin sent to the Salon of 1761 a *Convalescence of Louis XV on his Return from Metz* (the King had been dangerously ill there in 1744) in which Louis is received outside the Hôtel de Ville by the city fathers. At the same Salon Dumont 'le Romain' presented an *Allegory of the Peace of Aix-la-Chapelle in 1748* (Fig. 87); here Louis, dressed as Alexander, holds out an olive-branch to Paris, which has been

Opposite:
7. HYACINTHE RIGAUD: *Gaspard de Gueidan*. 1735. Oil on canvas, 146.5 × 113.7 cm. Musée Granet, Aix-en-Provence

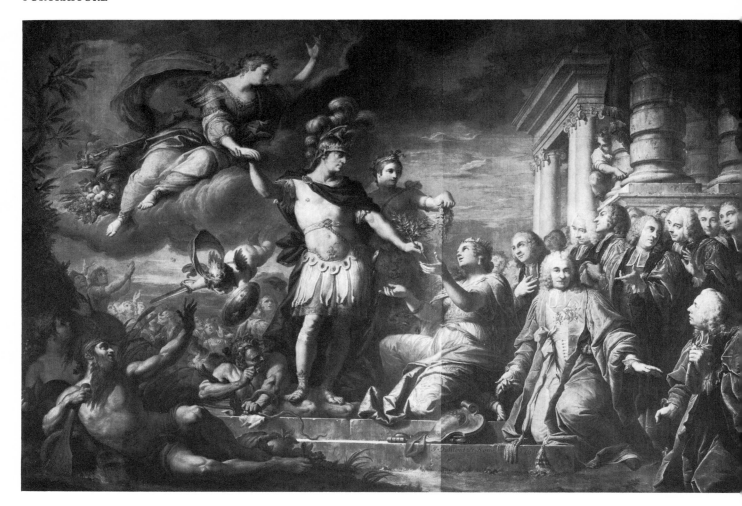

Fig. 87. JACQUES DUMONT 'LE ROMAIN': *Allegory of the Peace of Aix-la-Chapelle*. 1761. Oil on canvas, 472 × 330 cm. Musée Carnavalet, Paris

given him by Peace, who hovers in the sky; behind the personified Paris are the Provost of the Guilds and the aldermen of the city; the King is trampling Discord underfoot, who is pursued by the Genius of France, a winged and armed putto with fleurs-de-lis on his shield; to the left the rivers Seine and Marne greet the King, while the people of Paris rejoice in the background. Such works, by the use of allegory, raised portraiture to the status of history painting.

There was also a demand for more straightforward group portraits, such as that executed by Doyen in 1775 for the Ordre du Saint-Esprit (Fig. 88). The Order had commissioned for their chapel in the church of the Grands-Augustins in Paris a large painting of Louis XVI at Reims, receiving the homage of the Knights of the Order as their Grand Master (the event had taken place on 13 June 1775, two days after his coronation). The painting includes portraits of the leading members of the royal household: at the feet of the King are the Comte de Provence and the Comte d'Artois, then the Duc d'Orléans and the Duc de Chartres; in the background are the four chief officers of the Order, which was the leading and most aristocratic order of chivalry in France. This again was one of a series of works by various painters, and celebrated the different Grand Masters of the Order since it had been founded by Henri III in the late sixteenth century. The splendid architectural setting, reminiscent of Veronese, is imaginary, and the sumptuous costumes gave

Doyen further opportunity to display his love of Venetian and Rubensian painting.

The style for official portraits of the monarch had been set throughout most of Europe during the seventeenth century, and this style was followed by Hyacinthe Rigaud at the very beginning of the eighteenth in his portrait of *Louis XIV* (Fig. 89), which gained him international repute. It is a highly formal image of the elderly monarch, looking authoritative and authoritarian, framed by the baroque devices of column and enormous curtain, and swathed in ermine robes of state embroidered with gold fleurs-de-lis. The sumptuous overall effect created by Rigaud's brilliant talent for the imitation of rich stuffs almost renders the royal attributes of crown and sceptre superfluous. Portraits of the succeeding two monarchs followed much the same pattern, as can be seen in Louis-Michel Van Loo's *Louis XV* (Fig. 90), of which this version is one of the many autograph or good studio replicas made for dissemination throughout France and Europe; a team of copyists was employed at Versailles for just this purpose. Another *portrait d'apparat* ('parade' or ceremonial portrait) made early in the century by Rigaud is that of *Cardinal de Bouillon* (Fig. 90), comparable in its baroque devices with that of Louis XIV. Exiled by the King to Rouen over a religious dispute, the Cardinal had Rigaud come there in 1709 to paint this portrait, which celebrates one of the great moments of his career, when he was privileged to open the Holy Door in Rome in

Fig. 88. GABRIEL-FRANÇOIS DOYEN: *Louis XVI receiving the Homage of the Chevaliers du Saint-Esprit at Reims.* 1775. Oil on canvas, 345 × 385 cm. Musée National du Château de Versailles

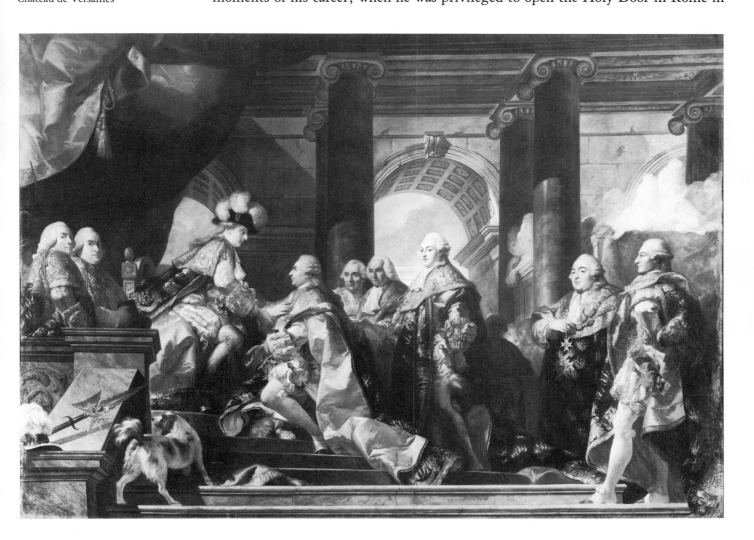

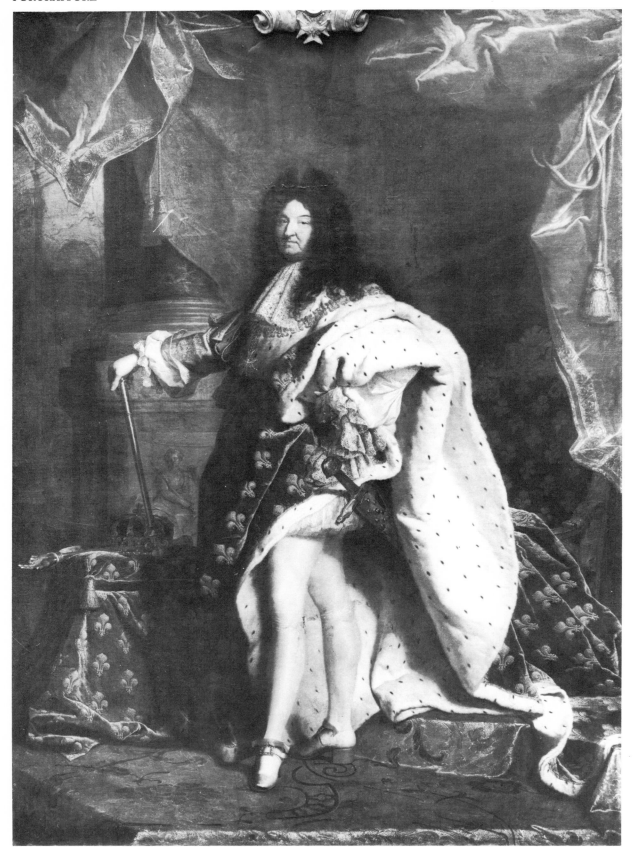

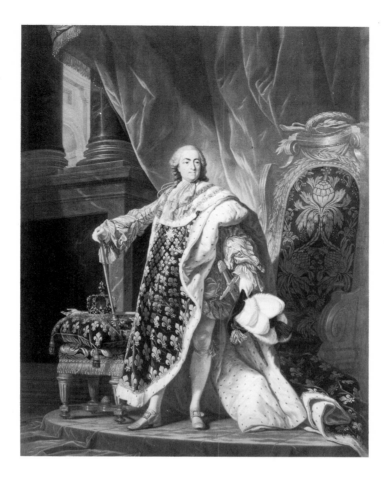

Fig. 90. LOUIS-MICHEL VAN
LOO: *Louis XV*. About 1761. Oil
on canvas, 137.5 × 105.4 cm.
Wallace Collection, London

the jubilee first year of the century. The hammer, the golden trowel and the coins all commemorate the event, and the Cardinal is attended by two young genii, scions of his noble house. The figure, again, is surrounded by superb draperies and a variety of attributes. The colours are warm, with dark red curtains and scarlet robes dominating, and the keen and sensitive drawing of the face is set off by the cooler purple of the collar and the ruby of the insignia glowing on the ermine.

A painter such as Rigaud, enormously in demand, employed a large workshop of assistants. Paintings would be priced according to the amount of work the master himself undertook; for modest clients there was a stock range of costumes and poses, and Rigaud himself might paint only the face and hands, or even just add finishing touches and a signature. In 1735, when he was charging 600 *livres* for standard half-length portraits with studio assistance, an 'entirely original' work, requiring care and individual thought, cost 3,000 *livres*: this was the remarkable portrait of Gaspard de Gueidan (Col. Plate 7), a cultured magistrate and future Président of the Parlement de Provence, who chose to have himself depicted as the shepherd Céladon, playing bagpipes, from d'Urfé's popular romance *L'Astrée*. This picture may be an ironic reference to the contemporary taste for portraits in mythological guise. It is a late work in Rigaud's career, with the whole design full of dancing and curving rhythms and an unusually cool palette, showing the artist's response to the rococo stylistic trends of the 1730s. It is also unusual in the careful attention to detail in the intricate costume, the rich gold brocades, and the instrument with its coats of arms.

Opposite:
Fig. 89. HYACINTHE RIGAUD: *Louis XIV*. 1701. Oil on canvas, 277 × 194 cm. Musée du Louvre, Paris

Nicolas de Largillière's portrait of *François-Jules du Vaucel* of 1724 (Fig. 92) is more typical of portraiture in the early decades of the century. The sitter was a wealthy *fermier général*, a member of the company which had the right to collect indirect taxes for the Crown. The picture, with its ample curves and saturated colour, breathes wealth and confidence; du Vaucel is self-assured in his expansive gesture, well fed in his podgy features and loosed buttons, well dressed in a superb brocade waistcoat with a matching lining in the sleeves of his velvet jacket. This kind of man made his fortune on paper, and we see general indications of his occupation: letters, pens and ink, a substantial ledger. Many *fermiers généraux* are

Fig. 91. HYACINTHE RIGAUD: *The Cardinal de Bouillon*. 1709. Oil on canvas, 274 × 217 cm. Musée Hyacinthe Rigaud, Perpignan

found among the leading patrons of art in this period. Indeed, one of the most powerful people in France in the mid-century, Madame de Pompadour, had been the wife of a *fermier général* before becoming official mistress of Louis XV in 1745. Her uncle, Le Normand de Tournehem, was also a *fermier général*, and she had him appointed Directeur des Bâtiments in 1745; he was succeeded in 1751 by her brother, the Marquis de Marigny (Fig. 97). The enormous fortune of Ange-Laurent de La Live de Jully (Fig. 93) was based on that of his father, another *fermier-général*. The younger La Live held the estimable official position of Introducteur des Ambassadeurs to the French court (a post worth 300,000 *livres* per annum); but

Fig. 92. NICOLAS DE LARGILLIÈRE: *François-Jules du Vaucel*. 1724. Oil on canvas, 138 × 105 cm. Musée du Louvre, Paris

Fig. 93. JEAN-BAPTISTE GREUZE:
Monsieur de La Live de Jully. 1757–9.
Oil on canvas, 116.8 × 88.5 cm.
National Gallery of Art,
Washington

unlike his father or du Vaucel he could, in his mid-thirties, devote more time to spending money than to earning it. Thus Greuze depicts him not as a grand businessman but as a highly cultivated *amateur*, finely but casually dressed in a housecoat, making music, a portfolio of prints and drawings in the background, and surrounded by the very latest in furniture '*à la grecque*', which he had commissioned. The restraint of Greuze's design reflects the fashionable classicizing taste of La Live, who was one of the greatest and most advanced collectors of the 1750s and 1760s.

Returning to the earlier generation, however, Largillière, like his friendly rival Rigaud, was a master at seducing the eye with a variety of tactile surfaces and stuffs. But whereas Rigaud tends to present his sitters in a theatrical way, Largillière more successfully conveys an intimate air, often setting his figure against a landscape to give a relaxed atmosphere. In the so-called *Belle Strasbourgeoise* (Fig. 94; identifiable by her costume and large *bicorne* hat) the warm autumnal landscape and the soft Rubensian lights on the sitter's face recall Largillière's Flemish origins. Her image is very striking in its simplicity of black, red and white, yet there is painstaking detail in the lovingly rendered costume—a costume that shows she was indeed

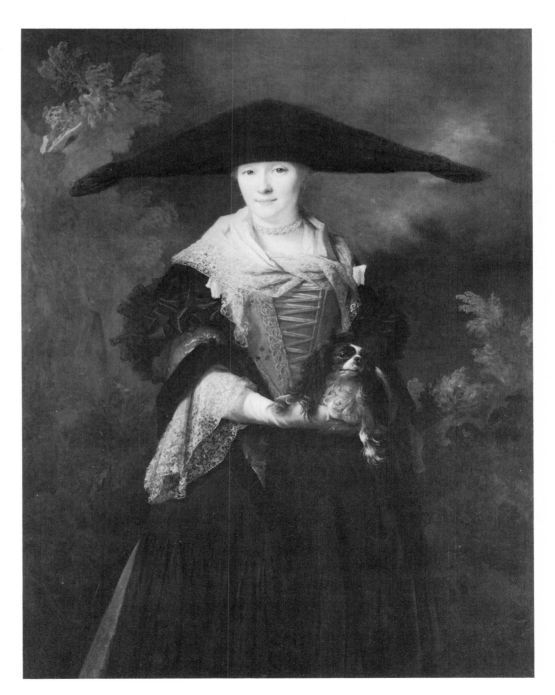

Fig. 94. NICOLAS DE LARGILLIÈRE: *La Belle Strasbourgeoise.* 1703. Oil on canvas, 138 × 106 cm. Musée des Beaux-Arts, Strasbourg

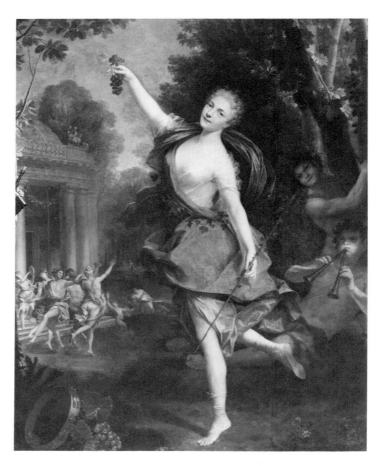

Fig. 95. JEAN RAOUX: *Mademoiselle Prévost*. 1723. Oil on canvas, 209 × 162 cm. Musée des Beaux-Arts, Tours

comfortably off! Another popular portrait-type in the early decades was the *portrait historié*, where the sitter is shown in some historical, mythological or literary guise (for example, Rigaud's *Gueidan*, Col. Plate 7). Actors and actresses were often shown in this way, playing a particular role. In 1723 the dancer Françoise Prévost made her name as a Bacchante in Roy and Lacoste's opera *Philomèle*, and Jean Raoux depicted her in that role the same year, though not in her stage costume or setting. Raoux made a number of portraits of this type, or in more elevated mythological guise, and a certain demand for such works continued throughout the century. There is something a little more sober in François de Troy's presumed portrait of the Duchesse de la Force (Fig. 96), who is dressed in relatively simple swathes of silk. The painter does not altogether flatter her rather heavy features, though the juxtaposition of the coarse young servant alleviates these; he is also a foil to her physical and social stature. Moreover, the idealized simplicity of her dress lifts her to a plane of mythic nobility (could she be cast as Pomona, goddess of fruit?). Yet there is a rich array of textures, which hold her to our world—fur, velvet, silk—and these tactile qualities are enhanced as she reaches out to take a peach we could ourselves imagine touching.

Rigaud and Largillière were also capable of producing restrained and realistic portraits, but their painterly abilities were best displayed in ceremonial portraits. Jean-Marc Nattier and his son-in-law Louis Tocqué continued this more showy manner into the 1760s. Tocqué had less worldly success than Nattier, but was still among the leading painters of the mid-century. Marigny presented a portrait of himself by Tocqué to the Académie in 1756 (Fig. 97), and one can see in its

formality the painter's admiration for the earlier generation, with whom he was often compared. His men are usually rather stiffly upright, and some contemporaries accused him of monotony in simply turning them to left or right. But his draughtsmanship is always sure and acute, and in works less formal than this one (e.g. the *Marquis de Lücker*, 1743; Musée des Beaux-Arts, Orléans) he has an unaffected psychological penetration that is in line with the greater realism of private portraiture in that decade.

Nattier was a great success at court, especially with his formal and mythological portraits. Before being accepted into the Académie as a history painter, he had made a reputation as a draughtsman for engravers, notably with a drawing of 1712 after Rigaud's portrait of Louis XIV (the drawing itself was purchased for the royal collection). He also made drawings for engraving after the allegorical *Marie de' Medici* cycle by Rubens at the Palais du Luxembourg. He developed a reputation chiefly for portraits in an allegorical vein, particularly with the *Maréchal de Saxe* of 1725 (Dresden), in which the sitter is being crowned by Time. Nattier sometimes cast the sitters themselves in allegorical or mythological roles—the Duchesse d'Orléans as Hebe, for example (Fig. 98); but critics such as Cochin, who espoused more advanced and realist aesthetics, soon pointed out the absurdity of showing modern women feeding mythological eagles. Nattier's daughter (Madame Tocqué) defended this in his biography, saying: 'He reconciled the two major branches of art in his works, so that the informed public did not know which to admire more in

Below, left:
Fig. 96. FRANÇOIS DE TROY: *The Duchesse de la Force*. 1714. Oil on canvas, 114 × 111 cm. Musée des Beaux-Arts, Rouen

Below, right:
Fig, 97. LOUIS TOCQUÉ: *The Marquis de Marigny*. 1755. Oil on canvas, 135 × 104 cm. Musée National du Château de Versailles

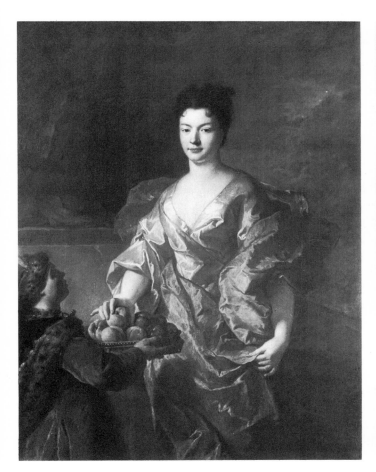

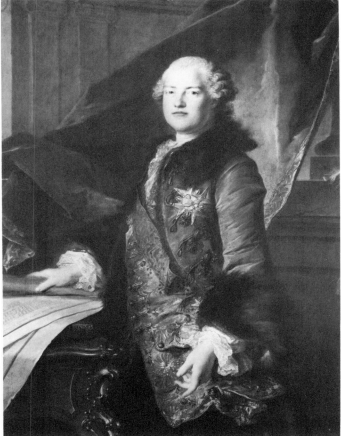

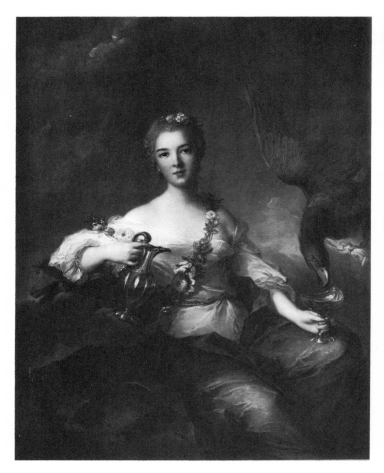

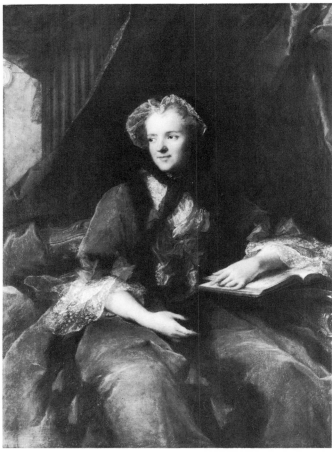

him—the history painter or the portraitist.' He also gained recognition for his extremely refined technique of glazes, and for the delicacy of detail and elegance of movement with which he invested his basically simple compositions. He made a series of large portraits of the daughters of Louis XV, refining his designs by avoiding any exuberance of movement (for example, in swags of curtain) and by employing a cool and restrained palette; nor did he fail to respond to the quieter and more domesticated world of the Petits Appartements, suppressing the fanfare of baroque pomp we have seen in Rigaud and Largillière. Indeed, a homely modesty informs his portrait of the Queen, *Marie Leczinska* (Fig. 99), and only the fleurs-de-lis on the back of her chair let on that we are in the presence of royalty. She specifically asked to be portrayed in 'town clothes' (as opposed to court finery) and, pausing as she reads her Bible, she might be mistaken for one of the *haute bourgeoisie*. She is depicted as thoughtful, gentle and sympathetic, and, not surprisingly, the portrait was much admired at the Salon of 1748. The Queen herself commissioned replicas from Nattier's own hand, and one of these (private collection) for the Président Hénault, a man of letters who moved in the enlightened circle of Madame du Deffand, shows the Queen reading a volume of philosophic essays, in place of her Bible!

Nattier and the Queen were responding to a vogue for more informal portraiture, showing sitters in a characteristic daily occupation, which had been developed particularly by Jacques-André-Joseph Aved during the preceding ten years or so. In

Left:
Fig. 98. JEAN-MARC NATTIER: *The Duchesse d'Orléans as Hebe.* 1744. Oil on canvas, 131 × 105 cm. Nationalmuseum, Stockholm

Right:
Fig. 99. JEAN-MARC NATTIER: *Marie Leczinska.* 1748. Oil on canvas, 138 × 105 cm. Musée National du Château de Versailles

his portrait of *Jean-Gabriel de la Porte du Theil*, Secrétaire du Cabinet du Roi, Premier Commis des Affaires Etrangères (Fig. 102), the sitter is at his desk and turns to the spectator the moment after sealing the Treaty of Vienna, which secured Lorraine for France in 1738. The candle for melting the wax has just been extinguished, the seal is in his hand, a quill is to one side, the documents are before him. This is a characteristic if not a daily activity, and forms the perfect image of a shrewd administrator, a serious, trustworthy servant of the Crown. There is an element of prosaic Dutch realism in Aved's style, which perhaps bears witness to his early training in Amsterdam, after which he studied in Paris. The work which established Aved's reputation was his natural and intimate portrait of *Madame Crozat* (Fig. 100), painted in 1741. Here a sitter of no public importance is shown, seemingly casually, in a relaxed home setting, passing her time at working a tapestry. A teapot sits ready behind, and Madame Crozat pauses for a moment to look up from her work, removing her pince-nez. It is just this commonplace gesture—the kind of action few women would particularly wish to commemorate, as a contemporary critic pointed out—that gives the painting its informality and effect of spontaneity. The sitter is not idealized, but she is shown as kindly, intelligent, and industrious as well as affluent. It is the simple domestic attributes, as another commentator put it, that help us to judge her character. More broadly, the picture expresses the same idea of a well-ordered, bourgeois existence as we see in works by Chardin of the same period (Col. Plate 12 and Fig. 142). How remote and formal de Troy's *Duchesse de la Force* (Fig. 96) looks by comparison! There is a flattering moral implication in such portraits. Occupations such as embroidery, knotting lace and reading were considered very proper occupations for leisured women, and to portray them in these pursuits indicated that they employed their time constructively, rather than being lazy, frivolous, or vain.

Such naturalness was a keynote in portrait painting for the rest of the century, though of course there was also a continuing demand for portraits of a more formal type. Aved painted the whole range of the ruling class of his day, from monarchs (in Holland) downwards. On the whole he left the French court to Rigaud and Largillière, who were succeeded by Nattier, Tocqué, and Drouais. Aved's contribution was to the image of the upper bourgeoisie—officials in the royal service, financiers and their wives—whom he showed in their private rather than their public aspect, industrious even at leisure. As a contemporary observed, 'M. Aved has the rare secret of rendering in his portraits not only the face, but also the genius, the character, the talents, the habits of the person he paints. Pose, draperies, accessory details—nothing is arbitrary. Everything that seems a matter of indifference even to recognized masters is essential to M. Aved: everything contributes to the resemblance and the main effect. Hide the heads of his figures, and you may not be able to tell *who* it is from the rest of the picture, but you can tell what are his interests, his manners, his faults, his virtues. . . .'

If the Queen could not be shown by Nattier actually using her hands, a royal mistress (or, rather, former royal mistress) could—and the repercussions of Aved's manner are still seen in François-Hubert Drouais's *Madame de Pompadour* of 1763-64 (Fig. 101), in which the sitter is working at an embroidery frame, but in a setting more sumptuous than that of Madame Crozat. Drouais has little of Aved's canny psychological penetration, and the detailed depiction of Madame de Pompadour's dress and fine furniture hardly compensates for this. The genteel embroideress of the 1760s had, twenty years before, aroused the passion of Louis XV (whose mistress she had been from 1745 to 1751), and Boucher had been the

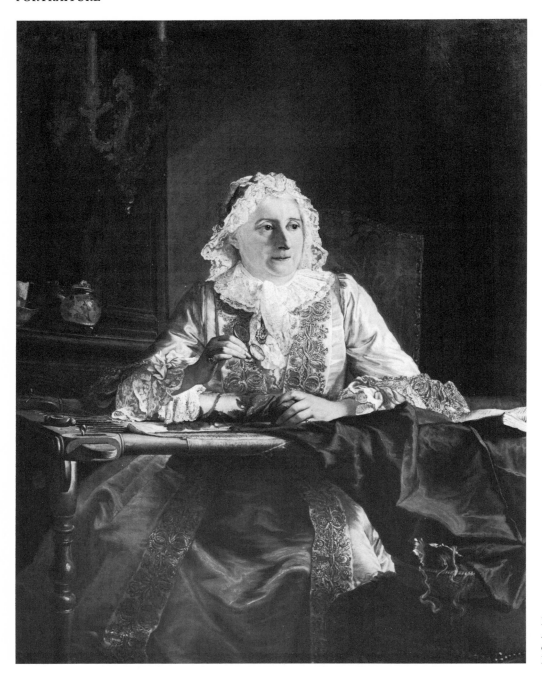

Fig. 100. JACQUES ANDRÉ JOSEPH AVED: *Madame Crozat*. 1741. Oil on canvas, 137 × 100 cm. Musée Fabre, Montpellier

painter who best conveyed the image of the young mistress. She was a keen collector, and had mild intellectual and musical interests too, which Boucher skilfully displays in several portraits of her. These qualities are reconciled with her full and pretty features in the Munich portrait (Col. Plate 8), where she is seated amongst fine furniture and hangings in her boudoir, pausing to look up from her book. A mirror reflects her bookcase, and other volumes are scattered around; to the left we see an untidy portfolio of engravings and some sheets of music, illustrating her interest in the arts. Above all, the picture displays the Marquise herself, as plump as the cushions on which she sits; even the delightful nape of her neck can be

seen to advantage in the mirror. She wears a beautiful blue silk damask dress, stitched with roses and flounced trimmings. The cool tones and rococo grace of Boucher's portraits are comparable with those of Nattier, but Boucher paints in a more impasted way, without the delicate glazes which give Nattier's works their smooth surface.

The tendency towards a sharp delineation of character—at the expense of the more conventional attributes or displays of costume—is represented most strongly

Fig. 101. FRANÇOIS-HUBERT DROUAIS: *Madame de Pompadour*. 1763–4. Oil on canvas, 217 × 156.8 cm. National Gallery, London

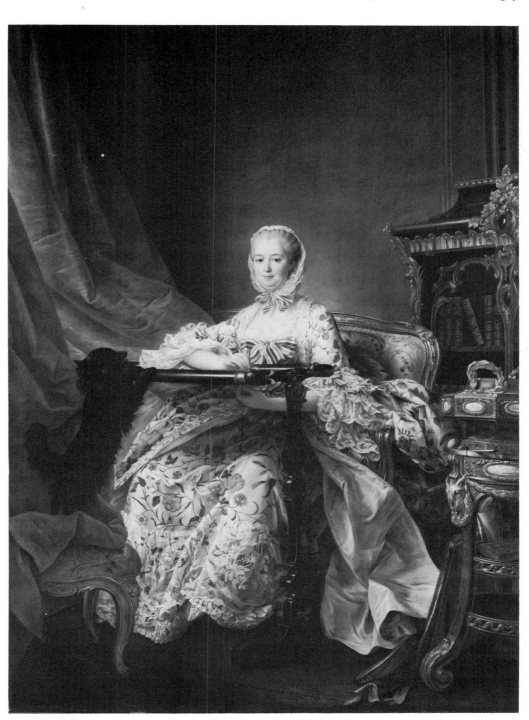

Fig. 102. JACQUES ANDRÉ JOSEPH AVED: *Jean-Gabriel de la Porte du Theil*. 1740. Oil on canvas, 124.4 × 92 cm. The Cleveland Museum of Art (Purchase, John L. Severance Fund)

in the pastels of Maurice Quentin de la Tour. In some of his preparatory studies, which are the least compromising of his works, he concentrates on the face alone, often giving a humorous look to the eyes and a slight twist to the mouth, which endows them with a vivid actuality and character. This can sometimes be a flattering effect, but he often treats his sitters with a mordant humour, so quick and merciless was his eye, which gives the impression that he penetrates their personality. The humour is affectionate, however, in the portrayal of his friend the *Abbé Huber* (Fig. 103), engrossed in a book as he reads into the night, though the

Opposite:
8. FRANÇOIS BOUCHER: *Madame de Pompadour*. 1756. Oil on canvas, 201 × 157 cm. Alte Pinakothek, Munich

Fig. 103. MAURICE QUENTIN DE LA TOUR: *The Abbé Huber*. 1742. Pastel on paper, 81 × 102 cm. Musée d'Art et d'Histoire, Geneva

depiction of a characteristic occupation is unusual in La Tour's work, which normally concentrates on physiognomy alone. He once wrote that, as opposed to the serious monotony of Corneille, he preferred the humorous variety of Molière's characters, which he felt to be closer to nature. It was very much the natural variety of characterization in his own work that made La Tour one of the most sought-after, and expensive, portraitists of his day. Moreover, he answered a general aesthetic demand for what seemed natural, voiced by critics during the 1740s and 1750s, a response that is also found in the work of Chardin, and the landscapes and marines of Vernet.

The directness and unaffected simplicity which Aved, La Tour and Tocqué share left its mark on portrait painting for the rest of the century. In this tradition there are few images as disarmingly frank as Joseph-Siffred Duplessis's *Madame Lenoir* (Fig. 104); it was shown at the Salon of 1769, and made his reputation in conjunction with other portraits. The sitter was an affluent hosier, and evidently had leisure for reading; she pauses to look straight back at the spectator, a wry smile

on her face. She wears a pale blue satin dress trimmed with white lace, and a cluster of fresh pale yellow roses in her *décolletage*. One critic (at the Salon of 1783) remarked that the perfect portrait would have the face painted by Duplessis and the costume by his chief rival, Alexandre Roslin. Indeed, the humour expressed in Madame Lenoir's face gives her a sense of life sometimes lacking in portraits by Roslin, for all his technical finesse. But Roslin could combine an intimate feeling for character with a more formal effect: a superb example of this is his portrait of the *Abbé Terray* (Fig. 105), painted for the Académie in 1774 during Terray's brief term as Directeur des Bâtiments between Marigny and d'Angiviller. Roslin, an artist of Swedish origin who soon afterwards returned to his native country, was a keen observer and a precise recorder of his sitters, whom he rarely flatters, but renders in a cool and detached manner. The painting of the gleaming silks, contrasting with the creamy-white intricacies of the lace, is a *tour de force*, and the perfection of Roslin's technique adds to the objectivity of the image. Terray emerges as an individual, in contrast to Tocqué's *Marigny* (Fig. 97), a comparable commission, where the sitter is reduced to a formal type.

Although the official portrait grew less formal during the second half of the century, the function of any particular portrait, and the sitter concerned, still determined its appearance. Thus when Boucher painted his own pretty young wife in 1743 (Fig. 106) he was at liberty to inject a note of ironic humour into the portrait, which is an intimate view of this coquettish and doll-like creature surrounded by the clutter and chinoiserie of her little boudoir. *The Abbess Battistina*

Below, left:
Fig. 104. JOSEPH-SIFFRED DUPLESSIS: *Madame Lenoir*. About 1764. Oil on canvas, 65 × 55 cm. Musée du Louvre, Paris

Below, right:
Fig. 105. ALEXANDRE ROSLIN: *The Abbé Terray*. 1774. Oil on canvas, 129 × 97 cm. Musée National du Château de Versailles

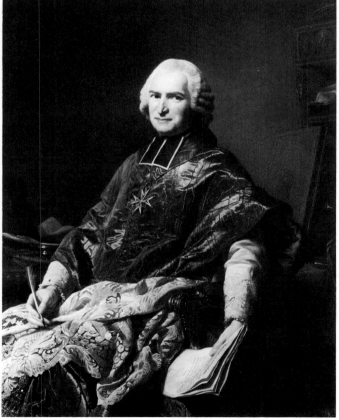

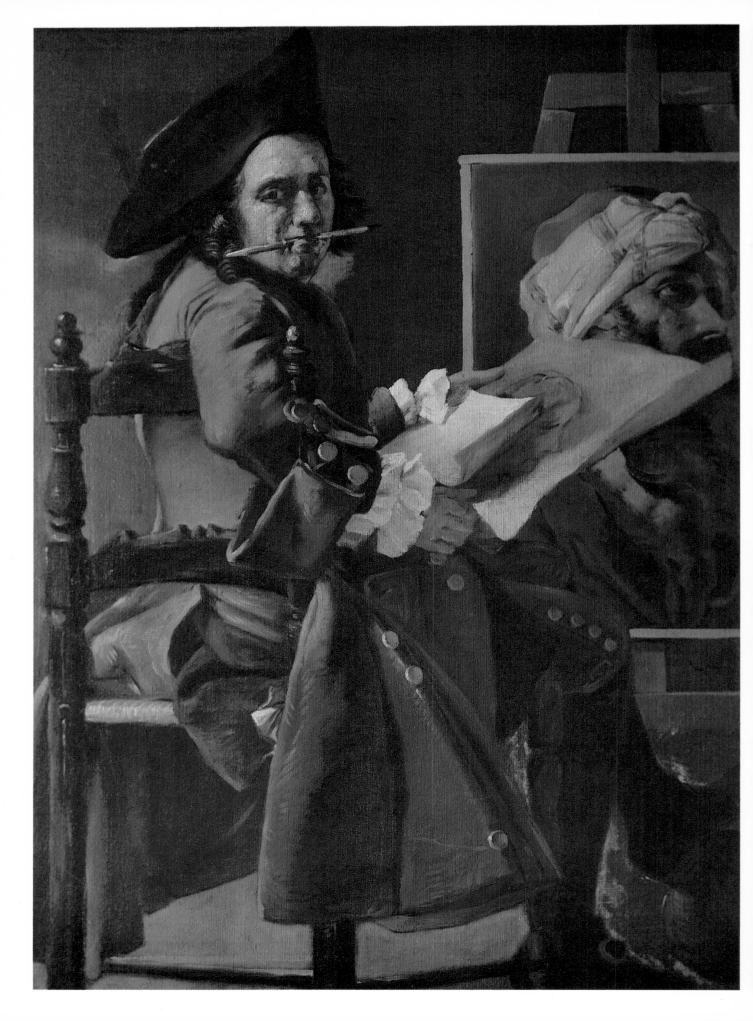

Opposite:
9. PIERRE SUBLEYRAS: *Self-Portrait*. About 1746. Oil on canvas, 130.5 × 101 cm. Gemäldegalerie, Akademie der bildenden Künste, Vienna

Fig. 106. FRANÇOIS BOUCHER: *Madame Boucher*. 1743. Oil on canvas, 57.2 × 70.8 cm. Frick Collection, New York

Vernazza (Fig. 107), painted only a couple of years earlier by Pierre Subleyras, forms the greatest possible contrast. The Abbess of the Romites of San Giovanni in Laterano is the subject of an austere essay in black, white and beige, in which the design plays on straight lines and angular forms and seems to answer the rectangular shape of the canvas. A sense of intellectual urgency is expressed in Louis-Michel Van Loo's *Denis Diderot* (Fig. 108), where the sitter is seen in private, without wig, writing at his desk. Here Van Loo paints in a spirited manner to suit the sitter and the type of portrait—quite different, for example, from his formal rendering of Louis XV (Fig. 90). Diderot is given the slightly dishevelled look reserved for creative people such as artists or men of letters. These portraits of intellectuals, certainly during the first three-quarters of the century, have a studied negligence, and usually show the sitter in casual working clothes, more absorbed in inspiration and creation than conscious of appearances. The portrait of Diderot was

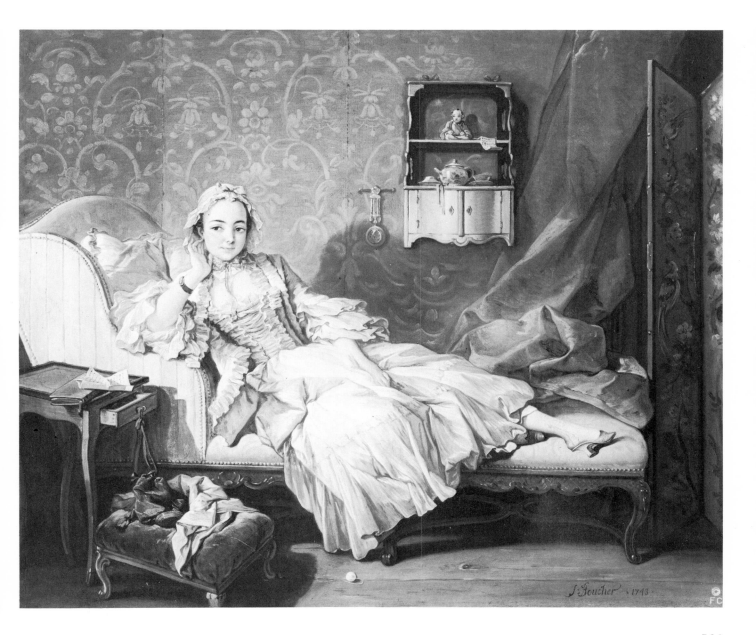

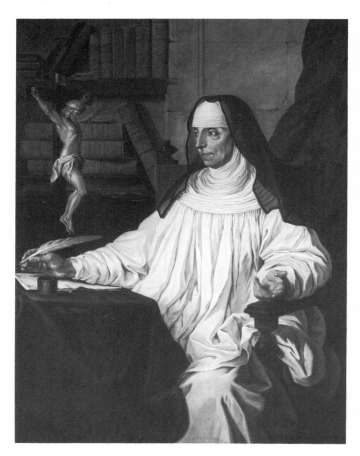

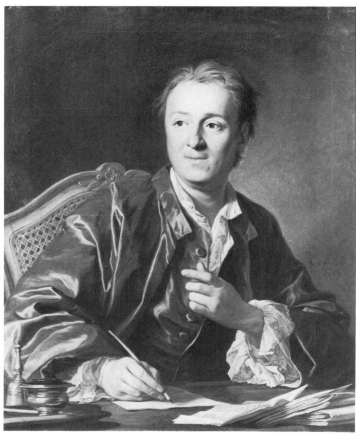

much admired for the lively image it gave of the volatile polymath, though Diderot himself joked that it made him look more like a Secretary of State than a *philosophe*.

Balthazar Sage (Fig. 109) was celebrated simply as a scientist in his day, for he was a chemist and a mineralogist, and founder of the Ecole des Mines. Following the example of Aved thirty years before in portraits such as *Madame Crozat* (Fig. 100) or *Jean-Gabriel de la Porte du Theil* (Fig. 102), Jean-François-Gilles Colson shows the sitter in his most characteristic environment, in this case a laboratory. He is surrounded by glass vessels, shelves of jars and mineral samples, and the unfortunate birds used in experiments with vacuums and gases. The chemist looks directly at the spectator, while gesturing towards his crowded table; the brick-red jacket and yellow waistcoat bring him forward from the penumbra behind. The scientist-in-his-laboratory or scholar-in-his-study type of portrait culminates, at least as far as the *ancien régime* is concerned, with David's moving *Monsieur and Madame Lavoisier* (Fig. 110), painted just before the Revolution. Here Madame Lavoisier, a pupil of David (a portfolio of drawings is behind her), is seen as a Muse to her husband, whom she assisted in his scientific work. Lavoisier was a rich *fermier général*, but also a famous chemist and physicist, with a special interest in oxygen, respiration and combustion; he discovered the composition of water in 1784. The instruments on his desk and on the floor designate his scientific concerns; but this large and solemn work (nearly three metres high), designed with neoclassical simplicity, seems above all to be a tribute to conjugal happiness.

Above, left:
Fig. 107. PIERRE SUBLEYRAS: *The Abbess Battistina Vernazza*. About 1740. Oil on canvas, 99 × 74 cm. Musée Fabre, Montpellier

Above, right:
Fig. 108. LOUIS-MICHEL VAN LOO: *Denis Diderot*. 1767. Oil on canvas, 81 × 65 cm. Musée du Louvre, Paris

Sobriety is the dominant characteristic of neoclassical portraits, and in them even artists are depicted as men of solid learning rather than inspiration. Antoine Vestier's *morceau de réception* for the Académie in 1786 was a portrait of one of its teachers, *Gabriel-François Doyen*, painted in 1781 (Fig. 111). He is shown as something of a classical scholar, with a prominent volume of the *Iliad* and a bust of Homer in the background: indeed, a perfect product of the Ecole Royale des Elèves Protégés. Doyen was well known for depicting Homeric themes, and was just the sort of history painter critics such as La Font de Saint-Yenne had hoped for in the late 1740s. Although he seems to be looking upwards to some private Muse, we see an artist who is bookish, learned and thoughtful rather than inspired; these solid intellectual qualities are also expressed by the firm drawing and the placing of Doyen's substantial figure in the curve of the armchair. Earlier portraits of artists are much less formal. There is a rawness, almost a smell of paint, and certainly no such immaterial concept as a Muse, in a *Self-Portrait* by Subleyras (Col. Plate 9). He presents us with an arrestingly forthright image of himself, leaning aggressively over the back of his chair as if annoyed by our intrusion, crayon-holder in his mouth, and fixing us with his eye. Compared with Vestier's tight neoclassical brushwork, that of Subleyras is impasted with *brio* in a bold, no-nonsense, workaday manner.

Fig. 109. JEAN-FRANÇOIS-GILLES COLSON: *Balthazar Sage*. 1777. Oil on canvas, 100 × 81 cm. Musée des Beaux-Arts, Dijon

Fig. 110. JACQUES-LOUIS DAVID:
Monsieur and Madame Lavoisier.
1788. Oil on canvas,
259.6 × 195.7 cm. The
Metropolitan Museum of Art, New
York (Purchase, Mr and Mrs Charles
Wrightsman Gift, 1977)

In 1787 Adélaïde Labille-Guiard painted a portrait of *Madame Adélaïde* (Fig.
112), one of the daughters of Louis XV, showing the sitter herself as a portraitist.
The princess has drawn in *trompe-l'oeil* relief the posthumous portraits of her father,
mother and brother—but these images are present to indicate her extreme devotion
to their memory, rather than to show any real talent she may have had as an artist.
Indeed, the whole picture is largely designed as a tribute to the late King and his
family: the plan on the stool is that of a convent at Versailles founded by the late
Queen and directed by Madame Adélaïde; the principal bas-relief above shows her
courage and that of her sisters in approaching the deathbed of Louis XV, who was
stricken with smallpox. The painting was also an opportunity to show Madame
Adélaïde's sumptuous costume, of which she was especially proud—on this
occasion a red velvet cloak and grey silk dress, both embroidered with gold. She was

also a noted collector of furniture. Apart from its memorial overtones, the technical refinement of the painting and the devoted rendering of the luxurious stuffs with which an eighteenth-century princess could surround herself strongly recall the large portraits of the same sitter and her sisters as children painted by Nattier thirty years before. Thus the official court portrait survived until the Revolution.

The new Queen was in tune with modern ideas, and these are reflected in the portrait of her by Elisabeth Vigée-Lebrun, Madame Labille-Guiard's chief rival at the Salon of 1787. *Marie-Antoinette with her Children* (Fig. 113) shows the sitter very much in the role of happy motherhood, with a touch of Greuzian sentiment. This painting is rather more formal in grouping and smooth in finish than Madame Vigée-Lebrun's most characteristic portraits, and the full, rounded forms, the softly rendered surfaces, and the naïve charm of the sitters combine to make it a good deal more flattering and appealing than the rather stiff spinster of Madame Labille-Guiard. As a contemporary critic pointed out, the portrait of the Queen pulled in the crowds but those who knew about art preferred the more subtle complexities of Madame Labille-Guiard's painting. Madame Vigée-Lebrun had been guided by Greuze, whose portraits and fancy-pictures of young girls, such as the *Young Girl pining over her Dead Bird* (Fig. 118), with their plump features and soft, rosy skin, were sensuous prototypes for her own style. Her art has not very much to do with exploring individual psychology, but more with flattering her sitters and showing them to be creatures of sensibility. The ravishing *Lady folding a Letter* (Fig. 114) is a typical example of the lush images that made her reputation in France before the Revolution and at the European courts where she subsequently took refuge.

While Greuze made a number of sober and unaffected portraits of the psychologically penetrating kind (for example *François Babuti*, *c.* 1761, private collection, Paris), he also worked against this trend with portraits which include mild symbolic references to love, transience, vanity, and suchlike (*Mademoiselle de Courteilles*, 1759, Brunswick, Herzog Anton Ulrich Museum), much as Chardin

Fig. 111. ANTOINE VESTIER: *Gabriel-François Doyen*. 1781. Oil on canvas, 130 × 96 cm. Musée du Louvre, Paris

137

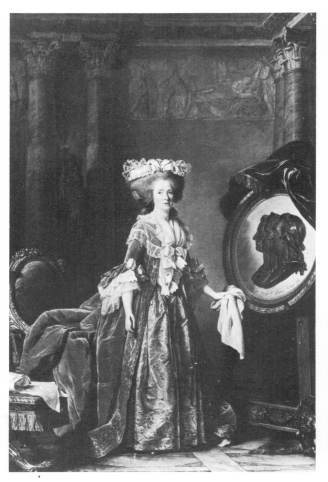

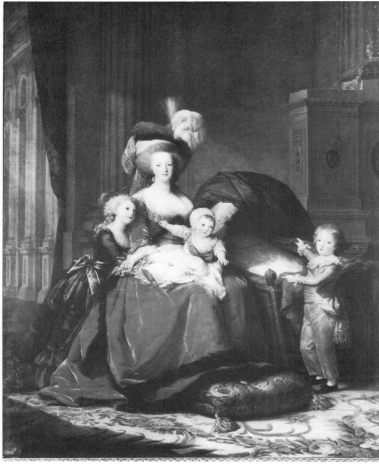

had already done in portraits such as *The House of Cards* (Fig. 116). Moreover, just as Greuze elevated genre painting towards history, so too he expanded the function of the portrait to express a larger meaning. In *The Well-beloved Mother* (Fig. 115) we have an elevated genre picture with a didactic meaning, whose cast of characters is the family of the wealthy financier Jean-Joseph de Laborde. The painting was commissioned by his mother-in-law, Madame de Nettine, who is prominent in the centre. The Marquis has been out shooting and returns to his abode (which might seem surprisingly humble for one of the richest men of the day!), where he throws up his hands in delight at the sight of his wife with their six children swarming happily around her. On one level this is a group portrait, with the family acting out a Rousseauesque ideal of clean, rustic simplicity in a world comparable to that of Greuze's bride in *The Village Betrothal* (Col. Plate 5). But the painting also promotes a notion of family love and family life that was relatively unusual in 1765, having been eagerly advocated by Enlightenment thinkers since the middle of the century: here are six children who, unusually, have not been consigned to a wet nurse, and the whole family is seen to enjoy a rich emotional satisfaction, centering on the delights of motherhood. Not only were such ideas reflected in a number of genre pictures in the later part of the century, but even Marie-Antoinette chose to be seen as a happy mother, albeit a rather superior, bourgeois one.

If the didactic element in Greuze's portrait of the Laborde family sets it apart from the majority of eighteenth-century portraits, nevertheless there are other

Above, left:
Fig. 112. ADÉLAÏDE LABILLE-GUIARD: *Madame Adélaïde*. 1787. Oil on canvas, 271 × 194 cm. Musée National du Château de Versailles

Above, right:
Fig. 113. MARIE-LOUISE-ELISABETH VIGÉE-LEBRUN: *Marie-Antoinette with her Children*. 1787. Oil on canvas, 260 × 205 cm. Musée National du Château de Versailles

instances where portraiture was used to embody a moral. A number of Chardin's portraits of the 1730s and 1740s are mildly moralizing pictures on the traditional theme of *vanitas*. Once they were engraved for a wider market they usually lost their identity as portraits and were given narrative titles and sometimes accompanying texts of moralizing verses. Such was the case with *The House of Cards* (Fig. 116), which on one level can be read as a fancy-picture on the theme of the vanity of human enterprise, but on another is a portrait of the son of one of Chardin's friends, Jean-Jacques Lenoir, a furniture-dealer and cabinet-maker. The self-absorption of the boy may be used by Chardin as a way of overcoming the difficulty he had in rendering expression, but it is also consistent in mood with the silent and contemplative world of his art as a whole. With certain figure paintings we cannot be sure whether we have a portrait, a vehicle for moral comment, a work which simply invites us to enjoy its skilful imitation, or a combination of all these.

Earlier in the century Alexis Grimou made a speciality of this type of fancy-portrait, as in his celebrated *Boy Pilgrim* and *Girl Pilgrim* (Fig. 117; 1726), of which several autograph replicas exist. They are exercises in a delicate but resonant Rembrandtesque chiaroscuro, adapting his rich browns and reds (Rembrandt had been one of the greatest painters of fancy-portraits in the previous century). Grimou was not alone among eighteenth-century painters in admiring and imitating the great Dutch master, and Chardin executed works which were compared with Rembrandt. The fancy-portrait remained popular throughout the century, and Greuze, for example, painted many works in this vein. His *Girl pining over her Dead Bird* (Fig. 118) may well have been intended to illustrate a famous poem by the

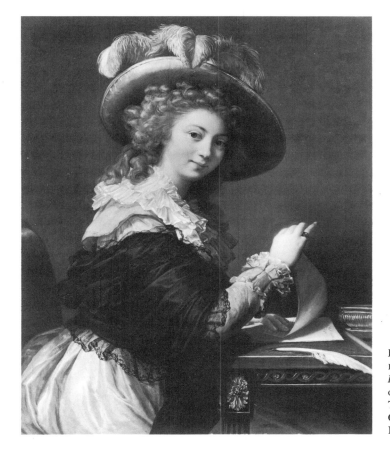

Fig. 114. MARIE-LOUISE-ELISABETH VIGÉE-LEBRUN: *Lady folding a Letter*. 1784. Oil on canvas, 93.3 × 74.6 cm. The Toledo Museum of Art, Ohio (Gift of Edward Drummond Libbey, 1963)

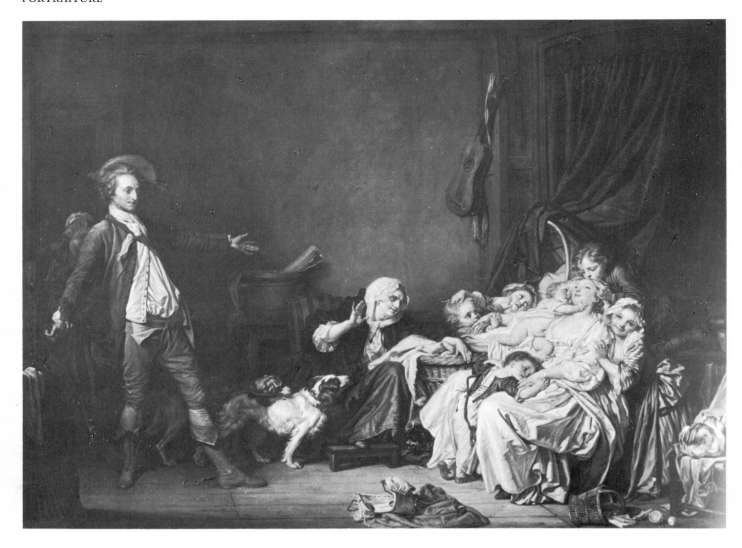

ancient author Catullus on the theme of a young girl's first encounter with mortality. Diderot took a salacious view of this plump and appealing young wench, and saw the theme of the picture as the loss of virginity. But it was the former, tender-hearted theme that appealed to the sensibility of most critics at the Salon of 1765, who also felt that its voluptuous forms, curved rhythms and luscious paint made it an exquisite demonstration of Greuze's painterly ability.

Fragonard, too, painted *figures de fantaisie*, which are sometimes loosely based on people he knew. *Music* (Fig. 119), in which the head is that of Monsieur de la Bretèche, brother of the Abbé de Saint-Non, is one of a series of such works, which were but pretexts for the artist to show his painterly virtuosity, and Fragonard was reputed to have dashed this one off in an hour. Above all, the spectator is aware of the vigorous curling and sweeping brushstrokes, which are reminiscent of the freely handled terracotta models of contemporary sculptors and are there to be appreciated and enjoyed for themselves alone.

While the modern spectator has no trouble in equally appreciating the lush, painterly effects of Fragonard and the more sparse and tensely applied brushmarks of David's portraits of the early 1790s, it is almost certain that these works by

Fig. 115. JEAN-BAPTISTE GREUZE: *The Well-Beloved Mother.* 1765. Oil on canvas, 99 × 131 cm. Laborde Collection, Madrid

Fig. 116. JEAN-BAPTISTE-SIMÉON CHARDIN: *The House of Cards* (or *Monsieur Lenoir's Son*). About 1737. Oil on canvas, 60.3 × 71.8 cm. National Gallery, London

Below, left:
Fig. 117. ALEXIS GRIMOU: *A Young Pilgrim Girl.* 1726. Oil on canvas, 82 × 63.5 cm. Uffizi, Florence

Below, right:
Fig. 118. JEAN-BAPTISTE GREUZE: *A Young Girl Pining over her Dead Bird.* About 1765. Oil on canvas, 53 × 46 cm. National Gallery of Scotland, Edinburgh

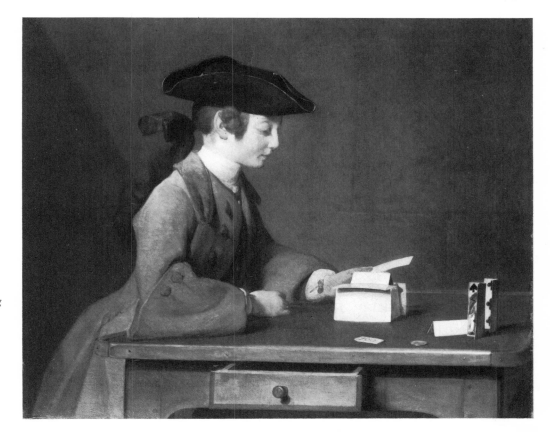

David in fact are unfinished. The background of *Madame Trudaine* (Fig. 120), and to some extent the treatment of the sitter's hair and dress, have a sketchy touch, which seems to convey something of David's own nervous excitement during these years. But as a result of the rapidly changing political events during the Revolution, and the rising and falling fortunes of his sitters, David had to leave a number of works unfinished (*Madame Trudaine* remained in his possession, and is listed as unfinished in the sale held in 1826 after his death). Even so, there is a great economy of means in David's portraiture at this time, and here he has the sitter turn to us with a disarming frankness, wearing a simple black dress. It may be that the combination of brick-red ground, white blouse and blue waistband is a conscious reference to the Republican colours; but however liberal the views of the Trudaines, the sitter's husband went to the guillotine in 1794—and David went to prison, which may explain the lack of finish here. The image is stark, when compared with the portraits we have seen made during the *ancien régime*, and lacks the attributes of comfortable bourgeois existence. It is as if David were taking portraiture back to the first principles of basic design, to expunge any delight in the fabric of privileged existence, and to deny the luscious indulgence of Fragonard's paint for paint's sake.

Left:
Fig. 119. JEAN-HONORÉ FRAGONARD: *Music* (or *Monsieur de la Bretèche*). 1769. Oil on canvas, 80 × 65 cm. Musée du Louvre, Paris

Right:
Fig. 120. JACQUES-LOUIS DAVID: *Madame Trudaine*. About 1793. Oil on canvas, 98 × 130 cm. Musée du Louvre, Paris

5 THE MINOR GENRES

The present volume, in adopting an eighteenth-century scale of values in regard to the genres of painting, is an attempt to redress the critical balance. But that is not to deny the considerable importance of the minor genres in relation to the total artistic output of the century, especially in decorative painting and cabinet pictures. There was an enormous demand for such works, and of course painters were happy to answer it.

Within these minor genres Watteau will always occupy a special place. He was essentially an independent spirit, transcending eighteenth-century or modern categorization. The academic hierarchy did not trouble him, and he successfully pursued a relatively modest and retiring career outside official artistic life. However, there is something to be said for the open-minded attitudes of the Académie in the early eighteenth century, for Watteau was received into that institution in 1717 as a painter of *fêtes galantes*, a genre devised especially for his reception. Even in 1712 his artistic independence was acknowledged when the choice of subject for his *morceau de réception* was, unusually, left to his own choice. *Fête galante* is a term impossible to translate, but refers to cabinet pictures with imaginary themes which show figures in costumes derived from the popular Italian comedy consorting in park-like settings, and usually with amorous intent. Watteau's official *fête galante* was the *Pilgrimage on the Isle of Cythera* (Fig. 121) and, not surprisingly, it is his most academic painting. A large work on the scale of a history painting, it has a specific theme, a narrative as clear as any by Poussin, and a variety of gesture and expression. The characters, dressed in the motley and archaic costumes of the theatre and the masquerade, are departing from the Isle of Cythera, where, with garlands of flowers, they have been paying homage to a statue of the presiding goddess, Venus. On the left we see couples, united by her spell and encouraged by *amorini*, embarking on a splendid gilded ship; reading from the right, where a pair of lovers are still tenderly self-absorbed at the shrine of the goddess, we can follow through two other prominent couples the progress of their departure. Since the nineteenth century the picture has been associated with a Romantic, melancholy view of love, tinged with the sad knowledge of the inexorable passing of time. This poignant interpretation is all too easily reinforced by the image of Watteau himself as a sickly and consumptive outsider, destined as he was for an early grave. The early biographies of Watteau (and a remarkable number of his acquaintances felt prompted to write about him) tell us that he was indeed sickly: when he visited London in 1719 it may well have been to consult the famous Dr Richard Mead as well as to contact the excellent French engravers

resident there. Melancholic, evasive, frequently changing address, he was a difficult character with a mordant wit, but very reliant on his small circle of friends. But the act of artistic creation itself is a very positive act of will—and the progress of love can be a positive and joyful one: the couples on the island of Venus have every appearance of departing in a contented and even optimistic frame of mind. The broad, looping S-curve of the landscape, and the almost dancing, swaying movements of the figures, give the picture a dynamic, not a languid rhythm, and the distant peaks and the surging trees of Cythera have a heightened intensity. Although it was the contemporary convention in landscape to paint foliage turning to brown and gold, this work is still overlaid with old varnish, which masks its cooler tones and perhaps makes it seem more mellow than it was in 1717. It is an enchanting, enchanted, but also profoundly meditated, observed and constructed image of human happiness; and, for all that it is a reverie, it is more robust than wistful. The modern spectator should be mindful of the Romantic nostalgia and sense of regret that has overlaid most accounts of this celebrated picture since the middle of the nineteenth century.

Arriving in Paris about 1702 from Valenciennes, near the Flemish border, Watteau worked first with Claude Gillot, a decorative painter, and about five years later moved to the workshop of Claude Audran, a leading designer of arabesque and other decorations. Under the influence of Audran he executed a number of (lost) commissions for decorations, some in the recently fashionable 'Chinese' style. Such cycles of decoration formed a large part of his early output, however, and although they are now known only through engravings, some slightly later panels

Fig. 121. JEAN-ANTOINE WATTEAU: *Pilgrimage on the Island of Cythera*. 1717. Oil on canvas, 127 × 192 cm. Musée du Louvre, Paris

Fig. 122. *Watteau and Monsieur de Jullienne (?)*. Engraving after Jean-Antoine Watteau by N. Tardieu, 1731. 41 × 33 cm.

Fig. 123. CLAUDE GILLOT: *The Quarrel of the Cabmen*. About 1707. Oil on canvas, 127 × 160 cm. Musée du Louvre, Paris

from the Hôtel Nointel have survived (Fig. 124). They are in the elegant arabesque manner of Audran, but already one senses a personal, humorous observation in the young man's courting dance. It was no doubt largely thanks to his training with Audran that Watteau achieved the fine decorative effect which he maintained throughout his career, and which made him one of the originators of the rococo style.

Gillot, who was also an easel painter and often worked as a designer for the stage, was especially fond of theatrical subjects, which he rendered in a fairly literal way. *The Quarrel of the Cabmen* (Fig. 123) is set on stage, before a backdrop, where two footmen argue at loggerheads over the right of way, urged on by their two passengers. The passengers are clearly male actors dressed as women: on the left Scaramouche, and on the right Harlequin, stock characters of the (Frenchified) Italian comedy of the day. The world of the theatre fascinated Watteau as much as it did his master, but the younger artist used it in a more inventive way. A number of Watteau's early works, including an *Isle of Cythera* of 1706 (private collection, Paris), can be directly related to known theatrical texts or productions, as can Gillot's *Cabmen*. A sense of theatre remained with French painters throughout the century and even formed a link between Watteau and the exemplary academic painter Charles-Antoine Coypel. Both artists, growing up in the shadow of Le Brun, were deeply concerned with expressing the passions; but perhaps it was partly Watteau's independence of the official academic training that enabled him to step imaginatively beyond the limits of Le Brun's codifications of expression, which Coypel could not, just as he was able to step outside the prosaic world of Gillot. The majority of his *fêtes galantes* are a personal pictorial theatre, where he disposes

actors as he pleases, often calling on his friends to play the parts and dressing them up in the costumes Caylus tells us he kept for this purpose. Thus the actual theatre was but a starting-point for a theatrical genre essentially invented from his own brain, playing on illusion and reality and setting his characters apart from the everyday world. Theatre enabled Watteau to transform life into art. But the world of his actors is real and absorbing to them; only when they turn to us, which they do rarely, is the spell broken by a bow or a declamatory gesture.

The vital source of Watteau's inspiration was nature, which he constantly and intensely observed and drew. His biographers are insistent on this study, and it may have had a profound, though not obvious, effect on later artists such as Fragonard and Chardin. It was nature both in the sense of landscape—as manifested in his numerous landscape drawings and the refined parks of his *fêtes galantes*—and in the sense of human nature, as revealed in his hundreds of figure-studies, which are different from those of most painters of his day. His paintings, it seems, were not totally worked out in advance and then in detail, which was normal academic practice; they often grew out of apparently casual drawings of single figures or groups, sometimes a vignette of a passing scene, sometimes more deliberately posed. It is his powers of observation and his gift for formulating his observations exactly that make the activities of Watteau's cast of characters so much more subtle, complex and intriguing than the accepted formulas of academic painters such as Coypel.

The painterly character of Watteau's work is also the result of an allegiance to a more natural approach to the art, reflected in his interest in Flemish painting—especially Rubens—and the Venetian masters. The circle he frequented during the second decade of the century—living for a time with the collector Pierre Crozat, on friendly terms with painters such as La Fosse, lodging later with Vleughels—consistently favoured the Venetian tradition of painterly colour over the emphasis on drawing promoted by official academic dogma.

One of the most puzzling, personal, yet quintessential *fêtes galantes* is the so-called *Fêtes Vénitiennes* (Col. Plate 10)—a later title, perhaps inspired by the oriental dress of the man on the left; when the picture was in the collection of Jean de Jullienne in the 1720s it was known simply as *Dance*. It is Watteau's friend Vleughels who wears the oriental dress, and the wan features of the musician playing bagpipes on the right have been convincingly identified as those of Watteau himself. While he gazes distractedly across at the dancing couple, the voluptuous carved nymph on the fountain seems to stir with interest at the sound of his music. Is the cloaked figure at the back indicating her presence, or is she—with her movement visible only to us—as unseen by the other characters as the nymphs in the celebrated *Pastoral Concert* by the young Titian in the Louvre, which in Watteau's day was attributed to Giorgione? What does Watteau's picture mean? Did it mean something specific to the artist and to his friend Vleughels, and perhaps to Jullienne? Is it about different phases, or types, of love? Or is it deliberately ambiguous, suggestive, poetic? Watteau's *fêtes galantes* do bring to mind the *poesie* of Giorgione and his followers in the early sixteenth century, and we should not attempt to read them in a literal or realist way. Watteau's own circle, as we have seen, was interested in this period of Venetian art, and Watteau, like Giorgione, worked for a small coterie of admirers and protectors, who in turn promoted a private and mysterious image of their artist; the works of the two painters present similar problems of interpretation to the modern spectator. Indeed, Watteau's meaning was already becoming obscure by the middle of his own

Fig. 124. JEAN-ANTOINE
WATTEAU: *The Cajoler*. 1707–8. Oil
on canvas, 79.5 × 39 cm. Private
collection

century, when even a well-informed critic like Caylus (who was judging by
conventional academic standards, however) could discern no subject or action in his
works.

The private character of Watteau's art is emphasized in the print of 1731 that
serves as frontispiece to the collected edition of engravings after his works,
published by the collector Jean de Jullienne (Fig. 122). The image is probably a
posthumous concoction from various autograph sources, and is a monument to the
friendship between artist and patron, who are shown together (if indeed the seated
cellist is Jullienne himself) in a typical Watteau park. Jullienne virtually made a
cult of Watteau's memory and ensured the dissemination of his imagery throughout
Europe in the three hundred or so engravings he commissioned after his works
during the 1720s and 1730s. With the exception of a few large canvases, Watteau
was *par excellence* a painter for the private collector. His works are made for close
scrutiny, with their exquisitely rendered details of faces and hands, the attention to
costume, the refined colouring of satins and shot silks. But although his *fêtes
galantes* do play an important part in the history of French decorative painting, and

Opposite:
10. JEAN-ANTOINE WATTEAU: *Fêtes
Vénitiennes*. About 1718. Oil on
canvas, 55.9 × 45.7 cm. National
Gallery of Scotland, Edinburgh

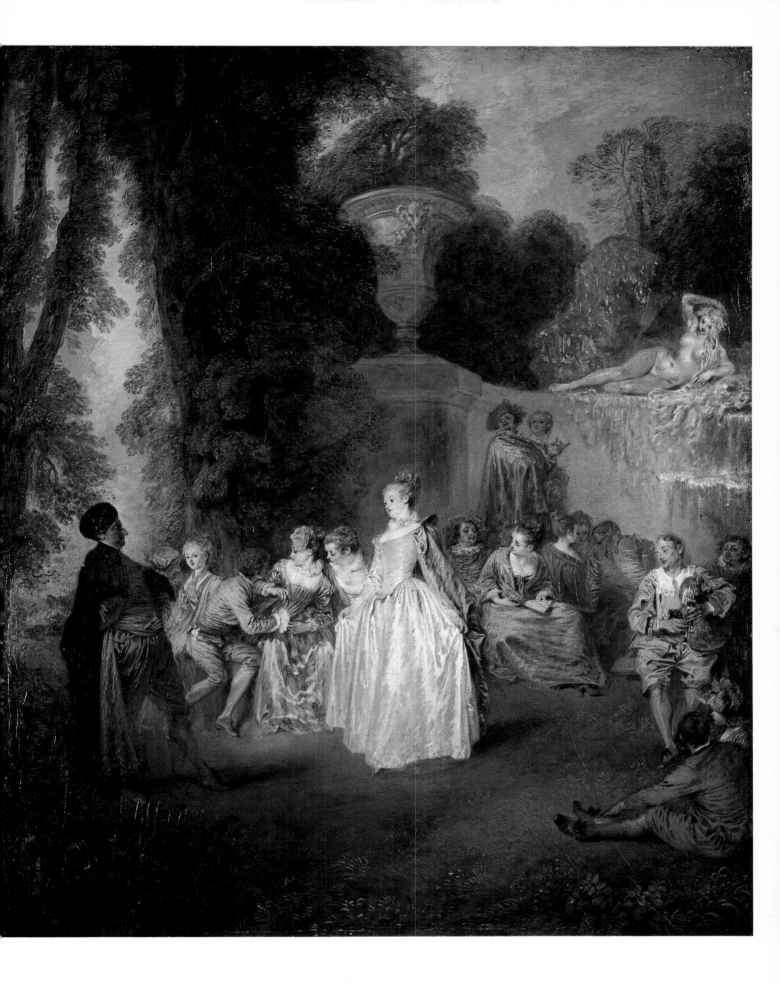

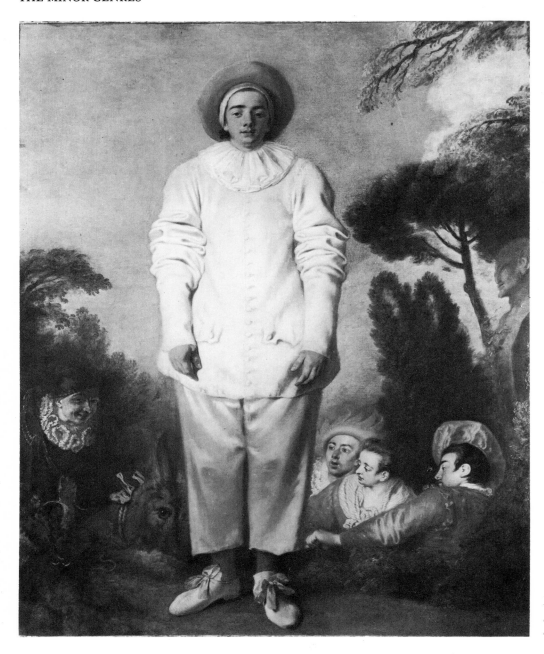

Fig. 125. JEAN-ANTOINE WATTEAU: *Gilles*. About 1719. Oil on canvas, 184.5 × 149.5 cm. Musée du Louvre, Paris

their style and subject-matter were widely known through Jullienne's promotion, we cannot agree with the Goncourt brothers that 'Watteau was the dominant master, to whose style, taste and vision the whole of eighteenth-century painting was in thrall'.

Of all Watteau's works, it was the *fêtes galantes* that found imitators. Some of the paintings executed in the last years of his short life (he died at the age of thirty-seven) indicate that his art was taking a new direction. The monumental rendering of *Gilles* (Fig. 125), ostensibly depicting a character from the Italian comedy, has yet to yield the secrets of its original destination and its original meaning. Absurd, awkward, yet moving, if Gilles did not appear so self-consciously overdressed it would be tempting to see this as the portrait of an actor, with four colleagues in the

background; some think it may once have formed a theatre sign-board. The very large scale and the direct presentation of the principal character are certainly exceptional in Watteau's work.

After his return from London in 1720 (it is not known whether *Gilles* dates from before or after this) Watteau lived with his friend Gersaint, a dealer in paintings and curiosities. For the entrance to his shop on the Pont Notre-Dame Watteau painted a large sign, which was originally divided in two down the centre and had an arched top to fit into the vaulted entrance. Inside the painting we step off the street into a rather grand, imaginary art-dealer's premises, where the customers on the right seem more preoccupied with love and gallantry than with purchasing works of art. A new departure for Watteau is the group on the left, which has all the casual appearance of a street-scene; a portrait of Louis XIV (the shop was called *Au Grand Monarque*) and a fine mirror are being packed with straw into a crate, and a passer-by pauses to watch. The painting did not remain as a sign for more than a few weeks, however, for it was purchased by a cousin of Jullienne, Claude Glucq, Conseiller au Parlement, whence it passed to Jullienne himself, from whom it was acquired by Frederick II of Prussia around the middle of the century. It seems that towards the end of his life Watteau was moving away from the genre of the *fête galante* to work on a more ambitious scale, and perhaps to confront the world around him more directly. Had he lived long enough to explore for himself the implications of this development, his work might have been of a different, and greater, consequence to the course of French painting in the eighteenth century.

Watteau's spell worked on many later painters. His immediate followers were lesser artists, who in their different ways attempted simply to imitate his style and his personal genre of the *fête galante*. However, later and more independent spirits—particularly Fragonard—assimilated the lessons of his art in a more intuitive and understanding way, and it was but a starting-point for their own. Watteau and Fragonard both cultivated their personal and artistic freedom; neither, for example, participated in official artistic life, and only exceptionally did either undertake an official commission. The nearest Fragonard came to doing so was in a cycle of four large decorative canvases, now known collectively as *The Progress of Love*, for the salon of Madame du Barry's house at Louveciennes (Figs. 127 and 128). Painted in 1771-3, these self-absorbed couples in idealized parks are unusually late descendants of Watteau's lovers, and in *The Surprise* (Fig. 127) the statue of Venus and Cupid is a direct tribute to the earlier painter's works, in which the goddess presides in many enchanted places, including Cythera itself. The two pairs of paintings add up to a not too serious allegory of the nature of love, showing the excitement of the pursuit (in *The Surprise* the lover appears just as his girl is reading his letter) and the mutual satisfaction of love and happiness attained (in *Love Letters*, Fig. 128, the couple read over their letters together). Perhaps on the advice of her architect, Claude-Nicolas Ledoux, Madame du Barry at the last minute rejected Fragonard's masterpieces for some much more fashionable, but to modern eyes dull, neoclassical works by Vien (Fig. 76). Although they too are on the theme of love, their classical trappings must have made them seem more like history painting than the oversized *fêtes galantes* of Fragonard. The stylistic contrast between the two sets of paintings is extreme, and it is a salutary warning to those who wish to interpret the eighteenth century as a linear stylistic progression to see that a carefree, painterly *brio* can be produced contemporaneously with a limpid and restrained classical manner. Fragonard had initially received a conventional academic training and produced a handful of history paintings on biblical and classical

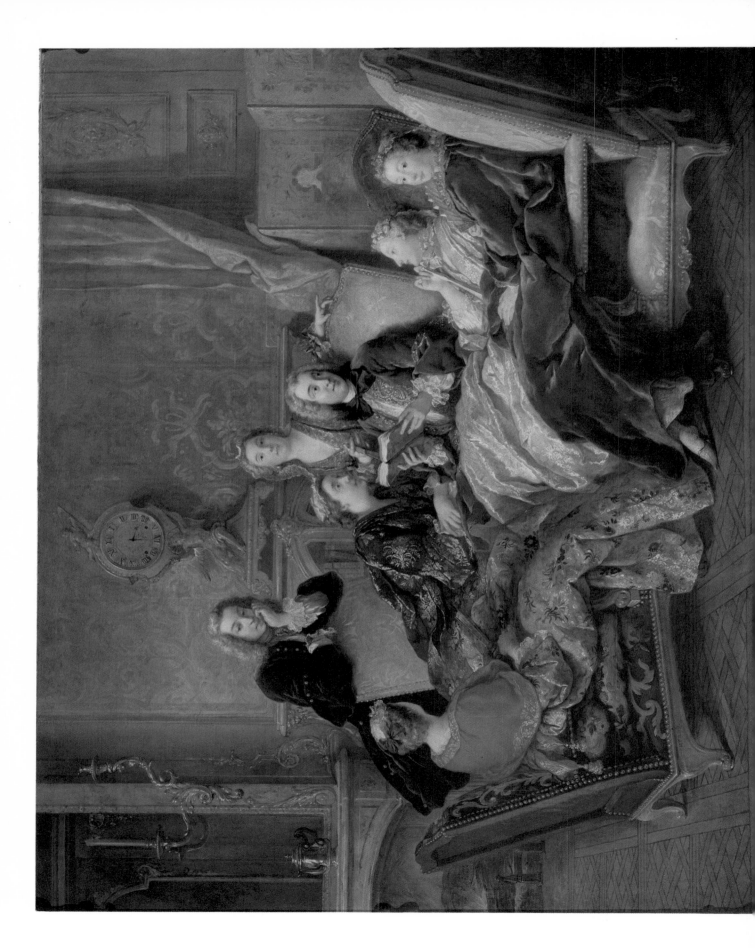

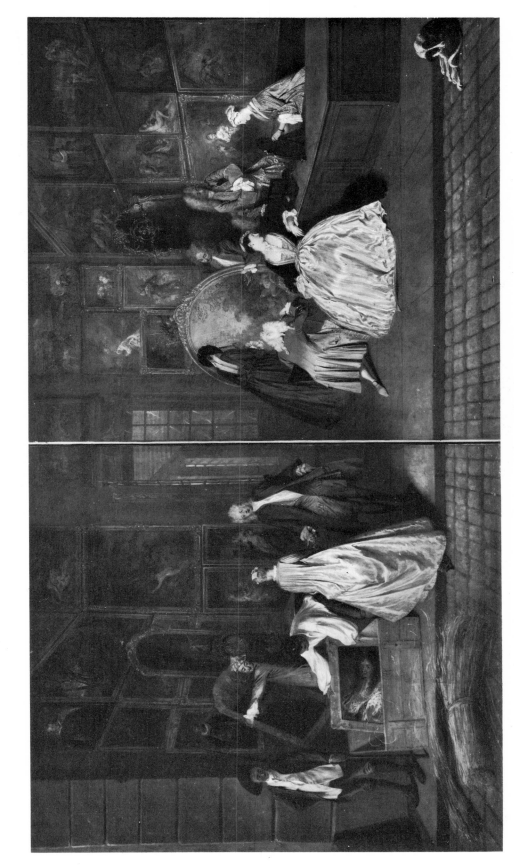

11. JEAN-FRANÇOIS DE TROY: *The Reading from Molière*. About 1728. Oil on canvas, 72.4 × 90.8 cm.
Collection of the Dowager Marchioness of Cholmondeley

Fig. 126. JEAN-ANTOINE WATTEAU: *Gersaint's Shopsign*. 1721. Oil on canvas, 182 × 307 cm.
Gemäldegalerie, Staatliche Museen, Berlin-Dahlem

themes. But like his principal teacher and example Boucher (with whom he shared an admiration for Watteau's free spirit), he excelled in decorative mythologies, genre and landscape, and in the original *figures de fantaisie* discussed in the preceding chapter.

Watteau had several pupils who traded on his reputation as a painter of *fêtes galantes*, such as Bonaventure de Bar, Octavien, and, especially, Jean-Baptiste Pater. Pater, who was received into the Académie in 1728 as a *'peintre de sujets modernes'*, was a prolific and repetitive artist, but famous in his day—Frederick II of Prussia had a very large collection of his works. Occasionally he made an interesting variation on the theme of the *fête galante*, such as the unusually large *Fair at Bezons* (Fig. 130) of about 1733. The subject was a popular autumn fair outside Paris, which Pater (like a number of his contemporaries) has used in a composition of sweeping movements reminiscent of Rubens' *Kermesse* (Louvre). It is a gathering of various types and amorous encounters from Watteau's works, displaying more knowledge than understanding of his art; but the design is impressive and sustained, and Pater's rather hard, artificial colour does have a personal poetry.

Nicolas Lancret was as much a rival as a follower of Watteau, and had also worked for a time in the studio of Gillot. He is a more independent artistic personality than Pater, attempting a greater range of subjects, including history paintings and portraiture—notably of actors and dancers; working with Gillot had stimulated his interest in the stage. *The Swing* (Fig. 129) is one of his variations on a

Above, left:
Fig. 127. JEAN-HONORÉ FRAGONARD: *The Surprise*. 1770–2. Oil on canvas, 318 × 224 cm. Frick Collection, New York

Above, right:
Fig. 128. JEAN-HONORÉ FRAGONARD: *Love Letters*. 1770–2. Oil on canvas, 318 × 215 cm. Frick Collection, New York

Fig. 129. NICOLAS LANCRET: *The Swing*. About 1730. Oil on canvas, 37 × 47 cm. Nationalmuseum, Stockholm

Fig. 130. JEAN-BAPTISTE PATER: *The Fair at Bezons*. About 1733. Oil on canvas, 106.7 × 142.2 cm. The Metropolitan Museum of Art, New York (Jules S. Bache Collection, 1949)

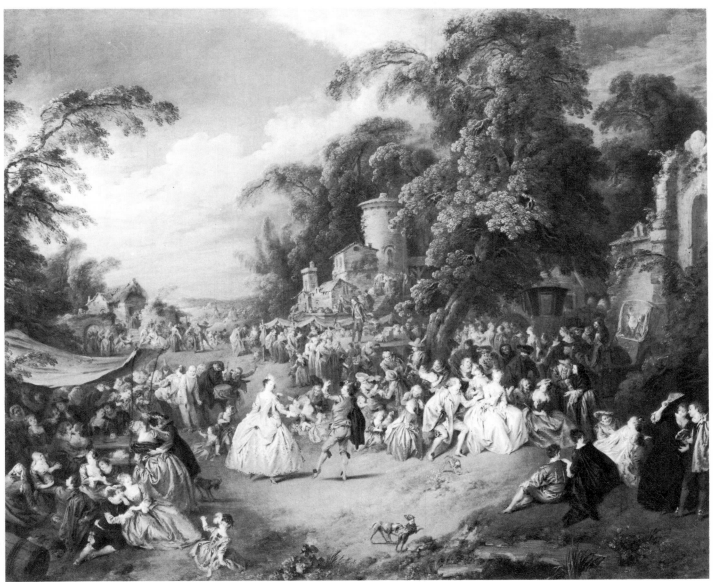

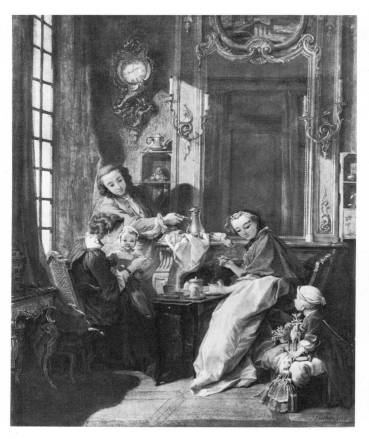

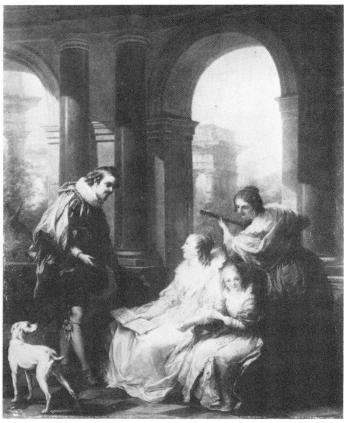

Watteau theme; the motif appears in decorative panels by Watteau, and became one of the favourites of rococo painting (Col. Plate 15). While Lancret's *Swing* and similar light-hearted subjects were executed as cabinet pictures, he also produced such works as part of larger decorative schemes in the manner of Watteau, for example in the salon of the Hôtel de Boullogne (Fig. 16), already mentioned in Chapter One. The delicate rhythms of Lancret's paintings form the perfect accompaniment to the carved surrounds of the panelling in such early rococo interiors.

The suggestion of the erotic and the gallant that we find to varying degrees in the work of Watteau and his imitators was rendered more prosaic in the 1720s by Jean-François de Troy, who made a number of cabinet pictures transposing the costume and setting of the *fête galante* into everyday dress and opulent bourgeois households. There is only a hint of such amatory goings-on in his *Reading from Molière* (Col. Plate 11), but enough knowing glances are exchanged. If de Troy lacks the poetic ambiguity of Watteau we can still enjoy his powers of imitation in his fabrics and furnishings, and his vivid documentation of a certain way of life and the setting in which it was lived. Boucher's *Le Déjeuner* (Fig. 131) of a decade later has much the same appeal, showing us a fashionable bourgeois interior with its asymmetrical candelabra and clock, its rococo furniture, the Chinese magot on the shelf, and the delightful women and children who are served with hot chocolate. This type of conversation piece was also very popular in exotic guise, with Turkish or Far-Eastern settings—or with a taste of chivalric Spain, as in the *Conversation Espagnole* that Carle Van Loo painted for Madame Geoffrin in 1754 (Fig. 132). The

Above, left:
Fig. 131. FRANÇOIS BOUCHER: *Le Déjeuner*. 1739. Oil on canvas, 81.5 × 65.5 cm. Musée du Louvre, Paris

Above, right:
Fig. 132. CARLE VAN LOO: *Spanish Conversation Piece*. 1754. Oil on canvas, 164 × 129 cm. Hermitage, Leningrad

fascination with the Near and Far East was connected with the rapid expansion of European trade during the eighteenth century, but this had a more direct effect on the decorative arts than on painting. The relatively more primitive European societies, such as Spain or peasant Russia, also held a fascination; but in painting, such exotic settings were pretexts for costume, fantasy, and escape, like the world of the *fête galante*, rather than reflections of any serious interest in other cultures.

The exotic settings and animals in the suite of decorative paintings made in 1739 for the Petits Appartements of the King at Versailles give additional interest and excitement to these variations on the theme of the chase. In Boucher's *Crocodile Hunt* (with its Carracci-like nudes!) and Van Loo's *Ostrich Hunt* (Figs. 133 and 134) not only the splendid animals, but also turbans, palm-trees, leopard-skins and a pyramid contribute to the exotic effect of otherwise brutally rendered scenes. An altogether more peaceful effect is conveyed by Van Loo's *Rest during the Hunt* (Fig. 135; pendant to *Resting Grenadiers* by Charles Parrocel, also in the Louvre), which was made for the King's dining-room in the Petits Appartements at Fontainebleau. The sweeping concave and serpentine movements of the composition, and its light, silvery tones—not to speak of its subject-matter—must have looked far more at home in the gilt and white panelling of Louis XV's dining-room than they do today, baldly presented alongside altarpieces and cabinet pictures for the scrutiny of the milling tourists in the Grande Galerie of the Louvre! Apart from the appropriateness of the subject as a backdrop to real dining, it also reflects the King's

Below, left:
Fig. 133. FRANÇOIS BOUCHER: *The Crocodile Hunt*. 1739. Oil on canvas, 181 × 128 cm. Musée de Picardie, Amiens

Below, right:
Fig. 134. CARLE VAN LOO: *The Ostrich Hunt*. 1738. Oil on canvas, 184 × 128 cm. Musée de Picardie, Amiens

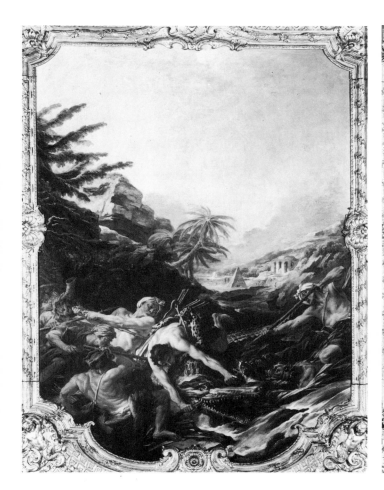

Fig. 135. CARLE VAN LOO: *Rest during the Hunt*. 1737. Oil on canvas, 220 × 250 cm. Musée du Louvre, Paris

passion for the hunt, as do the more exotic hunts of Boucher, Van Loo, and others, commissioned for Versailles.

The 'sport of kings' was celebrated in one of the major cycles of paintings made for Louis XV, the *Chasses Royales*, executed by Jean-Baptiste Oudry between 1733 and 1746. These were cartoons for tapestries to be woven at the Beauvais works, where Oudry had been nominated official painter in 1726, and where he also oversaw the execution of his own designs. There is evidence that he had conceived the idea of the *Chasses Royales* by 1728, with the view that they might play an important part in reviving the production and reputation of the Beauvais works under his guidance. There are nine subjects in all, five of which are very large scenes showing Louis XV and his entourage at different stages of hunting stags in the royal parks. One of the most monumental designs has a *Stag at Bay* in the rocks of Franchard at Fontainebleau (Fig. 136). Oudry had followed such hunts to take the necessary details, but of course the final paintings adopt a somewhat idealized view of events in order to show the huntsmen and their quarry to full advantage. The views of the royal estates are topographical, and taken from a slightly elevated viewpoint. In spite of such restrictions the paintings are brilliantly organized, and successfully combine a residue of the formality and stylization of traditional tapestry-design with a strong sense of observation that is a part of the new, more naturalistic and informal aesthetic of Oudry and his contemporaries. There was a tradition of hunting imagery stretching back to the Middle Ages, showing rulers in

their exclusive domains; Oudry's *Chasses Royales* were designed to replace sixteenth-century cartoons by Barent van Orley, which were still serving as models in the eighteenth century. Another way in which Oudry wished to renew tapestry, both at Beauvais and at the Gobelins, was by insisting that the weavers should abandon their old conventions for translating colours and imitate more closely the subtle modulations of painting. The *Chasses Royales* could be classified among the major landscape paintings of the century; but to Oudry and some contemporary critics this combination of landscape, portraiture and animal painting, brought together by the dramatic narratives of the hunt, added up to history painting. The series was sometimes referred to as *L'Histoire de Louis XV*, perhaps drawing a parallel with the *Histoire de Louis XIV* by Le Brun and his school at Versailles. Of course, Oudry's paintings are not as strictly 'historical' as those of the seventeenth century, but nevertheless, like Vernet's *Ports of France* (discussed in Chapter Six), they serve to illustrate how far the traditional classification of the genres was brought into question in the middle decades of the century, before the old academic values were resurrected in the neoclassical period. And what would a neoclassical critic have made of the sporting Louis XV's *Stag at Bay* in juxtaposition with Louis XIV's *Conquest of Franche-Comté* at Versailles, celebrating one of the Sun King's military victories?

The majority of Oudry's works are on a smaller scale than the *Chasses Royales* and are devoted to still life with game or the encounters of hunting-dogs and their quarry, or are set pieces suggesting the return from the hunt. Masterpieces of this last type are *The Dead Wolf* (Fig. 137) and *The Dead Roe* of 1721. These combine still life, living animals, plants and architecture in a landscape setting; they are not of course meant to be taken literally, but are ideal assemblages arranged in the most decorative possible combinations, and were probably destined for a particular

Fig. 136. JEAN-BAPTISTE OUDRY: *A Stag at Bay*. 1738. Oil on canvas, 357 × 661 cm. Musée National du Château de Fontainebleau

Fig. 137. JEAN-BAPTISTE OUDRY:
The Dead Wolf. 1721. Oil on canvas,
196.4 × 261.4 cm. Wallace
Collection, London

achitectural setting. In addition to their highly attractive combinations of texture
and colour, Oudry's pictures are arranged with all the grace and invention of the
contemporary rococo pictures of Lajoue (Fig. 150), Lancret, the young de Troy,
Boucher, or Natoire (Fig. 17). In *The Dead Wolf*, where we can just about imagine
the hunters off-stage preparing to enjoy the light meal left out for them on the
strange console, the design is dominated by the oblique position of this
architectural motif. The eye is led into the picture by the two dogs and the slant of
the gun, while the large shape of the architecture, and the smaller ones of dogs,
fruit, stone scrolls, and so on, have curling and curving rhythms. The colours are
the pale ones of rococo art, as opposed to the denser and more natural colours of
Alexandre-François Desportes (Fig. 138).

Desportes was Oudry's principal predecessor (their careers overlapped for a time)
in painting still life and the hunt, which he did in an official capacity for Louis
XIV. He was an exact observer and made large numbers of oil studies of birds,
animals and plants from the life, and also remarkably fresh and spontaneous
landscapes (Col. Plate 14). The realism of his art is recorded as having greatly
impressed Louis XIV, and he is always more sober and less studiedly decorative
than Oudry. Like his master Bernaert, Desportes belongs to a tradition of Flemish

Fig. 138. ALEXANDRE-
FRANÇOIS DESPORTES:
Still Life with a Peacock.
1717. Oil on canvas,
124 × 231 cm. Musée
de Peinture et de
Sculpture, Grenoble

realism going back to Frans Snyders, whereas Oudry had as a starting-point the
sumptuous decorative effects taught him by Largillière. Desportes's *Still Life with a
Peacock* of 1717 (Fig. 138) is a good deal more straightforward in presentation than
Oudry's *Dead Wolf*: the balustrade defines the shallow main pictorial space,
suggesting the classicism of the seventeenth century; the eye works across the
picture, rather than into it as in Oudry's work; the light travels evenly to describe
textures and surfaces, whereas Oudry's light always plays a more decorative role in
itself, varying the emphasis of different parts of the picture. The painting by
Desportes was made for the Château de la Muette, a hunting-lodge in the Bois de
Boulogne that belonged to the Duchesse de Berry, daughter of the regent. We do
not know the original destination of Oudry's *Dead Wolf*, though his works for Louis
XV, his most important patron, are well documented. He also worked for a number
of private patrons and, like many of his peers, for foreign collectors, to whom Paris
in the eighteenth century became an artistic centre to compare with Rome. Oudry's
most passionate foreign devotee was the Duke of Mecklenburg-Schwerin, who
admired the realistic (as opposed to the rococo) aspects of his paintings, which he
displayed beside Dutch and Flemish seventeenth-century masters; the museum at
Schwerin still houses the best single collection of works by Oudry.

Fig. 139. JEAN-BAPTISTE-
SIMÉON CHARDIN: *The Skate*.
Before 1728. Oil on canvas,
114.5 × 146 cm. Musée du
Louvre, Paris

The hierarchies of academic theory did not of course fundamentally affect the
market demand for pictures in eighteenth-century France. Although an artist such
as Chardin would have liked to be a history painter (a desire which his son, who
died tragically, also failed to fulfil), he had no difficulty in earning a handsome
living and finding satisfaction in the lowest-ranking of the genres. His artistic
origins are obscure, but his aspiration to the *grand genre* must have been encouraged
by his early master, the history painter Pierre-Jacques Cazès. However, by talent or
temperament, Chardin was not given to imaginative painting but to working from
observation, and with quite a slow and laborious technique. This may be why he
turned early to still life. Moreover, lacking the facility of Desportes and Oudry, he
never shows animals in movement or action; his world is a quiet and static one. No
doubt he also realized that he would need to develop a different branch of the genre
from his two rivals, and hence concentrated on dead game, fruit, and the kitchen
table.

After initially belonging to the Académie de Saint-Luc and exhibiting at the
Exposition de la Jeunesse, Chardin was received into the Académie in 1728, under
the sponsorship of Largillière, as a 'painter of animals and fruit', presenting *The
Skate* (Fig. 139) as one of his two *morceaux de réception* (although it had been painted a
year or two earlier). It is his most arresting and dramatic work, displaying the pink
and red entrails of the silvery-white skate, which seems to grimace at the spectator.
The young cat arching its back echoes our *frisson* at the gory sight. It is as if this
work were assembled from smaller still lifes—fish, oysters and spring onions to the
left, table-cloth, pots and utensils to the right. These form a range of contrasting

textures in a veritable display of painterly skill, designed to impress the spectator for its own sake. *The Buffet* (Louvre), its pendant, a work rather in the manner of Desportes but with more characteristic impasto, includes glass, pewter and fruit, with the wary encounter of a dog and a parrot for dramatic incident.

In the early 1730s Chardin received his first commissions for large decorative paintings (a type of work to which he returned throughout his life), including some still lifes with attributes of the visual arts and music, executed for the royal châteaux of Bellevue and Choisy during the 1760s (Louvre and private collections). Chardin is still best known for his smaller cabinet pictures, in which he explored, in many variations, the different parts of his *morceaux de réception*. Their subjects can be broadly grouped as dead game, the kitchen table (copper and ceramic pots, fish, meat, vegetables, eggs), and the dessert table (fruits, wine, porcelain, glass, silver, and pewter). Over some forty years subtle modifications of style and facture can be observed, and his designs move from the clearly-lit simplicity of presentation and bold impasto of *The Tobacco Box* (Col. Plate 12; probably late 1730s) to the muted chiaroscuro effects of the *Jar of Olives* (Fig. 140; 1760). *The Tobacco Box* is a relatively refined and 'above-stairs' subject, but it demonstrates to perfection Chardin's superb use of impasto in this period; the brushwork seems to assume the

Fig. 140. JEAN-BAPTISTE-SIMÉON CHARDIN: *Still Life with a Jar of Olives*. 1760. Oil on canvas, 71 × 98 cm. Musée du Louvre, Paris

Fig. 141. JEAN-BAPTISTE-SIMÉON CHARDIN: *La Fontaine*. 1733. Oil on canvas, 38 × 43 cm. Nationalmuseum, Stockholm

very textures of the surfaces he wishes to represent. There is a profound order and harmony in the disposition of these simple artefacts—every part of the whole securely jointed into place, as the carpentry of his father must have been—giving a reassuring sense of things being in their place in the world, even of moral certitude, analogous to that expressed in the classicism of Poussin.

Although Chardin continued to produce such direct and simple designs until the end of his life, he also made more complex assemblies, with more variety of objects, colour, and light, and consequently of brushwork. The glow of dense colour and the different shines and sheens of the *Jar of Olives*—reading from the pâté turned out on the board to the wineglasses, the fruit, the jar of olives, the porcelain tureen—are rendered with a range of varied brushwork and subtle glazes that make *The Tobacco Box* seem coarse for a moment by comparison. An important development, too, is in the use of light, for the later painting has a deep and mysterious chiaroscuro, out of whose gathered darkness the glistening, full, affirmative surfaces are conjured by the magic of Chardin's touch. The poetry of his art, the magic (Diderot's word) of his technique, and his powers of imitation were almost unanimously admired by critics and collectors in his day, and his works were to be found in most of the great cabinets. Only one or two commentators with 'elevated' taste, such as Mariette, disparaged his devotion to such lowly genres and found his manner of painting and his attachment to nature laboured. Mariette's view (1749) anticipated those of neoclassical critics, and after Chardin's death in 1779 his reputation fell quickly.

But he was 'rediscovered' in the mid nineteenth century, both for the direct and earthy realism of his still life and for the charming and reassuring view of life before the Revolution that is presented by his genre pictures.

In the early 1730s Chardin turned to figure painting, probably initially in response to an amicable taunt from the portrait painter Aved, that to paint a figure was much more demanding and worthy of reward than to paint a still life. Perhaps the remark especially piqued the thwarted history painter in Chardin, for he turned his hand at least to the lowly type of figure-work, genre painting. As with his still lifes, he drew his genre subjects from a world that he knew well and could observe with quiet patience: he expanded his still life to incorporate the immediately surrounding world of human activity. Cochin, who later engraved *La Fontaine* (Fig.

Fig. 142. JEAN-BAPTISTE-SIMÉON CHARDIN: *Morning Toilet*. 1741. Oil on canvas, 49 × 39 cm. Nationalmuseum, Stockholm

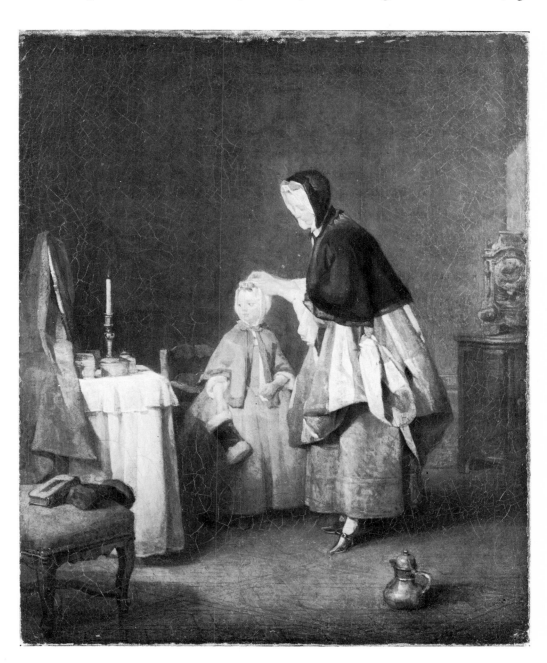

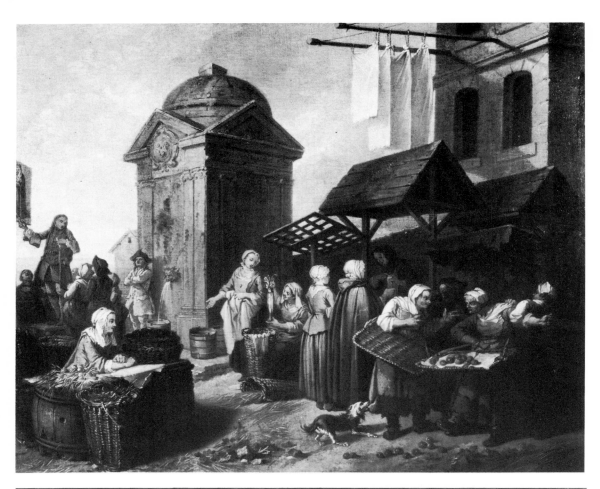

Fig. 143. ETIENNE
JEAURAT: *La Place
Maubert*. About 1753.
Oil on canvas,
52 × 63 cm. Private
collection, England

Fig. 144. ETIENNE
AUBRY: *Paternal Love*.
About 1775.
Oil on canvas,
78.7 × 101.6 cm. The
Barber Institute of Fine
Arts, University of
Birmingham

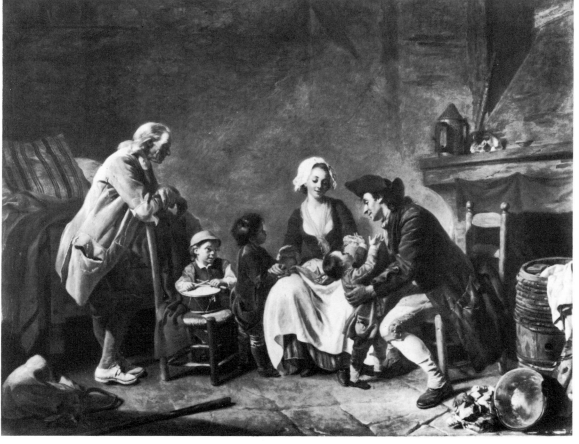

141; 1733), claimed that this was the painting made after Aved's gibe; certainly, of Chardin's genre pieces it is the one most directly related to his still lifes, and the copper urn and all the other items on the left of the picture can be found in his still-life works of these years. The familiar rich impasto is carried over into the homespun workaday garments of the woman drawing water—a solid figure, with carefully articulated hands, but whose face is deliberately hidden, probably owing to Chardin's difficulty in dealing with expression. He gives further spatial and narrative interest by opening a door at the right, where we catch a glimpse of another woman and a child.

Chardin's move into figure painting met with a favourable response at the Salon of 1737, where *La Fontaine* was shown with seven other genre works. Developing into the 1740s, his manner of painting figures became more and more refined, as did their surroundings. From the down-to-earth world of the kitchen, he now takes us into the living-quarters of a genteel bourgeoisie. In contrast to the stolid labour of the maid in *La Fontaine*, a new psychological acuteness enters into *The Morning Toilet* (Fig. 142; 1741) in the piquant gesture of a young girl's first coquettish glance into the mirror. The delicate moment is expressed in the whole refined movement of the picture, rising and falling with perfect interval, a gentle light muting its exquisite colouring of gold, red, pink, blue, black, and cream. The subtle constructions and balance of Chardin's figures and his new ability to capture a psychological moment may be partly due to the fact that by the early 1740s he had made a number of large-scale half-length figures, including portraits (Fig. 116).

Invention did not come easily to Chardin, and his matchless designs were the

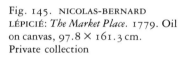

Fig. 145. NICOLAS-BERNARD LÉPICIÉ: *The Market Place.* 1779. Oil on canvas, 97.8 × 161.3 cm. Private collection

outcome of a hard struggle with himself; in order to extract the maximum results from his labours he made replicas of his hard-won successes. By the late 1740s his figure compositions were becoming weak in design, for he had exhausted his inventiveness in that genre after twenty years. At the Salons of the 1750s he simply showed repetitions of his earlier works. Moreover, from 1755 onwards the rising star of Greuze, with his more consciously dramatic manner, must have made Chardin's static world look staid and uninteresting, and perhaps discouraged him from continuing with figure painting. While Greuze was trying to raise lowly genre painting to the more elevated status of history, and even made a vain bid for recognition as a history painter proper, Chardin seems to have been happily enough resigned to his low standing in the academic hierarchy; yet he still enjoyed a life actively committed to the institution of the Académie, for example in his function as *tapissier* of the Salons.

Chardin's genre painting was serious and 'elevated' in its own way—in contrast, for example, to the rather raucous art of Etienne Jeaurat. One of Jeaurat's specialities was the depiction of Parisian street-life. His street-scenes are quite theatrical in presentation, and his *Place Maubert* (Fig. 143) is strongly reminiscent of Hogarth's street-scenes, such as *The Four Times of Day* (engraved in 1738; Hogarth's work was well-known in Paris), though much less richly crowded with incident, detail and comment. In *La Place Maubert* two market women argue over some upset goods; but we are given a rather rudimentary picture of the locality, which suggests that this scene, like Gillot's *Quarrel of the Cabmen* (Fig. 123), may be based more on the stage than on observation in the street. Diderot once called Jeaurat 'the Vadé of painting', a reference to Jean-Joseph Vadé (1720–57), who wrote coarse comedies incorporating the jargon of the streets; the painter Jeaurat and the writer Vadé belonged to the same intellectual circle, which cultivated a somewhat academic interest in popular language and slang. In 1757 Jeaurat sent to the Salon a painting inspired by Vadé's *La Pipe cassée*, a burlesque poem.

In the 1760s Greuze invented his own dramas as a means of defying traditional hierarchy, and cast his characters in a personal pictorial theatre. The narrative and sentimental aspects of Greuze's moral exemplars in modern dress were enormously influential during the 1770s and early 1780s. Among his many imitators was Etienne Aubry. Aubry always presents such scenes as his *Paternal Love* (Fig. 144) with a more dignified naturalism and less declamation than Greuze, but their works (cf. *The Well-Beloved Mother*, Fig. 115) are ideologically similar. Each of these is a didactic picture advancing an ideal of family life. In Aubry's version a much loved father tenderly lifts his little child, watched with approval by his own doting parents on the left. This painting belonged to d'Angiviller and reflects his moralizing taste.

The Market Place (Fig. 145) was painted by Nicolas-Bernard Lépicié in the same year as Aubry's *Paternal Love*. As we have seen in Chapter One, it was a didactic picture; it demonstrates that a sense of moral earnestness can be found in all the genres during the 1770s and was not the prerogative of academic history painters. It is significant that Lépicié had embarked on a career as a history painter but in the mid-1770s opted for portrait and genre painting because they were more lucrative. His *Market Place* is an idealized view of Les Halles in Paris—the fountain would have been recognized by contemporaries, as would the astrological column of the Halle au Blé. The picture is very different from Jeaurat's coarse market scene (Fig. 143), painted some twenty-five years before. Jeaurat himself, incidentally, had turned to a more Greuzian, moralizing art by the 1770s.

12. JEAN-BAPTISTE-SIMÉON CHARDIN: *The Tobacco Box*. About 1737. Oil on canvas, 32.5 × 42 cm.
Musée du Louvre, Paris

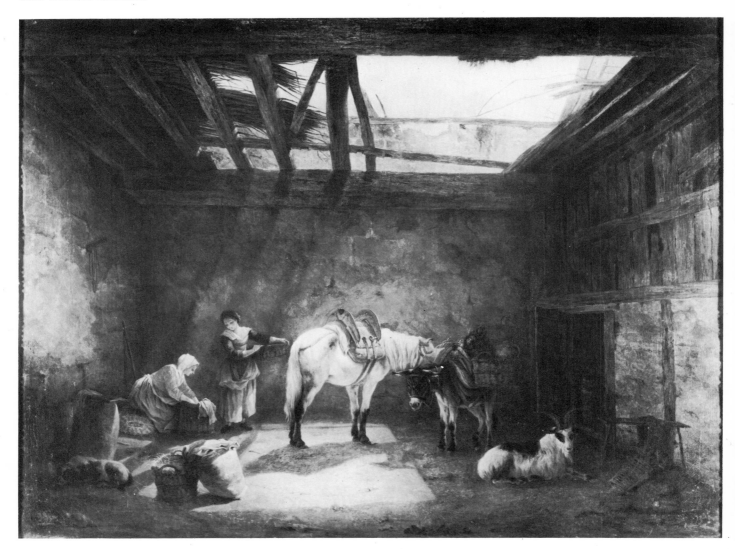

Fig. 146. JEAN-FRANÇOIS LEGILLON: *A Ruined Barn*. 1789. Oil on canvas, 52.5 × 69 cm. Musée du Louvre, Paris

While this move towards greater seriousness of purpose was a general trend in painting, it did not mean that there was no market for works of far fewer pretensions—quite the opposite was the case. In spite of official efforts to encourage history painting, the artists, as always, painted what they could sell. Jean-François Legillon's *Ruined Barn* (Fig. 146) is as much a typical work of the Salon of 1789 as Regnault's *Descent from the Cross* (Fig. 54) or David's *Brutus* (Fig. 86). From the mid eighteenth century until well into the nineteenth there was a continuing demand for small-scale genre pictures in the Dutch and Flemish manner, for portraits, and for landscapes.

6 LANDSCAPE

In an art dominated by academic hierarchy a respectable living could only rarely be made by French landscape painters. The most common function of landscape painting in the late seventeenth and early eighteenth centuries was a decorative one, with a group of paintings forming an integral part of an interior. Normally they would be set above doors, windows, or chimney-pieces, and there were a few schemes with landscapes as large mural decorations. Numerous artists are recorded as having produced such decorations for the royal palaces and other destinations, but relatively few of their works survive. The combination of the fact that landscape was in any case regarded as a lowly genre and that it was used decoratively in architectural contexts made the paintings especially vulnerable. They might easily be replaced by changing fashion and, more readily than figure paintings, suffer through subsequent neglect. For the art historian it can be difficult to trace the provenance of such landscapes because, being fixtures, they were not usually included in inventories of collections or listed in testaments, and their description is rarely precise. Thus many landscape painters are little more than names to us (such as Cossiau, Focus, or Forest), passed on only by records of their activities in commissions and accounts.

Etienne Allegrain's *Landscape with a River* (Fig. 147) was made in 1700, together with a pendant, for one of the summer apartments of the Ménagerie at Versailles. The scene is clearly constructed, with rocks, trees and architecture around the open space of a winding river; there are fishermen in boats, washerwomen, and the traditional pastoral staffage of cattle. The eye is led into space by the curve of the river, the repeated shapes of the trees, the diagonals of paths, and the softening of aerial perspective into the background. This type of rational and structured landscape is based on the heroic, ideal landscapes produced by Poussin in the mid seventeenth century; but a general peacefulness replaces the highly charged moral and didactic intention of Poussin's *paysages historiques*. While Poussin's landscapes were intended to be closely studied and 'read' for their philosopical content, the ideal landscapes of Allegrain and other painters in the late seventeenth and early eighteenth centuries, such as Allegrain's son Gabriel (1679–1748) or Francisque Millet (1666–1723), were not designed to sustain close attention. These painters adapted aspects of Poussin's art for their own decorative purposes, but they did not wish to imitate the personal complexity of his meaning.

This period of French landscape painting awaits further study. We do know, however, that a variety of styles were current, often in eclectic combinations, so that we cannot speak of any one stylistic trend. Etienne Allegrain's son Gabriel

Fig. 147. ETIENNE ALLEGRAIN:
Landscape with a River. 1700. Oil on
canvas, 86 × 136 cm. Musée du
Louvre, Paris

Opposite, above:
13. FRANÇOIS BOUCHER: *Landscape
with Temple and Watermill.* 1743.
Oil on canvas, 90.8 × 118 cm. The
Bowes Museum, Barnard Castle,
Co. Durham

Opposite, below:
14. ALEXANDRE-FRANÇOIS
DESPORTES: *Landscape.* About 1700.
Oil on paper, laid down,
25 × 53 cm. Musée National du
Palais de Compiègne

worked in a more fussy and picturesque manner than his father, which is a mixture of Italianate and a more Flemish style. His colour is warmer and more autumnal in tone, often Rubensian, and more loosely brushed (as can be seen in a pair of paintings in the Musée des Beaux-Arts in Dijon). We find a similar freely brushed Venetian-cum-Flemish use of colour in the landscape backgrounds of Largillière's contemporary portraits. As for many artists, for Largillière landscape was but one genre among others, and a small cabinet picture of a wooded landscape (Fig. 148) is the only known work by him in this genre. The bold contrasts of light and shade, the picturesquely blasted trees, and the dominant russet and gold colouring may derive from the landscapes of his father-in-law Jean Forest (1635–1712), but also bear comparison with the landscape backgrounds of Watteau in these years.

In addition to Poussin and Rubens, Claude Lorrain was another source for painters in this period, who knew best his early landscapes and seaports. Pierre-Antoine Patel the Younger (1648–1707) admired especially his treatment of light and aerial perspective and his precise rendering of foreground foliage, plants, and grasses. Claude's atmospheric seaports lie behind the *Imaginary Seaport* of Michel Boyer (Fig. 149), with its impressive architecture and golden light. This picture was originally oval and would have served as decoration set into the panelling of a room. Though as a painter of cabinet pictures Boyer collaborated with other artists, such as Watteau, who would paint the figures, he was best known for his architectural caprices, which were extensively commissioned for the royal palaces.

Architectural painting—showing seaports, grand columned buildings, or ruins—was effectively a sub-genre of its own, and a very popular type of decorative painting throughout the century. It was closely allied to stage-design and scene-painting; the Italian-born Jean-Nicolas Servandoni (1695–1766), best known in his day as a stage-designer, also painted architectural caprices and was an architect in his own right. Jacques de Lajoue was received into the Académie in 1721 as a *peintre d'architecture*, in which genre he gave free rein to his fancy in complex ornamental designs that are typical manifestations of the rococo style. He too was a stage-designer, and there is something theatrical about his *Landscape with a Damaged Statue of Neptune* (Fig. 150), a luridly lit fantasy of trees and architecture set at the fringe of some long-neglected park. Later in the century, in 1766, Hubert Robert was also received into the Académie as a *peintre d'architecture*, with a more sober painting not so very different from Boyer's *Imaginary Seaport*, though perhaps more convincing architecturally—a fantasy on the *Port of Ripetta* (Ecole des Beaux-Arts, Paris). When Robert painted his monumental rendering of *The Temple of Diana at Nîmes* (Fig. 160) in 1787—one of a set of four paintings showing the major antiquities of Provence—he was simply adapting the well-tried architectural genre of decoration to more 'serious' and archaeologically-minded neoclassical taste. It is easy for today's visitor to the Louvre to be unaware of the fact that these grand works were commissioned to decorate a salon at Fontainebleau, and our loss that we but rarely see such decorative schemes complete. We have noted in Chapter One, for example, how Vernet's *Four Times of Day* (which include seaports in the decorative tradition of Boyer), still *in situ* at Versailles, were put in place with some care by the artist himself.

Returning to the generation of landscape painters active at the beginning of the

Fig. 148. NICOLAS DE LARGILLIÈRE: *Wooded Landscape*. About 1700–10. Oil on canvas, 36 × 64 cm. Musée du Louvre, Paris

century, Pierre Domenchin de Chavannes (1673–1744) derived his own early landscape style from the example of Claude. His *Landscape with a Rock Arch* (Fig. 151) is inspired by the early pastoral landscapes of the seventeenth-century master, several of which were in French collections. He explores the slanting fall of delicate light on trees and in the soft, atmospheric distance, to which our eye is also led by the gently winding path. The picture is one of four commissioned in 1709 for Trianon-sous-Bois at Versailles. Domenchin de Chavannes was the leading decorative landscape painter of his day, and his attractive and undemanding vision had some influence on Boucher. He continued to work for the Crown, and his later works (such as the two pendants of 1737 still at Fontainebleau) become more fantastic in conception, bolder in brushwork and colour, and more swaying in rhythm.

Fig. 149. MICHEL BOYER: *Imaginary Seaport: Sunset.* About 1710–20. Oil on canvas, 120 × 150 cm. Musée de Varzy

Fig. 150. JACQUES DE LAJOUE: *Landscape with a Damaged Statue of Neptune*. About 1746. Oil on canvas, 81.5 × 101.5 cm. Musée du Louvre, Paris

Whether landscape painters wished to express some conceptual ideal or adapted their manner to provide very superior forms of interior decoration, the study of nature at first hand was by no means excluded. For all the artifice and sophistication of Watteau's paintings, for all his passionate concern with human character, he also made some of the most unaffected, direct, and carefully observed drawings from nature of the century. It is indicative of the mid-century reaction against rococo grace that Watteau's academic biographer, the Comte de Caylus, especially admired his exemplary study of nature, while (from a purely academic point of view) remaining somewhat critical of his devotion to the *fête galante*. It was just at this period, too, that the remarkable sketching activities of Alexandre-François Desportes became known outside the artist's immediate circle, through a lecture delivered to the Académie by his nephew in 1749. Though Desportes's oil sketches from nature (Col. Plate 14) were not purchased by the Direction des Bâtiments until 1784, the audience of 1749 heard how he went out with a special painting-box and prepared paper in order to paint directly in the open air. This must have

been partly for the pure pleasure of imitation and of being taken out of himself for an afternoon, and partly to train the response of his hand to what his eyes saw. Only in one or two cases do the oil studies of landscape compare directly with the backgrounds of his finished paintings. The studies, probably executed in the decades either side of 1700, could hardly be further removed from the sumptuous, baroque assemblages of still life, game, and royal hounds for which he was publicly known (Fig. 138); such conceptual works are as far removed as Watteau's *fêtes galantes* from the immediate observation of nature, though it may form the basis of their individual parts.

Although there was an increasing interest in a closer study and more direct presentation of nature, especially from the mid-1740s onwards, Boucher's *Landscape with a Temple and Watermill* (Col. Plate 13) is representative of the dominant landscape aesthetics of the first two thirds of the century. Boucher invites us into a world where unhappiness and disturbing human passions seem impossible, a delicate artifice with a hint of the ancient pastoral dream, where, as a contemporary put it, 'we recognize with pleasure a happy mixture of views of Rome and Tivoli with Sceaux and Arcueil'. But such picturesque combinations of half-recognized sites in Italy or near Paris do nothing to make Boucher's dream more real; there is a deliberate artifice in his powdery, rococo pastel shades of eggshell blue, coral pink, pale lemon and turquoise. There was a perennial demand for this kind of fancy in

Fig. 151. PIERRE SALOMON DOMENCHIN DE CHAVANNES: *Landscape with a Rock Arch.* 1709. Oil on canvas, 116 × 122 cm. Musée National du Château de Fontainebleau

Fig. 152. JEAN PILLEMENT: *Landscape with Cascade and Washerwomen*. About 1790. Oil on canvas, 48 × 70 cm. Musée Fabre, Montpellier

landscape, and it continued to exist—sometimes in the same work—beside the more realist tendencies of the second half of the century. Still in the 1780s, Hubert Robert was showing Boucher-like figures wandering in landscapes where ancient ruins were decoratively deployed—a not too serious reflection of the revived interest in classical antiquity; and Joseph Vernet was introducing a greater sensitivity to nature's variety of mood in similar decorative designs.

Jean Pillement is a characteristic little master of the decorative rococo landscape, as exemplified in his *Landscape with Cascade and Washerwomen* (Fig. 152), executed in the colours of hard, bright porcelain. Pillement travelled all over Europe and in 1767 disseminated his designs through a large suite of engravings, not only landscapes but also ornamental and floral motifs in the fashionable 'Chinese' style. The present picture, which probably dates from the 1790s, typifies his approach to landscape painting until the end of the century, maintaining a love for artificial, inventive fancy well into a period when a more naturalistic aesthetic prevailed. Fragonard, more directly than Pillement, continued the tradition of Boucher, who had been his master in the early 1750s. His celebrated pair of canvases *The Swing* (Col. Plate 15) and *Blind Man's Buff*, which he painted in the late 1760s for the Abbé de Saint-Non, almost certainly as decorations to be set into panelling, epitomize Fragonard's inventive fancy and also his brilliant and fluid handling of paint—in which he liked to demonstrate his virtuosity even more than Boucher. There is a nod in the direction of the more realist tendencies of these years; the spectator can more readily identify with these leisured people amusing themselves in their grand park than with Boucher's rosy milkmaids. But, though the superb trees recall those Fragonard had drawn at the Villa d'Este in 1760 when he was in Italy with Saint-Non, his nature is nevertheless larger than life, his foliage more artful, his azure sky more radiant, and his brushwork fairly crackles with vitality. For Fragonard, as for nearly all painters who turned to landscape in eighteenth-century

178

France, it has to be emphasized that this genre was only one of several they might practise. For the dozens of young artists trained up to be elevated history painters, or less ambitious decorative figure painters, the landscapists were few in number.

Critics who found rococo style and fantasy frivolous and 'merely' decorative soon found a natural alternative in the art of Claude-Joseph Vernet, who plays the central role in the story of French eighteenth-century landscape painting. It was indeed auspicious for Vernet that the beginning of his career coincided with the establishment of frequent Salons during the 1740s. Sent to Rome from his native Avignon by a local aristocratic *amateur* in 1734, by the next decade he had established an international reputation there, supplying visitors and natives with idealized—but none the less vivid—interpretations of the Roman Campagna and the coast near Naples. He was also in demand as a topographical painter, and among his most impressive works are two monumental views of Naples from the north and from the south (Fig. 153), probably commissioned by the Abbé de Canillac, who was French chargé d'affaires in Rome. The work illustrated is an exact rendering of Naples, yet painted with a lively touch (whose absence in later works was regretted by contemporaries) and a keen eye for amusing incident, such as the tourist having his purse cut in the foreground. Vernet was famed in his day as an assiduous student of nature, and this is borne out by his surviving drawings from nature, which are in the tradition of careful observation established by Claude and his contemporaries early in the previous century. When young artists came to him for advice, Vernet always encouraged them to study directly from nature and to avoid the dry routines of academic art education. Marigny, Cochin and Soufflot visited Vernet's studio in Rome in 1750, and it may well have been their sight of his topographical paintings that stimulated the great royal commission to paint views of the principal French seaports, for which Vernet returned to France in

Fig. 153. CLAUDE-JOSEPH VERNET: *The Bay of Naples from the South.* 1748. Oil on canvas, 100 × 197.5 cm. Musée du Louvre, Paris

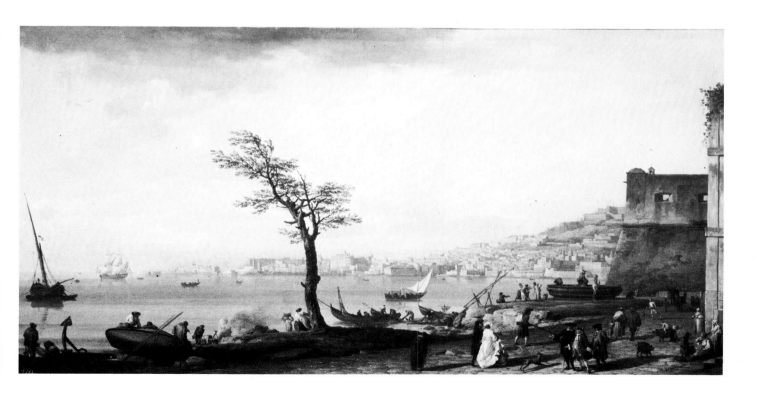

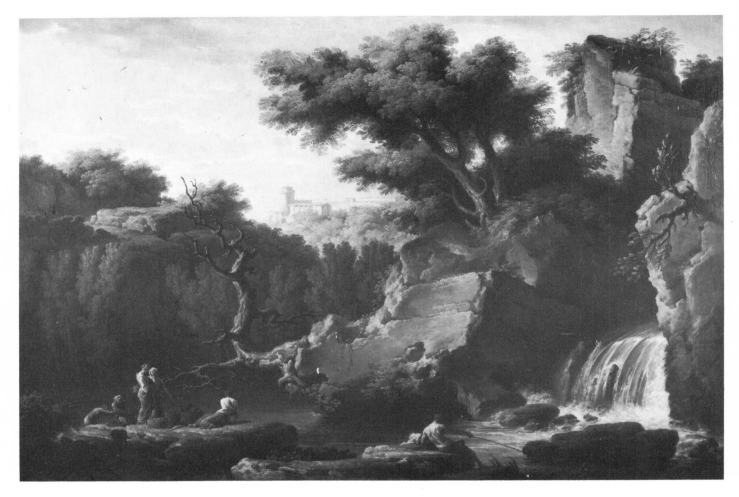

Fig. 154. CLAUDE-JOSEPH VERNET:
Landscape with a Waterfall. 1747.
Oil on canvas, 99.5 × 136.5 cm.
Collection of the Duke of Buccleuch
and Queensberry

1753. He was in Italy independently, however, and was not directly involved with official French artistic life there. His imaginary landscapes, seaports and coast scenes are reminiscent of seventeenth-century masters like Gaspard Dughet, Salvator Rosa, and Claude, and his immediate roots lie in the example of their early eighteenth-century followers in Italy. The *Landscape with a Waterfall* (Fig. 154) evokes both Dughet and Rosa, and the overall design comes from Jacob de Heusch, a Dutch follower of these two in early eighteenth-century Rome. Vernet delights in the contrasting textures of rocks, foliage, and foaming water. The contemporary spectator would have associated such wild sites (though not too far from civilization, and peopled by benign fisherfolk) with visits to the famous picturesque cascades of Tivoli or Terni. Vernet's landscape seemed more realistic than that of Boucher, and his browns, ochres and greens more the colours of nature than of the artist's studio. Moreover, the reminiscence of admired old masters must have enhanced the appeal of these handsome souvenirs of the Grand Tour.

Compared with the works of the landscape painters we have looked at so far, which are relatively uniform in content and consistent in mood, Vernet's landscapes and marines display much greater variety. While the earlier painters were still to some degree concerned with the ideal of seventeenth-century precedent, Vernet was more interested in rendering the actual variety of nature, with the result that his vision could more readily be compared with everyday experience of the different

types of weather, inland or at the coast. The variety in Vernet's portrayal of nature helped to sharpen the senses of the eighteenth-century spectator, and won critical acclaim for revealing nature's different beauties and effects. This conscious interest in variety is shown in the way he often conceived his works in sets of four contrasting pieces showing the four times of day, for example, with different weather effects and mixing land and sea; Claude composed only contrasting pairs of works. Vernet's study of natural variety can be seen as an aspect of the eighteenth-century interest in taxonomy: he might be said to 'classify' a variety of different experiences of the natural world. This concern with particular effects increasingly challenged the old concept of the ideal in landscape painting, but the subject was not fully explored until the nineteenth century.

But even in his pairs of paintings Vernet makes a bolder (and perhaps less subtle) contrast than that between Claude's morning and evening effects. *Calm* and *Storm* (Figs. 155 and 156) are characteristic pendants, painted in Paris in 1773 on commission for the King of Poland but in fact purchased by Lord Clive (of India), who had admired similar works on a visit to Vernet's studio in 1771. *Calm* is a warm sunset scene, bathed in a golden glow, reminiscent of Claude's early seaports. In a letter to Lord Clive, Vernet enumerates the details of the picture—buildings, shipping, foreground incidents—showing how we are meant to 'read' it and enjoy his powers of imitation. *Storm* is by contrast a dramatic affair. We might remember that travel by sea was a real hazard in the eighteenth century, and the danger of shipwreck almost equal to that of a motor accident today. But Vernet was not striving to express horror in a vivid, documentary way: after all, his storm is not too distressing, and his work, like that of most eighteenth-century painters, conforms to good taste and is designed to please. This dramatic storm effect accords well with the eighteenth-century notion of the 'sublime', as defined in Edmund Burke's *A Philosophical Enquiry into the Origin of our Ideas of the Sublime and Beautiful* (1756). Burke distinguishes two fundamental categories of aesthetic experience—beauty and sublimity—the latter including the sensation of terror before the ruthless power of nature and the dangers of the ocean. Indeed, this pair of pictures could well be intended to illustrate Burke's notions, which were well known in Paris.

Pitted against the elements, Vernet's figures are not without heroism. Contemporaries, such as Diderot in his reviews of works by Vernet shown at the Salon, found these groups very engaging and even moving, and they can indeed be interpreted as diminutive versions of the figures in some historical or religious work: the central group in the *Storm* can be read as an Entombment or a Lamentation. Men of feeling were moved by the vivid impression of nature in such a work and by the actions, gestures and expressions of figures with whom it was easy to identify. Vernet renders the power and the beauty of the elements in an exciting way, delighting in the transient effects of light and weather, as the clouds and rain scud across the sky, rapidly sketched in with lively brushwork.

If Vernet's interest in natural variety is a reflection of contemporary taxonomy, his most specific exercise in classification was to depict the French seaports for the King. Returning to France in 1753, he was given a detailed itinerary, but he was licensed to select his own viewpoints when pictorial requirements demanded it. The details of quayside life in which the paintings abound were intended to suggest the characteristic commercial activities of each region—as does *Tunny-Fishing at Bandol* (Col. Plate 16). Thus the *Ports of France* are didactic pictures, and part of a conscious effort by the Direction des Bâtiments to encourage 'serious' painting. These very large works are horizontal in format and display a large expanse of sky, which gives

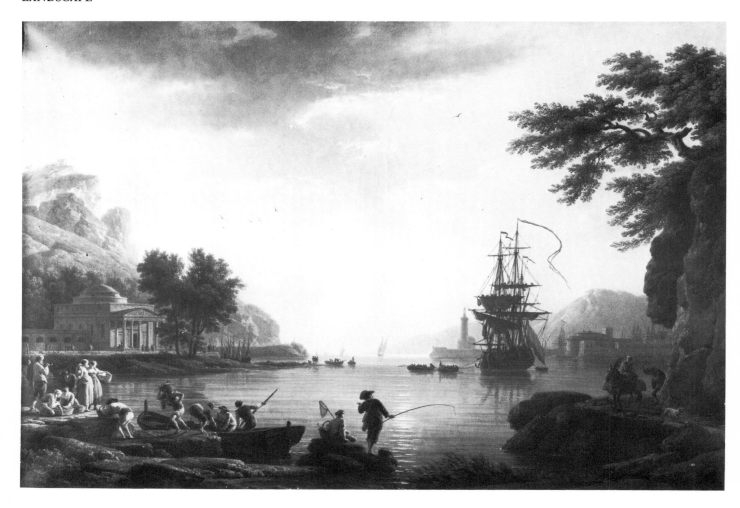

them an atmosphere of light, openness and grandeur that was admired by all the critics. Their particular brilliance, however, lies in the way Vernet managed to reconcile the exacting demands of topography with an overall monumentality of conception. The magnificent eighteenth-century city of Bordeaux (Fig. 157) was in itself a triumph of art over nature, and so too Vernet exercises artistic control over the complexity of natural appearances. The spectacle of nature extends before us, the pale morning sun dispelling the last mist on the River Garonne and warming the honey-coloured stonework of the town. We have a sense of a particular place at a particular time, and within this extensive, skilfully designed panorama Vernet can pick up a detail like the translucent earrings of a lady, or a delicate posy of flowers. The painting is intelligent in its overall design and is sustained across its full four square metres by precise yet succulent brushwork. The elderly gentleman in the foreground is the Intendant of the region, the Marquis de Tourny, who, with the architects Gabriel father and son, instigated the rebuilding of Bordeaux in the 1740s, centering on the splendid Place Royale, which we can see near the middle of Vernet's view.

As there was no port of significance for some way to the west of Marseilles, Vernet was asked to depict 'some distinctive subjects which would characterize this part of the coast of Provence'. One of these was tunny-fishing, done with a special system of nets, which the artist has placed in sight of the Château de Bandol (Col. Plate

Fig. 155. CLAUDE-JOSEPH VERNET: *Calm: Sunset*. 1773. Oil on canvas, 114 × 160 cm. Private collection

16). This lively spectacle was a popular attraction for visitors to Provence during the summer months. With a good deal of humour, Vernet shows some rather elegant spectators who have come out in small boats to watch the fishermen as they hook and lift the big fish out of the tumultuous water. The background, a masterpiece of tonal painting in a high key, captures the brilliant but hazy atmosphere of early morning on the Mediterranean. For personal reasons, but also because of the financial constraints of the Seven Years War of 1756–63 (the French navy looked a lot better in his paintings than in reality), Vernet completed only fifteen out of the proposed twenty or more *Ports* (the last was painted in 1762). But in scale and quantity of pictures this remained one of the largest official commissions of the century and presented a vivid challenge to the status of idealized history painting.

Among Vernet's numerous imitators and followers, it was Pierre-Jacques Volaire who developed the more sensational aspects of his art; Volaire settled in Naples at the end of the 1760s and became a specialist in painting eruptions of Vesuvius (Fig. 158). These works, and imitations of them, were eagerly collected by visitors to Naples, where this dramatic phenomenon excited the curiosity both of sensation-seeking tourists and of those with more scientific interests. For Volaire it provided a pretext for compositions, often very large in scale, with strong contrasts of light and dark, hot fire and cool moonlight, which he had learned from the moonlit seaports

Fig. 156. CLAUDE-JOSEPH VERNET: *Storm on the Coast*. 1773. Oil on canvas, 114 × 160 cm. Private collection

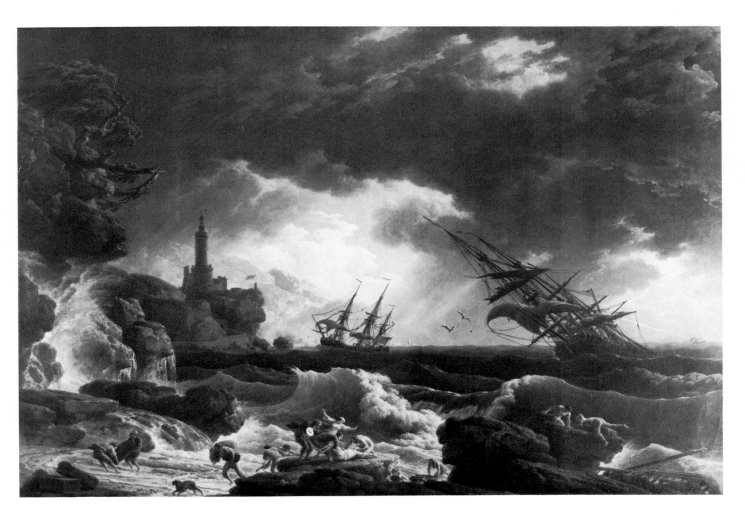

of Vernet. He had assisted Vernet with the *Ports of France* from 1754 to 1762, and though night scenes with high contrasts of effect were his forte, he also made a number of topographical works, and variations on Vernet's idyllic scenes of Neapolitan coastal life.

Academic values being what they were, there was normally little official encouragement for landscape painters. But their works were eagerly purchased by private collectors—far more so than monumental history paintings, which were the academic ideal. Indeed, at the height of the academic revival encouraged by d'Angiviller the authorities were concerned at the fact that their campaign to promote history painting was having little effect on private taste, while the lesser genres were flourishing. In the early 1780s Pierre wrote to d'Angiviller in annoyed tones about this public preference: 'There are two hundred French painters in Rome,' he wrote, 'and all of them are landscape painters'. We have seen in Chapter One how Pahin de la Blancherie's Salon de la Correspondance, which included a Vernet exhibition in 1783 as part of a campaign to encourage genres other than history painting, was suppressed by d'Angiviller. But official attitudes to the lowlier genres had been more liberal in the middle of the century. The *Ports of France* commission is material proof of this, and indeed Marigny once sympathized with a complaint from Natoire, who, writing from Rome, deplored the fact that students of the Académie preferred 'to grovel in the one genre [history] rather than seek perfection in the other [landscape]'. A keen landscape draughtsman (in which he had been encouraged by Vleughels in Rome and by Oudry in Paris), Natoire was

Fig. 157. CLAUDE-JOSEPH VERNET: *The Port of Bordeaux, seen from the Château Trompette.* 1759. Oil on canvas, 165 × 263 cm. Musée de la Marine, Paris

arguing that landscape should feature in the academic curriculum. A number of academic discourses in these years around 1750 expressed the view that it was better to excel in a 'low' genre than to paint insipid history pictures, and that good execution of the former was preferable to poor invention in the latter. Even the academically-minded critic La Font de Saint-Yenne recognized that the careful observation and brilliant technique of painters like Chardin, Oudry and Vernet made a valid alternative to poor history painting. But by the 1770s the Abbé Laugier, a staunch neoclassicist in matters of art, was writing: 'A picture of perfect invention [by which he meant an elevated choice of subject], even if it is painted in a mediocre way, will succeed far better than if it were from the best brush but only of mediocre invention'. However, at the mid-century sound technique and careful attention to nature became almost rallying cries for some critics, artists and commentators. Studying nature by drawing and painting in the open air was the alternative to studio routine and vacant idealism; the variety of nature could in itself be a sufficient subject for art: 'If ever there was a subject providing action and variety, it is landscape. There, you cannot expect any two instants to be the same. The landscape changes and varies as many times as the refraction of the sun's light which illuminates it. Nature appears at one moment clear and luminous, as if everything had responded to the clarity of the sunlight. A moment later a storm will come, the sky goes dark, buildings which were dull in tone become luminous in comparison with the clouds. When the sky becomes serene again, the artist can profit from that moment by seizing a ray of light bursting on the background, while by the use of shadows he can create a natural-looking effect of foreground space; a cloud appears, and intercepts the light to produce another effect. It would run counter to probability to suppose that nature lay at rest in a landscape, because

Fig. 158. PIERRE-JACQUES VOLAIRE: *The Eruption of Vesuvius.* 1771. Oil on canvas, 130 × 227 cm. Musée des Beaux-Arts, Nantes

that supposes a fixed light, which is impossible.' (Abbé Gougenot, *Lettre sur la peinture ... à M. xxx*, 1749.)

In the light of ambiguous official attitudes to landscape painting, it is significant that the careers of nearly all landscape painters were launched by private sponsorship. For many artists who trained at the Académie landscape would be merely one area of activity among others. Vernet, after first working as a decorative painter in his native region, was sent to Rome by a local *amateur*; Fragonard and Hubert Robert were encouraged by the Abbé de Saint-Non; in 1777 the *fermier général* and collector Bergeret de Grancourt took Fragonard on a tour of Italy as his draughtsman, and also commissioned huge landscapes from him and Volaire for his château near Montauban. In 1754 Robert had been taken to Italy as draughtsman to the French Ambassador, the Marquis de Stainville (later Duc de Choiseul), and his Roman drawings were purchased for the private collection of Marigny, and also by Mariette. It was almost certainly Choiseul who introduced Robert to Saint-Non, and he secured a trip to Naples for another of his protégés, Jean Houël, as an artist to accompany the Chevalier d'Havrincourt, an aristocrat who was making the Grand Tour. Houël had already been employed at Choiseul's country home, Chanteloup, where in the 1760s he painted decorative landscapes and some very Dutch-inspired views of other Choiseul properties. He had also been drawing-master to the *amateur* Blondel d'Azincourt, who, through Marigny, secured him a place at the Académie in Rome in 1769. Such instances of the private sponsorship of landscape painters were frequent.

Landscape artists found a new means of support in the vogue for luxuriously illustrated travel books, initiated in France during the 1770s by the Abbé de Saint-Non and Benjamin de Laborde in what was intended to be a joint publication venture. However, this collaboration did not last long, and in 1779 Laborde independently produced a two-volume *Tableau de la Suisse*, which he followed in the 1780s with a *Description de la France*. Saint-Non's contribution was the especially magnificent *Voyage pittoresque de Naples et de Sicile* (1781–6), which employed the talents of a number of French painters and draughtsmen in Italy. Although strictly they fall outside a discussion of painting, the topographical views of places and monuments in these books are an important illustration of the increasingly scientific spirit of enquiry into landscape as an exact classification of unique phenomena, and can be compared with the monumental topography of Vernet's *Ports of France*. After his trips to Naples in 1769 and further to Sicily in 1770, and the success at the Salon of 1775 of his Sicilian drawings, Jean Houël returned there for three years in 1776 and then travelled on to Lipari and Malta with a view to preparing drawings for publication. He was able to sell the original drawings to Louis XVI and Catherine of Russia in order to finance their publication, in engraved form, in his magnificent *Voyage pittoresque des Isles de Sicile, de Lipari et de Malte* (1783–7), something of a rival to Saint-Non's enterprise. Houël's volumes are not merely concerned with monuments, topography and physical geography, however, but also provide a fascinating and detailed account of the manners and customs of the inhabitants of those islands, which until the 1770s were little visited by northern Europeans.

Once Hubert Robert had been introduced into French artistic circles in Rome by the French Ambassador, his drawings of the Italian scene found a ready clientele. Inspired by Panini, the Italian specialist in ruins, he also executed small cabinet pictures (Fig. 159) depicting ancient ruins, sometimes fanciful, sometimes topographical, sometimes placing recognizable monuments in fanciful settings or

Fig. 159. HUBERT ROBERT: *A Ruined Triumphal Arch*. 1780. Oil on canvas, 72 × 58.5 cm. Musée du Louvre, Paris

combinations, and always painted with a spirited touch. He produced countless such works for the rest of his life, sometimes on a very large scale for a specific decorative context. We have already seen an example of the latter in the commission for monumental, and more archaeological, neoclassical decorations of 1787 for Fontainebleau (Fig. 160). After settling in France, Robert often recorded the Parisian scene, as when, in 1786, the old houses on the Pont Notre-Dame were demolished (Fig. 161), or when the Opéra was destroyed by fire in 1781 (several versions). The real specialist in Parisian topographical painting was Pierre-Antoine de Machy, who also painted ruins and architectural caprices, but his style is much drier and more prosaic than Robert's. Robert also developed a reputation as a landscape gardener, working extensively for the Marquis de Laborde at his country home, Méréville, and in 1778 being officially nominated Dessinateur des Jardins du

Fig. 160. HUBERT ROBERT: *The Temple of Diana at Nîmes*. 1787. Oil on canvas, 242 × 242 cm. Musée du Louvre, Paris

Roi. In this capacity he replanted parts of the gardens at Versailles for Louis XVI; a pair of paintings shows the cutting down of old trees at the Bosquet des Bains d'Apollon in the winter of 1774–5 (Fig. 162), which was remodelled to Robert's designs. The paintings were commissioned by d'Angiviller for the royal collection, and portray one aspect of his reorganization of the arts for Louis XVI. In the park at Versailles Robert rearranged the original formal placing of the seventeenth-century sculptures, including the group of Apollo's horses by the Marsy brothers seen here, in a more verdant and rocky, natural-looking setting. Members of the court are gathered to watch the men at work, and this unorthodox glimpse of the château recalls the unusual viewpoints Robert adopted for many of his eye-catching Roman drawings. He was also one of a commission set up to turn the Louvre into a museum, and in 1777 was made Garde du Muséum, or Curator. Here he played an important part in official artistic life, and supplemented his already considerable income from the sale of drawings and cabinet pictures.

Robert's friend of Roman years, Fragonard, was a painter who worked in several genres—history, gallant mythology, narratives of his own invention, portraiture, and also landscape, which was one of his major interests. Just as *The Swing* (Col.

Opposite:
15. JEAN-HONORÉ FRAGONARD: *The Swing*. Late 1760s. Oil on canvas, 215 × 186 cm. National Gallery of Art, Washington (Samuel H. Kress Collection)

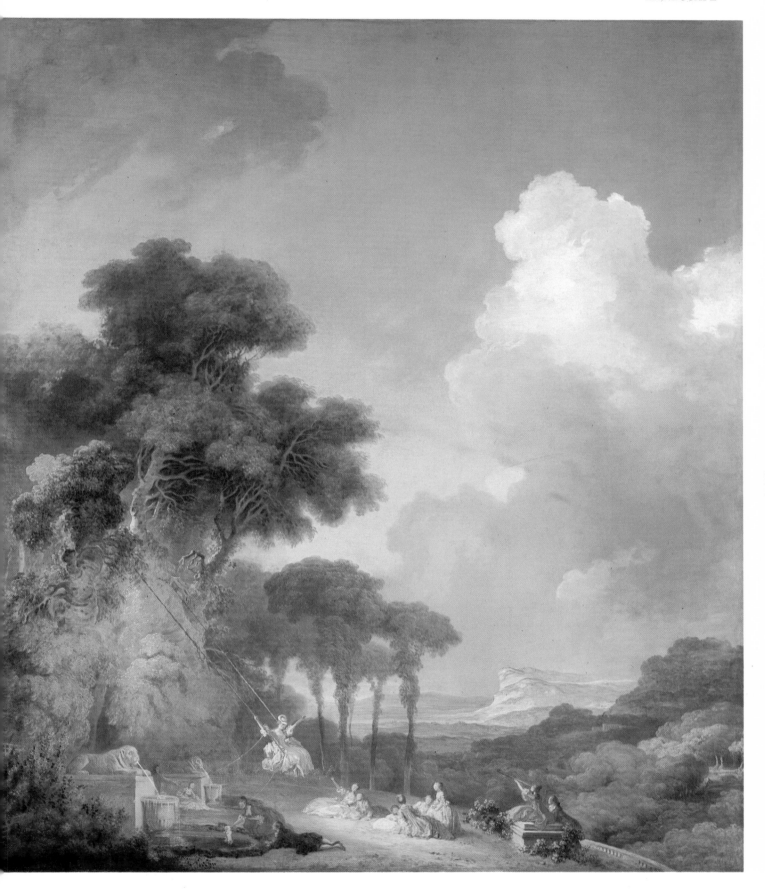

Fig. 161. HUBERT ROBERT:
*Demolition of Houses on the Pont
Notre-Dame.* 1786. Oil on canvas,
73 × 140 cm. Musée du Louvre,
Paris

Plate 15) is a fantasy based on his knowledge of Italian cypresses and elegant French parks, the *Fête at Saint-Cloud* (Fig. 163) is also a brilliant combination of artifice and observation. This very large painting (well over two by three metres), commissioned by the Duc de Penthièvre for his Hôtel de Toulouse about 1775, celebrates a favourite Parisian outing of late September, when the great fountains played in the park at Saint-Cloud and all Parisian society came to enjoy the fun of the fair. Theatricality is a keynote of the picture: on the left we see a theatre with two actors, and on the right a marionette theatre, while spectators in the centre watch a gushing fountain. But overall we are presented with a spectacle of superabundant nature, where deftly observed, Watteauesque figurines are dwarfed by magnificent soaring and arching trees, to match the soaring fountain and the arching clouds. The various genre scenes, which also include people buying dolls and baubles from stalls, are sharply observed; but in the pursuit of pleasure, everyone seems oblivious of the rampant nature surrounding them.

There is still a hint of the magical gardens of the Villa d'Este in Fragonard's *Fête*, but he also made more down-to-earth cabinet pictures, which were his response to the taste of contemporary collectors for northern landscapes of the seventeenth century. His *Return of the Drove* (Fig. 164) is reminiscent of Wynants and Berchem, and the amorous encounter of the two rustics typifies certain gallant subject-matter of his own day; it may well be intended to illustrate one of the sentimental pastoral idylls or *Contes Moraux* (1762) of Marmontel, the story of *Annette and Lubin*. Of course the painting is very much a product of the studio, based on other art rather than on any direct study of nature; yet it seems a more recognizable world than that of Boucher's *Temple and Watermill* (Col. Plate 13). Even more familiar is the world of Philippe-Jacques de Loutherbourg's *Pastoral Landscape* of 1763 (Fig. 165), which is far more soberly painted, without any of Fragonard's late-rococo flourish, and

with a basic green and ochre palette which is closer to nature than Fragonard's. It is a rather grand and vigorous reinterpretation of Berchem, and at the Salon Diderot greatly admired its sincere and earthy feeling. The relative realism of seventeenth-century Dutch and Flemish art is widely reflected in French landscapes of the 1760s; in 1769 Jean Houël painted four overdoors depicting sites of interest for his patron the Duc de Choiseul, and the *View of the Loire* (Fig. 166) seems surprisingly inspired by Albert Cuyp (an artist little appreciated in France at this time, but whom Houël may have come to know through his early training as an engraver).

In the last three decades of the century there was a host of little masters who specialized in landscape. Sometimes they were admitted to the Académie with associate status, as were César Van Loo, Taunay, Demarne, Legillon (Fig. 146) and Lafontaine. But many others pursued flourishing careers in the margins of official life, and their names only emerge for us in the *livrets* of the open Salons of the Revolutionary years. One of these was Louis-Gabriel Moreau the Elder, who tried unsuccessfully for a place at the Académie; but he did become painter to the Comte d'Artois in 1778 and found a ready market for his small decorative landscapes in gouache and oil, and for his topographical works made in Paris and the surrounding area. The sketchy brushwork of his *View of Vincennes* (Fig. 167)—as loose in the sky as if done from nature—gives it a remarkable freshness and sparkle, features that led to his 'rediscovery' by realist landscape painters in the mid nineteenth century (it

Fig. 162. HUBERT ROBERT: *The Bosquet des Bains d'Apollon in 1774–5*. 1777. Oil on canvas, 124 × 191 cm. Musée National du Château de Versailles

16. CLAUDE-JOSEPH VERNET: *Tunny-Fishing: A View of the Gulf of Bandol.* 1755. Oil on canvas,
165 × 263 cm. Musée de la Marine, Paris

was purchased by the Louvre in 1872). It seems as much a study of hedges, copses and fields as a view of the Château, which is relegated to the distance.

Another such 'rediscovery' of the later nineteenth century was Georges Michel, in whose case we have to take into account a degree of deliberate critical neglect in the 1830s and '40s that was designed to obscure the achievements of some earlier generations of landscape painters in order to boost the 'novelty' of Barbizon realism. We know little of Michel's background, but during the 1780s, when he was in his twenties, he found employment as a drawing-master in several noble houses, and was taken on tours in Germany and Switzerland. A certain Baron d'Ivry, himself an amateur painter, sponsored him and purchased his works. Michel was also a friend of Madame Vigée-Lebrun, and her husband, the famous art-dealer Lebrun, acted as an agent for him. But he is another landscapist who only comes to public view at the Salon of 1791; until 1814 he continued to exhibit views of Paris and its region, and landscapes inspired by the hills of Montmartre (Fig. 168). After the early 1820s and until his death he led an obscure and recluse existence, which contributed to his critical neglect during the following decades. Like Rembrandt, whom he greatly admired, Michel affected disdain for the classical academic tradition, and propounded a parochial, stay-at-home view of painting: 'Anyone who cannot spend his whole life painting within four square miles is only an oaf looking for the mandrake, and will find only a void. I ask you, did the Flemish and Dutch ever travel? Nevertheless, they were good painters, the worthiest and boldest and most objective'. The few dated landscapes by Michel are from the 1790s, and are rendered in Rembrandtesque browns, ochres and greys; they continue the taste for Dutch-style works which we have seen in the 1760s. They can also be seen to form a link with the work of realist landscape painters of the nineteenth century, and it was Alfred Sensier, a friend and supporter of the Barbizon painters, who 'rediscovered' their precursor and secured his place in the canon of rebels and anti-academic artists by devoting a scholarly biography to him in 1873.

Given a certain amount of grist by the non-idealizing tendencies, which can be traced back to the mid-century, the academic revival of the 1770s and 1780s nevertheless saw a renewal of interest in the nobler traditions of landscape. Thus, even for a critic such as Diderot, who in the 1750s and 1760s had advocated a realist aesthetic, the heroic landscapes of Poussin became a standard by which to judge the more direct responses to nature of Vernet and the painters who came after him. As a critic writing A Blow at the Salon of 1779 put it, 'If the painter devotes his time merely to the study of nature, he will produce nothing but frivolous bagatelles. The answer to this is profound thought, which will guide the artist's brush and furnish the spectator with enough ideas and feelings to last a lifetime'. Another critic, writing in 1783, said the modern painter should study not the northern little masters but the landscapes of the great history painters who have practised the genre: 'It is there that they will feel their ideas enlarged, their style growing more noble, that they will even learn to see nature in forms which she does not really possess, yet which will seem stronger, bolder, more striking, more original than her ordinary forms. This beau idéal, which has been so much discussed in history painting, which Raphael understood, also exists for landscape'.

The artist who did most to revive the 'historical' landscape was Pierre-Henri de Valenciennes, who was a pupil of the history painter Doyen, and was welcomed into the Académie in 1787. When his own pupil, Jean-Baptiste Deperthes, wrote a history of landscape painting in 1820, he drew a parallel between David's revival of history painting and the rise of historical landscape under Valenciennes. The latter

submitted to the Salon of 1787 *The Ancient City of Agrigentum* (Fig. 169), which is both a carefully constructed essay in the manner of Poussin's mountainous landscapes and an imaginary reconstruction of an ancient site. He also had a feeling for nature, which is revealed in the fresh and direct oil studies he made in Italy in the early 1780s (Fig. 170) and later in France. He wrote an interesting and influential treatise on landscape painting, the *Elémens de Perspective* (1799), in which he stressed the value of painting in the open air in order to understand and capture nature's transient effects. But there seems to be a strict distinction between these exercises in gathering material on the spot and the entirely conceptual constructions of the historical landscapes that Valenciennes made for exhibition. It was not until well into the nineteenth century that artists such as Corot reconciled the spontaneity of sketching from nature with the large-scale studio work. Small-scale works such as Valenciennes's *Mercury and Argus* of 1793 (Fig. 171), a cabinet picture half-way between the freshness of his oil sketches and the grandeur of his most ambitious canvases, spawned a host of attractive imitations among his many pupils.

The idealized landscapes of Valenciennes and his pupils, and the more down-to-earth approach of Michel and other painters, form two parallel traditions in landscape painting, which continued unbroken from the last decades of the *ancien régime* into the early nineteenth century. Valenciennes can be said to have made landscape painting academically acceptable, and the official seal of approval came in 1816, when a special Prix de Rome for landscape painters was established at the

Fig. 163. JEAN-HONORÉ FRAGONARD: *The Fête at Saint-Cloud.* About 1775. Oil on canvas, 216 × 335 cm. Private collection, Paris

Fig. 164. JEAN-HONORÉ
FRAGONARD: *The Return of the Drove.*
About 1765. Oil on canvas,
64 × 80 cm. Worcester Art
Museum, Massachusetts (Theodore
T. and Mary G. Ellis Collection)

Fig. 165. PHILIPPE-JACQUES DE
LOUTHERBOURG: *Pastoral Landscape.*
1763. Oil on canvas,
114 × 194 cm. Walker Art Gallery,
Liverpool

Fig. 166. JEAN HOUËL: *The Loire between Amboise and Lussault.* 1769. Oil on canvas, 84 × 161.5 cm. Musée des Beaux-Arts, Tours

Ecole des Beaux-Arts. Of course, the aim was to produce historical landscapes in the manner of Poussin; but Valenciennes, through precept and example, also made the oil-study from nature an accepted part of academic landscape practice in the early nineteenth century. However, the direct study of nature was still but a way to train the eye and hand and to provide a basis from which the artist could proceed to make idealized landscapes in the studio. It was not until the advent of the Impressionists that the 'study' grew to larger proportions and seriously threatened the status of the 'finished' idealized landscape of the old academic tradition.

Even the academic recognition of landscape painting by the creation of the special Prix de Rome owed nothing to the old Académie Royale, but arose from the innumerable discussions about artistic education that attended the abolition of that institution in the 1790s (for example Quatremère de Quincy, *Suite aux considérations sur les arts du dessin en France*). The exclusiveness of the Académie was a major factor in its abolition in 1793. Louis-Gabriel Moreau and Georges Michel are but two famous names who did not make the grade even of *agréé* at the Académie—and for the handful who did, such as Legillon (Fig. 146), there were dozens of landscape and genre painters, not to speak of those who aspired to history, who were rejected and had to exist in the margins of the art world. We will never know how many painters, let alone students at the Académie itself, were denied the opportunity to exhibit in public and promote their work for a reasonable living. We have seen in Chapter One some of the attempts to overcome this problem in the 1770s and '80s, attempts which were suppressed by d'Angiviller. The hundreds of works in the minor genres shown at the Salons of 1791 and 1793 are an indication of the discontent and frustrating sense of exclusion that must have existed. Apart from the fact that their institution was under royal patronage (and was thus outlawed by the Constitution of 1791), the members of the Académie were a very privileged group, for example in their exclusive right to elect new members and to exhibit at the

Opposite, above:
Fig. 167. LOUIS-GABRIEL MOREAU THE ELDER: *View of the Château de Vincennes from Montreuil.* About 1770. Oil on canvas, 47 × 86 cm. Musée du Louvre, Paris

Opposite, below:
Fig. 168. GEORGES MICHEL: *Landscape with a Windmill.* About 1790–1800. Oil on canvas, 58.4 × 80.6 cm. Fitzwilliam Museum, Cambridge

Opposite, above:
Fig. 169. PIERRE-HENRI DE
VALENCIENNES: *The Ancient City of
Agrigentum.* 1787. Oil on canvas,
110 × 164 cm. Musée du Louvre,
Paris

Opposite, below:
Fig. 170. PIERRE-HENRI DE
VALENCIENNES: *The Two Poplars at the
Villa Farnese.* About 1783. Oil on
paper, laid down, 25.3 × 37.8 cm.
Musée du Louvre, Paris

Fig. 171. PIERRE-HENRI DE
VALENCIENNES: *Mercury and Argus.*
1793. Oil on panel,
24.4 × 32.4 cm. The Bowes
Museum, Barnard Castle,
Co. Durham

Salon. Indeed, David himself felt he had been hampered by the Académie early in his career, and had in effect taught himself what really mattered, by first-hand study of the old masters in Italy. Thus, for personal as well as ideological reasons, he was happy to lead the destruction of that institution, its rigid teaching, and its hierarchies of the *ancien régime*.

In October 1789 there had been a violent dispute between the officers of the Académie and some of the younger artists, led by David, who demanded an exhibition of the works of Jean-Germain Drouais, who had died in Rome before receiving any academic recognition. In the eyes of the Académie this lack of official distinction precluded any such exhibition. The underlying issue here was the idea of equality among artists: in August that year the Declaration of the Rights of Man had pronounced equality of opportunity for all French citizens, and David and other radical artists felt that the Académie should recognize equality at least among its members and even among all artists. In 1790 some three hundred artists assembled for the first meeting of a Commune des Arts, a positive move towards a more egalitarian institutional alternative to the Académie. There was also a limited recognition of the new artistic equality at the Salon of 1791, which was open to all;

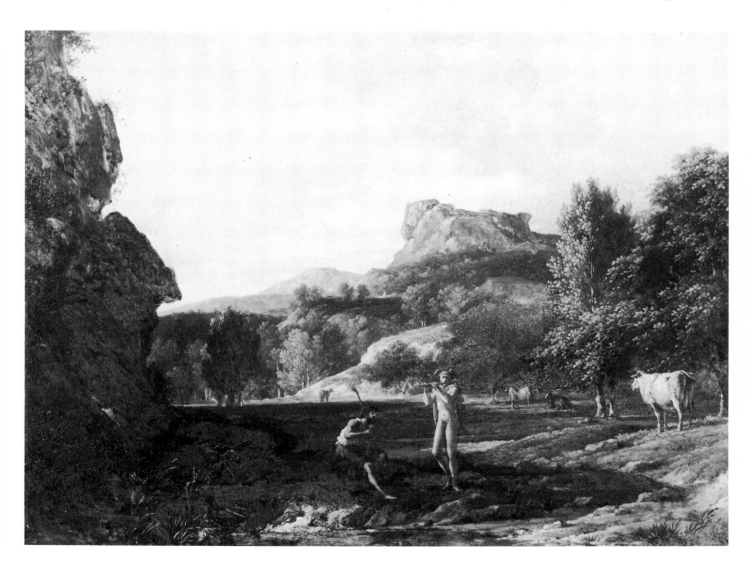

works were listed in numerical order of their sequence around the walls rather than by academic hierarchy, and membership of the Académie was only very discreetly indicated in the *livret*. The authority of the Académie was increasingly eroded during the early 1790s, when there were innumerable discussions and documents aimed at its revision or abolition and bringing into question the whole system of art education. On 8 August 1793 David made an impassioned speech to the Convention on the need to abolish the Académie, and later the same day the doors were finally sealed on the official art institution of the *ancien régime*.

BIOGRAPHICAL
NOTES

BIOGRAPHICAL NOTES

These notes are intended to supplement such biography of artists as is contained in the text; the main monographs are also cited. See Select Bibliography for abbreviations used.

ALLEGRAIN, Etienne (Paris 1644 – id. 1736)
Reçu in 1677, he remained exclusively a landscape painter. He above all executed decorative works for the royal châteaux, in a rigidly structured manner derived from Nicolas Poussin. His son Gabriel (1679 – 1748), *reçu* 1716, was also a landscape painter, exhibiting at the Salon 1737 – 47.

Schnapper, 1968.

AUBRY, Etienne (Versailles 1745 – id. 1781)
Reçu as a portraitist in 1775, he exhibited at the Salon 1771 – 81; from the mid-1770s onwards he also painted genre and illustrations to modern literature.

F. Ingersoll-Smouse, 'Quelques tableaux de genre inédits par Etienne Aubry', *GBA*, Period V, 9, i, 1925, pp. 77–86; C. Duncan, 'Happy mothers and other new ideas in French art', *Art Bulletin*, 55, iv, 1973, pp. 270–83.

AVED, Jacques-André-Joseph
(Douai 1702 – Paris 1766)
He first trained under the French engraver Bernard Picard in Amsterdam. Coming to Paris in 1721, he worked with the portrait painter Alexis-Simon Belle (d. 1734), and was *reçu* 1734 as a portrait painter. Returning to Holland for a time, he portrayed the Stadholder Willem IV in 1751. Exhibited at the Salon 1737–59.

G. Wildenstein, *Le peintre Aved*, 2 vols., 1922.

BELLE, Clément-Louis-Marie-Anne
(Paris 1722 – id. 1806)
Pupil of Lemoyne (q.v.), he was *agréé* 1759, *reçu* 1761 as a history painter; Professeur 1765. He exhibited at the Salon 1759–71.

BOUCHER, François (Paris 1703 – id. 1770)
Pupil of Lemoyne (q.v.), he won the Prix de Rome in 1724 and spent four years in Italy 1727–31, in the company of Natoire (q.v.) and Carle Van Loo (q.v.). In the 1720s he also made engravings after Watteau, who influenced his figure-style and the rococo rhythms of his designs. After a first royal commission in 1735, he became a leading decorator of royal palaces and private residences. He was especially favoured by Madame de Pompadour. He also produced designs for tapestries, for Sèvres porcelain, and for the Opéra. *Agréé* 1731, *reçu* 1734 as a history painter, he had a successful academic career: Professeur 1737; on the death of Van Loo in 1765, made Directeur de l'Académie and Premier Peintre du Roi. Exhibited at the Salon 1737–69, in all the genres. With the more severe tastes of the 1760s, his reputation began to decline; Mariette, a contemporary collector and writer on art, was both admiring and critical when he wrote: 'he was born a painter; there are few who surpass him in facility. You could say he was born with a brush in his hand'. He had a large studio and many imitators.

A. Ananoff, *François Boucher*, 2 vols., 1976.

BOULLOGNE, Louis de
(Paris 1654 – id. 1733)
Pupil of his father, he spent five years in Rome 1675–80, studying Raphael and the Bolognese masters; his own works were carefully prepared in the best academic tradition, with many exemplary drawings (Louvre). *Reçu* 1681; Professeur 1694; Directeur 1722. He was ennobled in 1724, and Premier Peintre du Roi 1725.

Caix de Saint-Aymour, *Les Boullogne*, Paris, 1919; Schnapper, 1968; A. Schnapper, 'Esquisses de Louis de Boullogne sur la vie de Saint Augustin', *Revue de l'art*, 9, 1970, pp. 58–64.

BOYER, Michel (Le Puy 1667 – Paris 1724)
Reçu 1701 as an architectural painter, his origins are obscure. He worked as a decorative painter, mainly for the Direction des Bâtiments.

Schnapper, 1968.

BRENET, Nicolas-Guy (Paris 1728 – id. 1792)
He studied under Boucher (q.v.) and always maintained a painterly quality in his work. However, training also at the Ecole Royale des Elèves Protégés marked him as a leader of the revival of serious history painting in the 1760s. In Rome 1756–9; *agréé* 1762; *reçu* 1769; Professeur 1778. The admiration of d'Angiviller and Pierre (q.v.) led to important State commissions in the 1770s, in addition to his work for the Church. He maintained a faithful respect for the monumental tradition of Rubens and the Bolognese School. He exhibited at the Salon 1763–91.

M. Sandoz, *Nicolas-Guy Brenet 1728–1792*, 1979.

CHARDIN, Jean-Baptiste-Siméon
(Paris 1699 – id. 1799)
Pupil of the history painters Pierre-Jean Cazès (1676–1754) and Noël-Nicolas Coypel (q.v.), Chardin remained a painter of still life and, from the early 1730s onwards, genre subjects. *Agréé* and *reçu* 1728, Conseiller 1743, he took an active part in the life of the Académie as Treasurer from 1755 and *tapissier* of the Salon. He exhibited at the Salon 1737–77.

G. Wildenstein, *Chardin*, Paris, 1933; *Chardin*, Paris, Cleveland and Boston, 1979 (exhibition catalogue by P. Rosenberg).

COCHIN, Charles-Nicolas
(Paris 1715 – id. 1790)
Engraver, from a family of engravers; *reçu* 1751, he exhibited engravings and drawings at the Salon 1742–81. He played an important part in academic affairs as Secretary and Historiographer of the Académie from 1755. Important for his influence on official taste and patronage through his writings and advice, recommending the serious study of nature and the antique.

S. Rocheblave, *Charles-Nicolas Cochin, graveur et dessinateur*, 1927; C.-N. Cochin, *Recueil de quelques pièces concernant les arts*, 3 vols., 1757–71; C. Henry, *Mémoires inédits de Charles-Nicolas Cochin*, 1880.

COLSON, Jean-François-Gilles
(Dijon 1733 – Paris 1803)
Son of a miniature and portrait painter, he trained at Dijon, Besançon and Paris. He aspired unsuccessfully to become a history painter, and settled for a career as a portraitist of careful and sincere directness. From the early 1770s he was employed as engineer, sculptor and architect to the Duc de Bouillon at Navarre. Remaining outside the official Académie, he also taught perspective, and wrote about art. He exhibited at the open Salons 1793–99.

Trois peintres bourgignons du XVIIIe siècle: Colson, Vestier, Trinquesse, Dijon, 1969 (exhibition catalogue by P. Quarré *et al.*).

COYPEL, Antoine (Paris 1661 – id. 1722)
Pupil of his father Noël (1628–1707; Directeur of the Rome Académie, 1673–5), he early absorbed the lessons of Italian art. *Reçu* 1681 as a history painter, he had an exemplary official career working for the Crown and the Duc d'Orléans (as his Premier Peintre, 1688); Directeur of the Académie 1714; Premier Peintre du Roi 1716; ennobled 1717. A leading follower of Charles Le Brun (1619–90), his style was tempered by the grand manner and rarer colour of Carlo Maratta (1625–1713).

Dimier, Vol. I (L. Dimier); Schnapper, 1968; A. Schnapper, 'Antoine Coypel: la Galerie d'Enée au Palais-Royal', *Revue de l'art*, 5, 1969, pp. 33–42.

COYPEL, Charles-Antoine
(Paris 1694 – id. 1752)
Son of Antoine Coypel (q.v.), the weight of this dynastic family of artists meant that he was *reçu* as early as 1715 as a history painter; 1722 Premier Peintre to the Duc d'Orleans; 1730 Professeur; 1747 succeeded Lemoyne as Directeur of the Académie. He exhibited at the Salon 1737–47. As well as painting and writing a great deal of art theory, he was a celebrated dramatist.

A. Schnapper, 'A propos de deux nouvelles acquisitions: "le chef-d'oeuvre d'un muet" ou la tentative de Charles Coypel', *Revue du Louvre*, 18, 1968, pp. 253–64; for his part in the Concours of 1727, and the other painters concerned, see P. Rosenberg, 'Le Concours de peinture de 1727', *Revue de l'art*, 37, 1977, pp. 29–42.

COYPEL, Noël-Nicolas (Paris 1690 – id. 1734)
Half-brother of Antoine Coypel (q.v.) but only four years older than the latter's son Charles-

Antoine (q.v.), Noël-Nicolas was *reçu* 1720 as a history painter; he took part in the Concours of 1727; Professeur, 1733. He died prematurely, and his major work was destroyed in the eighteenth century (a cupola in Saint-Sauveur, Paris, 1731).

Dimier, Vol. II (J. Messelet).

DAVID, Jacques-Louis
(Paris 1748 – Brussels 1825)

A pupil of Vien (on the recommendation of Boucher), he won the Prix de Rome at the fourth attempt in 1774; in Rome 1775–80, he studied especially the seventeenth-century masters and the antique, as more robust alternatives to the mid-eighteenth-century manner. *Agréé* 1781, *reçu* 1783 as a history painter, having emerged from Rome as effective leader of the French School. He also painted portraits, and exhibited at the Salon 1781–1810. During the Revolution he was a Deputy at the Convention and voted for the death of Louis XVI. He played a major part in the abolition of the Académie Royale and in the reorganization of the arts during the Revolution and the Empire. Exiled with the return of the Bourbons, he remained in Brussels from 1816 until his death.

De David à Delacroix (nos. 27–38), A. Brookner, *Jacques-Louis David*, London, 1980, and A. Schnapper, *David*, Fribourg, 1980, are the most recent books. For a stimulating article read T. Crow, 'The *Oath of the Horatii* in 1785: painting and pre-Revolutionary politics' in *Art History*, I, 4, 1978, pp. 424–71.

DESHAYS, Jean-Baptiste-Henri
(Rouen 1729 – Paris 1765)

Mainly a pupil of Restout (q.v.), he won the Prix de Rome in 1751; studied at the Ecole Royale des Elèves Protégés and then spent four years in Italy 1755–9. *Reçu* 1759 as a history painter; exhibited at the Salon 1759–65. His heavy neo-baroque manner is comparable with Brenet (q.v.) and Doyen (q.v.).

M. Sandoz, *Jean-Baptiste Deshays 1729–1765*, 1978.

DESPORTES, Alexandre-François
(Champigneulle 1661 – Paris 1743)

Pupil of Nicasius Bernaerts (1620–78), he considered becoming a portrait painter; he was court painter to the King of Poland in 1695, and his *morceau de réception* (1699) was a self-portrait. But he was essentially an animal painter, and worked as such especially for the Direction des Bâtiments. Conseiller at the Académie 1704; exhibited at the Salon 1699–1742.

Dussieux.

DETROY, *see* Troy

DOMENCHIN DE CHAVANNES,
Pierre Salomon (Paris 1673 – id. 1744)

Reçu as a landscape painter 1709, he was one of the leading decorative landscape painters of his day. Exhibited at the Salon 1737–8.

Schnapper, 1968.

DROUAIS, François-Hubert
(Paris 1727 – id. 1775)

Son of a portrait painter; Carle Van Loo, Boucher and Natoire were his other teachers. *Agréé* 1754, *reçu* 1758 as a portrait painter, he was favoured by Madame de Pompadour, Madame du Barry, and the royal family. These sitters and the nobility in general (especially their children) he flattered in a sweet and pleasing manner. Exhibited at the Salon 1737–75.

C. Gabillot, 'Les trois Drouais', *GBA*, Period IV, 35, i, 1906, pp. 246–58.

DROUAIS, Jean-Germain
(Paris 1763 – Rome 1788)

Pupil of his father François-Hubert (q.v.), but with quite a different talent, he studied also under Brenet (q.v.) and David, who had more effect on his aspirations as a history painter and on his style. In 1784 he won the Prix de Rome and went to Italy with David, where he died of smallpox.

C. Gabillot (see preceding entry); *De David à Delacroix* (no. 52).

DOYEN, Gabriel-François
(Paris 1726 – St Petersburg 1806)

Pupil of Carle Van Loo (q.v.), he won the Prix de Rome in 1746. In Italy 1752–5 after studying at the Ecole Royale des Elèves Protégés; *reçu* 1759 as a history painter. Exhibited at the Salon 1759–81; a leading history painter of the day, with many commissions from d'Angiviller; Professeur 1776. In 1791 he moved to Russia to work for Catherine II.

M. Sandoz, *Gabriel-François Doyen 1726–1806*, 1975.

DUMONT, Jacques, 'le Romain'
(Paris 1701 – id. 1781)

From a family of sculptors, he was a pupil of Antoine Lebel (1705–93). In Rome during the second decade of the century until 1725, he was *reçu* 1728 as a history painter; Professeur 1736;

Adjoint-à-Recteur 1748; Recteur 1752; Chancelier 1768. Exhibited at the Salon 1737–61.

Dimier, Vol. II (M.L. Bataille).

DUPLESSIS, Joseph-Siffred
(Carpentras 1725 – Versailles 1802)

Son of a surgeon, he went independently to Rome in 1745, where his style was influenced by the sober realism of Subleyras (q.v.). In Carpentras 1749–52, he then moved to Paris, where his talent only came to the fore at the exhibition of the Académie de Saint-Luc in 1764. *Reçu* 1774, but by then highly fashionable and a leading official portrait painter (*Louis XVI*, 1775; Versailles). He was director of the galleries at Versailles under Louis XVI and, after a period of retirement at Carpentras 1792–6, during the later 1790s. Exhibited at the Salon 1769–93.

J. Belleudy, *J.-S. Duplessis, peintre du roi (1725–1802)*, Chartres, 1913.

DURAMEAU, Louis-Jacques
(Paris 1733 – Versailles 1796)

First studied under the sculptor J.-B. Dufernex, then joined the studio of Pierre (q.v.). Prix de Rome 1757; Ecole Royale des Elèves Protégés 1757–60; Rome 1761–4. *Reçu* 1774, and enjoyed the encouragement of Cochin (q.v.), Pierre and d'Angiviller. Though his contemporaries knew him best as a decorator (ceilings of Versailles Opéra and Hôtel de Nivernais; both destroyed), he was also a leading history painter, working for Church and State. Exhibited at the Salon 1767–89.

M. Sandoz, *Louis-Jacques Durameau 1733–1796*, 1980.

FRAGONARD, Jean-Honoré
(Grasse 1732 – Paris 1806)

Pupil of Boucher, he won the Prix de Rome in 1752; 1752–5, Ecole Royale des Elèves Protégés; in Italy 1755–61, where he became friendly with Hubert Robert and was sponsored by the Abbé de Saint-Non. *Agréé* 1765 but never became an Académicien and rarely exhibited at the Salon. 1773-4, in Italy again with the *amateur* Bergeret de Grancourt. In 1793 David appointed him Curator of the Muséum des Arts.

G. Wildenstein, *The paintings of Fragonard*, London, 1960.

GILLOT, Claude (Langres 1673 – Paris 1722)

Pupil of the history painter Jean-Baptiste Corneille; *agréé* 1710; *reçu* 1715 as a history painter. Died relatively unknown. Now best known as a draughtsman and engraver, his paintings are rare; they are usually on theatrical themes, and he was also a celebrated designer of theatre sets. His interest in the theatre influenced his friend and pupil Antoine Watteau.

Dimier, Vol. I (E. Dacier).

GREUZE, Jean-Baptiste
(Tournus 1725 – Paris 1805)

A precocious draughtsman, he first trained in Lyons and then in Paris, where he was *agréé* in 1755. In Italy with the Abbé Gougenot 1756–9; the experience had little direct effect on his art, in contrast with the case of most of his contemporaries. Returning to Paris, he made his reputation with realistic portraits and genre. Exhibiting at the Salon 1755–69, he ceased to do so when the Académie refused to recognize him as a history painter; instead, he showed at the Salon de la Correspondance 1779–85, and in his studio. His versions of the modern moral subject, or elevated genre, were somewhat out of fashion after 1780.

Jean-Baptiste Greuze, Hartford, San Francisco and Dijon, 1977 (exhibition catalogue by E. Munhall).

GRIMOU, Alexis
(Romont, Switzerland, *c.*1680 – Paris 1740)

Apparently self-taught by studying Rembrandt and Van Dyck, he was *agréé* in 1707, but disqualified from entry in 1709 for not producing his *morceau de réception*. He painted portraits and fancy-portraits.

C. Gabillot, 'Alexis Grimou', *GBA*, Period IV, 40, i, 1911, pp. 157–72, 309–23, 412–26; Dimier, Vol. II (L. Réau).

HALLÉ, Noël (Paris 1711 – id. 1781)

From a family of history painters, and brother-in-law of Restout (q.v.), he won the Prix de Rome in 1736; in Rome 1737–44. *Agréé* 1746, *reçu* 1748 as a history painter; 1755 Professeur; 1775 Directeur of the Académie in Rome. Essentially a history painter, exhibiting at the Salon 1746–79, he was reliable and conservative rather than of advanced taste; he also made some portraits and genre paintings.

O. Estournet, 'La famille des Hallé', *Réunion des Sociétés des Beaux-Arts des Départements*, 19, 1905, pp. 71–236.

HOUËL, Jean-Pierre-Louis-Laurent
(Rouen 1735 – Paris 1813)

Landscape painter, draughtsman, and engraver. Pupil of J.-B. Descamps in Rouen, he came to Paris in 1755 and trained as an engraver. He painted topographical landscapes for the Duc de

Choiseul and travelled in Italy 1769–72. *Agréé* 1774; in southern Italy and Sicily 1776–9, making drawings for publication. Exhibited at the Salon 1775–91.

N. Vloberg, *Jean Houël, peintre et graveur*, 1930.

JEAURAT, Etienne
(Paris 1699 – Versailles 1789)
Pupil of Vleughels (q.v.), he was *reçu* in 1733 as a history painter; Professeur 1743; Recteur 1765; Chancelier 1781. He exhibited history paintings and genre (especially Parisian street-life) at the Salon 1737–69.

P. Wescher, 'Etienne Jeaurat and the French eighteenth-century *genre de moeurs*', *Art Quarterly*, 32, 1969, pp. 153–65.

JOUVENET, Jean (Rouen 1644 – Paris 1717)
An admirer of Poussin, and working under Le Brun at Versailles, his early works are mainly secular decorations. From the mid-1680s he devoted himself mainly to religious works, often on an enormous scale. *Reçu* 1675; ascended the academic hierarchy to become Directeur of the Académie 1705–8.

A. Schnapper, *Jean Jouvenet*, 1974.

LABILLE-GUIARD, Adélaïde
(Paris 1749 – id. 1803)
Pupil of a miniaturist and later under the pastellist La Tour (q.v.), she first exhibited in 1774 at the Académie de Saint-Luc. She then studied with Vincent (q.v.), whom she married in 1800 after her much earlier separation from Nicolas Guiard. *Reçue* 1783 as a portrait painter, with her rival Elisabeth Vigée-Lebrun (q.v.). Exhibited at the Salon 1783–1800. Her Revolutionary sympathies meant she could remain in Paris during the 1790s, unlike Mme Vigée-Lebrun.

M.-A. Passez, *Adélaïde Labille-Guiard*, 1973.

LA FOSSE, Charles de (Paris 1636 – id. 1716)
After visiting Italy 1658–63, where his interests were more Venetian than Roman, he worked under Le Brun at Versailles (Salon de Diane; Salon d'Apollon). *Reçu* 1673; proceeded to the post of Chancelier by 1715. He undertook major decorations—Montagu House, London, 1690–1; the Invalides, 1709; and Versailles.

Dussieux; M. Stuffmann, 'Charles de la Fosse et sa position dans la peinture française à la fin du XVIIIe siècle', *GBA*, Period VI, 64, 1964, pp. 1–121.

LAGRENÉE, Jean-Jacques, the Younger
(Paris 1739 – id. 1821)

Pupil of his elder brother Louis-Jean-François, he won a scholarship to Rome 1763–8; *agréé* 1769; *reçu* 1775 as a history painter; Professeur 1781. Exhibited at the Salon 1771–1804.

M. Sandoz, 'Jean-Jacques Lagrenée, peintre d'histoire', *BSHAF*, 1962, pp. 121–33.

LAJOUE, Jacques de (Paris 1686 – id. 1761)
Reçu as a painter of architecture in 1721, he exhibited architectural caprices at the Salon 1737–53. As well as such fantasies and decorations, he painted a few portraits and religious works.

Dimier, Vol. II (M.L. Bataille).

LANCRET, Nicolas (Paris 1690 – id. 1743)
Pupil of Gillot (q.v.) and rival of Watteau, he was a painter of *fêtes galantes* (*reçu* as such in 1719), scenes from the stage and the dance, and portraits.

G. Wildenstein, *Lancret*, 1924.

LARGILLIÈRE, Nicolas de
(Paris 1656 – id. 1746)
Trained in Antwerp, he also studied with Peter Lely in England 1674–80. Principally a portrait painter (of the urban bourgeoisie rather than the court), he also made history paintings, landscapes and still life. *Agréé* 1683; *reçu* 1686; rose to become Directeur of the Académie 1738–42.

G. Pascal, *Largillière*, 1928.

LA TOUR, Maurice Quentin de
(Saint-Quentin 1704 – id. 1788)
A highly successful portraitist in pastel, he was *agréé* 1737, *reçu* 1746. He exhibited at the Salon 1737–87.

A. Besnard, *La Tour*, 1928.

LEGILLON, Jean-François
(Bruges 1739 – Paris 1737)
Pupil of J.-B. Descamps at Rouen, he went to Rome in 1770 for four years. In Paris he was *agréé* 1788, *reçu* 1789, and exhibited landscapes and minor genre at the Salon 1789–95. His manner sometimes recalls Hubert Robert.

D. Coeckelberghs, *Les peintres belges à Rome de 1700 à 1830*, Brussels/Rome, 1976, pp. 400–1.

LEMOYNE, François (Paris 1688 – id. 1737)
Pupil of Louis Galloche (1670–1761), he won the Prix de Rome 1711. *Agréé* 1716; *reçu* 1718. 1723–4 with his patron, a M. Berger, in Rome, Bologna, and Venice, where he especially admired Veronese. His sumptuous and elegant style was passed on to his pupils Natoire and Boucher.

Dimier, Vol. I (C. Saunier).

LÉPICIÉ, Nicolas-Bernard
(Paris 1735 – id. 1784)

Son of François-Bernard Lépicié, engraver and Secrétaire de l'Académie, and a pupil of Carle Van Loo. Prix de Rome 1759; *agréé* 1764; *reçu* 1769 as a history painter; Professeur 1780. He exhibited at the Salon 1765–85. A history painter until the early 1770s, he devoted his last ten years to genre, reminiscent of Greuze and Chardin. His religious and historical works are dull, but the later works reveal a new spirit of observation.

F. Ingersoll-Smouse, 'Nicolas-Bernard Lépicié', *RAAM*, 43, 1923, pp. 39–43, 125–36, 365–78; 46, 1924, pp. 122–30, 217–28; 50, 1926, pp. 253–76; 54, 1927, pp. 175–86.

LOUTHERBOURG, Philippe-Jacques de
(Strasbourg 1740 – London 1812)

In Paris from 1755, a pupil of Carle Van Loo and J.-G. Wille (1715–1808); also frequented the studio of Francesco-Giuseppe Casanova, a painter of battles and landscapes, and was influenced by Vernet (q.v.). *Agréé* 1763; *reçu* 1767; he exhibited landscapes, battles, genre and shipwrecks at the Salon 1763–79, to critical acclaim. In 1771 he moved to London, where his career forms part of the history of British art.

Philippe-Jacques de Loutherbourg, London (Iveagh Bequest, Kenwood), 1973 (exhibition catalogue by R. Joppien).

MÉNAGEOT, François-Guillaume
(London 1744 – Paris 1816)

In Paris he was a pupil of Deshays (q.v.) and then of Boucher. Prix de Rome 1766, with three years at the Ecole Royale des Elèves Protégés; in Italy 1769–74. *Agréé* 1777; *reçu* 1780; his academic career led to the post of Directeur of the Académie in Rome 1787–92. He exhibited at the Salon (1777–90 and 1806) a range of historical, mythological and religious works.

N. Willk-Brocard, *François-Guillaume Ménageot 1744–1816*, 1978.

MICHEL, Georges (Paris 1763 – id. 1843)

He trained initially under an obscure history painter from the Académie de Saint-Luc. However, he was more devoted to nature than the ideal, and turned to landscape. He gained employment as a draughtsman and as a copyist and restorer, especially of Dutch and Flemish seventeenth-century works. He exhibited at the open Salons of the 1790s and until 1814.

A. Sensier, *Etude sur Georges Michel*, 1873; *De David à Delacroix* (no. 131).

MOREAU, Louis-Gabriel, the Elder
(Paris 1739 – id. 1805)

Landscape painter in gouache, watercolour, and oil. Pupil of the architectural and topographical painter P.-A. de Machy (1723–1807), he was refused admission to the Académie in 1787 and 1788, and was only able to exhibit at the open Salons after 1791. Previously he showed at the Salon de la Jeunesse, the Salon de la Correspondance, and the Académie de Saint-Luc. While we admire the fresh observation of his oil view-paintings, he was more productive of gouaches, which are mild rococo caprices.

G. Wildenstein, *Un peintre de paysage au XVIIIe siècle: Louis Moreau*, 1923.

NATOIRE, Charles-Joseph
(Nîmes 1700 – Castel Gandolfo 1777)

Pupil of Galloche and Lemoyne (q.v.), he won the Prix de Rome in 1721. In Italy 1723–8, under the guidance of Vleughels (q.v.). *Agréé* 1728; *reçu* 1734 as a history painter; his academic career led him to the post of Directeur of the Académie in Rome in 1751, but he was too lax for the more classicizing climate of the 1770s and had to resign in 1774. He worked in all the genres, exhibiting at the Salon 1737–57. Ennobled 1756.

Charles-Joseph Natoire, Troyes, Nîmes and Rome, 1977 (exhibition catalogue by I. Julia *et al.*); *Don Quichotte vu par un peintre du XVIIIe siècle: Natoire*, Compiègne and Aix-en-Provence, 1977 (exhibition catalogue by O.P. Sebastiani).

NATTIER, Jean-Marc (Paris 1685 – id. 1766)

Son of a portrait painter, Nattier studied under Jeaurat (q.v.) and Rigaud (q.v.). *Reçu* 1718 as a history painter, he nonetheless devoted himself to the portrait. He exhibited at the Salon 1737–63, and had risen to the post of Professeur by 1752.

Dussieux; P. de Nolhac, *Nattier*, 1925; Dimier, Vol. II (G. Huard).

OUDRY, Jean-Baptiste
(Paris 1686 – Beauvais 1755)

First instructed by his father, Oudry was mainly formed by Largillière (q.v.), who encouraged an interest in all the genres. *Agréé* in 1717; *reçu* 1719 as a history painter; Professeur 1743. He remained above all a painter of still life, landscape, hunting scenes, and Louis XV's dogs. He also worked for the courts of Sweden, Denmark and Mecklenburg. He exhibited at the Exposition de la Jeunesse 1722–5, and at the Salon 1737–53.

Dussieux; H. N. Opperman, *Jean-Baptiste Oudry*, 2 vols., New York, 1977.

PATER, Jean-Baptiste-Joseph
(Valenciennes 1695 – Paris 1736)
Son of a sculptor who was a friend of Watteau, and from the same native town, Pater was Watteau's pupil in 1713 and returned to work with him in 1721. *Reçu* 1728. His imitations of Watteau had considerable success.

F. Ingersoll-Smouse, *Pater*, 1928.

PERRIN, Jean-Charles-Nicaise
(Paris 1754 – id. 1831)
Pupil of Doyen (q.v.) and Durameau (q.v.), he shared second place in the Prix de Rome with Regnault (q.v.); Rome 1780–84; *agréé* 1786; *reçu* 1787 as a history painter. He exhibited at the Salon 1787–1822.

De David à Delacroix (no. 137).

PEYRON, Jean-François-Pierre
(Aix-en-Provence 1744 – Paris 1814)
Pupil of Michel-François Dandré-Bardon (1700 –83), then of Louis-Jean-François Lagrenée in Paris, he won the Prix de Rome in 1773. In Rome 1775–82 under the directorship of Vien (q.v.). In the shadow of his peer David, he virtually gave up painting after 1789. He exhibited at the Salon 1787–1812.

De David à Delacroix (nos. 138–41).

PIERRE, Jean-Baptiste-Marie
(Paris 1713 – id. 1789)
Pupil of Natoire; Prix de Rome 1734; Rome 1735–40 under the directorship of de Troy. *Agréé* 1741; *reçu* 1742 as a history painter; 1744 Professeur; 1768 Adjoint-à-Recteur; 1770 Directeur of the Académie and Premier Peintre du Roi, following Boucher. In these latter posts he was a powerful force, with d'Angiviller, in reforming French painting along more serious and academic lines, in reaction to the manner of Boucher, Natoire, and their generation. He exhibited at the Salon 1741–69, devoting his last twenty years to academic administration.

PILLEMENT, Jean (Lyons 1728 – id. 1808)
In Lyons he trained under the obscure Daniel Sarrabat; later, in Paris, he produced designs for Gobelins tapestries. In 1745 he went to Spain, and later travelled throughout Europe. A prolific landscape painter, he placed a pastoral staffage in idyllic rococo settings derived from Domenchin de Chavannes (q.v.) and Boucher. But he also made works of keener observation, and shipwrecks and coast scenes in the manner of Vernet.

RAOUX, Jean (Montpellier 1677 – Paris 1734)
Trained in Montpellier, and then in Paris under Bon Boullogne (1649 – 1717), he won the Prix de Rome in 1704. After spending three years in Rome, Florence and Venice, 1711–14, he returned to Paris. *Reçu* as a history painter, he later devoted himself to fanciful portraits rendered by artificial light in the manner of Schalken, and to portraits of scantily clad actresses in mythological roles.

Dimier, Vol. II (G. Bataille).

REGNAULT, Jean-Baptiste
(Paris 1754 – id. 1829)
Pupil of Jean Bardin, with whom he travelled to Italy. Back in Paris in 1775, he won the Prix de Rome the following year, and returned to Rome. In Italy his works were much admired, by Anton Raphael Mengs among others. *Agréé* 1782; *reçu* 1783; he pursued a successful academic career, painting history, mythology and portraits throughout the Empire and Restoration period. He exhibited at the Salon 1783–95.

De David à Delacroix (nos. 148–52).

RESTOUT, Jean (Rouen 1692 – Paris 1768)
Pupil of his uncle Jouvenet (q.v.), he was *agréé* 1717, and *reçu* 1720 as a history painter. In 1729 he married into the Hallé family, linking himself to another dynasty of history painters. He had a successful academic career, becoming Professeur in 1733 and Directeur of the Académie in 1760. Essentially a religious painter in the tradition of Jouvenet, he produced some secular works and a few portraits. He exhibited at the Salon 1737–63.

Jean Restout, Rouen, 1970 (exhibition catalogue by P. Rosenberg and A. Schnapper).

RIGAUD, Hyacinthe
(Perpignan 1659 – Paris 1743)
From an old family of painters, he studied under his uncle Jean Ranc at Montpellier, coming in 1681 to Paris, where Le Brun encouraged him to become a portrait painter. *Agréé* in 1684, he won the Prix de Rome in 1685 but did not visit Italy. *Reçu* 1700 as a history painter, he nevertheless made his reputation as portraitist, and was commissioned that year to portray Felipe V of Spain and Louis XIV. An admirer of Van Dyck, he too had a European reputation, and painted the top ranks of court, Church and Parisian society. Ennobled in 1727, he became Directeur of the Académie in 1733.

Dussieux; J. Roman, *Le livre de raison du*

peintre Hyacinthe Rigaud, 1919; C. Colomer, *Hyacinthe Rigaud, 1659–1743*, Perpignan, 1973.

ROBERT, Hubert (Paris 1733 – id. 1808)
Pupil of the sculptor M.-A. Slodtz, he went to Rome in 1754 under the sponsorship of the Duc de Choiseul, then French Ambassador. In Italy until 1765, he travelled widely, visiting Naples with the Abbé de Saint-Non. *Agréé* and *reçu* in 1766 with an architectural caprice based on his Roman experience, he continued to paint fanciful Italianate landscapes and ruin-pieces; he also painted contemporary Parisian scenes. He exhibited at the Salon 1767–98.

C. Gabillot, *Hubert Robert et son temps*, 1895; M. Beau, *La collection des dessins d'Hubert Robert au Musée de Valence*, Lyons, 1968.

ROSLIN, Alexandre
(Malmö, Sweden, 1718 – Paris 1793)
Trained under the Swedish court painter G.E. Schröder (1684–1750), he travelled in Italy 1748–51 before coming to Paris in 1752. Exhibiting regularly at the Salon from 1750, he was especially protected by the daughters of Louis XV, and also successfully portrayed artists and intellectuals. *Reçu* in 1753, during the next two decades he was highly fashionable. 1774–8 he travelled to Sweden, Russia, Poland, and Vienna, but after this period his work was less fashionable in Paris.

G. W. Lundberg, *Röslin Liv och Verk*, Malmö, 1957.

SAINT-AUBIN, Gabriel-Jacques de
(Paris 1724 – id. 1780)
Having tried unsuccessfully in the early 1750s to establish a career as an academic painter, he turned to engraving and drawing, and was an especially keen observer of the Parisian scene.

E. Dacier, *Gabriel de Saint-Aubin, peintre, dessinateur et graveur*, 2 vols., 1929–31.

SUBLEYRAS, Pierre
(Saint-Gilles-du-Gard 1699 – Rome 1749)
Trained in the studio of Antoine Rivalz in Toulouse, he went to Paris in 1726. 1727 Prix de Rome; 1728–35 at the Académie in Rome. Sponsored by the French Ambassador, the Duc de Saint-Aignan, Pope Benedict XIV and others, he was able to continue a celebrated career in Rome, where he was one of the leading painters in the 1740s. He did not exhibit in Paris, but his reputation was high and his influence considerable. Essentially a painter of religious works, he also made portraits and genre paintings.

Dimier, Vol. II (O. Arnaud); M. Poch-Kalous, *Pierre Subleyras in der Gemäldegalerie der Akademie der bildenden Künste in Wien*, Vienna, 1969.

SUVÉE, Joseph-Benoît
(Bruges 1743 – Rome 1807)
First trained in the new Bruges Academy, he went to Paris in 1763 and entered the studio of Jean-Jacques Bachelier. In 1771 he won the Prix de Rome at the third attempt. In Rome 1772–8, where he was influenced by the classicizing manner of Vien (q.v.) and the current interest in antiquity. *Agréé* 1778; *reçu* 1780 as a history painter; Professeur 1790; exhibited at the Salon 1779–96. Directeur of the Académie in Rome for a short time in 1792, until it was abolished; returning to the reinstated post in 1801, he took the institution from the Palazzo Mancini to the Villa Medici. A rarefied and idealizing history painter, he also made incisive portraits.

D. Coeckelberghs, *Les peintres belges à Rome de 1700 à 1830*, Brussels/Rome, 1976, pp. 214–24.

TOCQUÉ, Louis (Paris 1696 – id. 1772)
Son of an architectural painter, he trained under the history painter Nicolas Bertin (1668–1736), and under Rigaud (q.v.) and Nattier (q.v.). *Agréé* 1731; *reçu* 1734 as a portrait painter. He painted official portraits of the royal family, and also less formal ones of the bourgeoisie and of artists. He travelled to Russia 1756–8 to paint Catherine II, and also to Denmark. Exhibited at the Salon 1737–59.

A. Doria, *Louis Tocqué*, 1929.

TROY, François de
(Toulouse 1645 – Paris 1730)
Son of a portrait painter, and father of Jean-François (q.v.). He trained mainly in Paris, and was *reçu* into the Académie in 1674 as a history painter. He executed mainly portraits, however, exhibiting many at the Salons of 1699 and 1704. He had a successful academic career, becoming Directeur of the Académie in 1708.

P. Detroy, 'François de Troy, 1645–1730', *Etudes d'art publiées par le Musée National d'Alger*, 12–13, 1955–6, pp. 213–58.

TROY, Jean-François de
(Paris 1679 – Rome 1752)
Pupil of his father François (q.v.), he travelled independently to Italy 1699–1707; *reçu* 1708 as a history painter, he followed a sound academic career, and replaced Vleughels (q.v.) as Direc-

teur of the Académie in Rome in 1738. He exhibited at the Salon 1737–50. Mainly a productive, robust and eclectic history painter, especially of tapestry cartoons for the Gobelins, he also made portraits, genre scenes and landscapes.

Dussieux; Dimier, Vol. II (G. Brière); A. Busiri Vici, 'Opere romane di Jean de Troy', *Antichità Viva*, IX, 2, Rome, 1970, pp. 2–20.

VALENCIENNES, Pierre-Henri de
(Toulouse 1750 – Paris 1819)
First trained in Toulouse, in 1773 he entered the Paris studio of Gabriel-François Doyen (q.v.), who must have taught the highest ideals of academic art. In Italy 1777–86, he absorbed the lessons of Italian art and also painted fresh oil studies in the open air, probably on the advice of Vernet. At the same time as David's regeneration of history painting during the 1780s, Valenciennes revived the ideal 'historical landscape' of seventeenth-century precedent, and this led to the creation of a special Prix de Rome for landscape in 1816. He exhibited at the Salon 1787–1814.

P.-H. de Valenciennes, *Elémens de perspective pratique . . . suivis de réflexions et conseils . . . sur le genre du paysage*, 1799–1800 (2nd edn. 1820); *Pierre-Henri de Valenciennes*, Toulouse, 1956 (exhibition catalogue by R. Mesuret); *Les paysages de Pierre-Henri de Valenciennes*, Paris, 1976 (exhibition catalogue by G. Lacambre).

VAN LOO, Carle (Charles-André)
(Nice 1705 – Paris 1765)
The most important of a dynasty of artists, Carle studied early with his elder brother Jean-Baptiste in Turin and Rome (1712–19). Prix de Rome 1724; in Italy again 1727–34. *Reçu* 1735 as a history painter; Professeur 1737; Recteur 1754; Directeur of the Académie 1763. Made Premier Peintre du Roi in 1762, he was regarded as the leading history painter of France; he worked mainly in this genre, but also made portraits and decorative works. In charge of the Ecole Royale des Elèves Protégés in 1749. He exhibited at the Salon 1737–65.

M.-F. Dandré-Bardon, *Vie de Carle Vanloo*, 1765; *Carle Vanloo*, Nice, Clermont-Ferrand and Nancy, 1977 (exhibition catalogue by M.-C. Sahut).

VAN LOO, Louis-Michel
(Toulon 1707 – Paris 1771)
Son and pupil of Jean-Baptiste Van Loo and nephew of Carle (q.v.), he won the Prix de

Rome in 1725; in Italy 1727–33. *Reçu* 1733, he was portrait painter to the Spanish court until 1752. Returning to France, he exhibited at the Salon 1753–69. A conscientious portraitist, he is perhaps more consistent, but less ambitious, than his more celebrated uncle.

VERNET, Claude-Joseph
(Avignon 1714 – Paris 1789)
Trained at Avignon and Aix-en-Provence, he established his reputation as a landscape and marine painter in Italy, 1734–53. *Agréé* 1746; *reçu* 1753 as a marine painter; Conseiller 1766. His most important commission was for the *Ports of France*, executed 1754–65. He exhibited at the Salon 1746–89.

L. Lagrange, *Joseph Vernet et la peinture au XVIIIe siècle*, 1864; F. Ingersoll-Smouse, *Joseph Vernet, peintre de marine*, 1926; *Claude-Joseph Vernet*, London (Iveagh Bequest, Kenwood) and Paris, 1976 (exhibition catalogue by P. Conisbee).

VESTIER, Antoine (Avallon 1740 – Paris 1824)
Studied under Pierre (q.v.) in 1760; travelled in England and Holland; exhibited at the Salon 1781 and 1785–1806; *agréé* 1785; *reçu* 1787. One of the leading portraitists of the end of the *ancien régime*.

P. Dorbec, 'Antoine Vestier', *RAAM*, 29, 1911, pp. 362–76; see also under Colson.

VIEN, Joseph-Marie
(Montpellier 1716 – Paris 1809)
Coming to Paris in 1740, he studied under Natoire and won the Prix de Rome in 1743. In Rome 1744–50, under Jean-François de Troy. Influenced by Pompeo Batoni and his circle, he became interested in seventeenth-century painting, and also in working from life and from nature: this led him away from the suave elegance of Natoire's generation. He played a part in the 1760s revival of religious painting in Paris. Encouraged by the antiquarian Comte de Caylus, he also pioneered a style '*à la grecque*' relying directly on ancient classical prototypes. His exemplary academic career led to an appointment as head of the Ecole Royale des Elèves Protégés; to the directorship of the French Académie in Rome 1775–81; and to the directorship of the Paris Académie and the post of Premier Peintre du Roi in 1789. He encouraged such important young artists as David, Peyron, and Vincent (qq.v.).

F. Aubert, 'Joseph-Marie Vien', *GBA*, Period I, 22, i, 1867, pp. 180–90, 282–94, 493–

507; 1867, ii, pp. 175–87, 297–310, 470–82; *De David à Delacroix* (nos. 193–4); T. Gaehtgens, 'J.-M. Vien et les peintures de la Légende de sainte Marthe', *Revue de l'art*, 33, 1974, pp. 64–9.

VIGÉE-LEBRUN, Marie-Louise-Elisabeth
(Paris 1755 – id. 1842)
Daughter of a portraitist and pastellist, she was encouraged by friends of her father, such as Doyen and Vernet. She also studied Rubens and old masters in Paris, and the fancy-portraits of Greuze. She married the dealer J.-P.-B. Lebrun in 1776. *Reçue* 1783 with Adélaïde Labille-Guiard (q.v.). She held a highly fashionable *salon*. During the Revolution she took refuge in Italy, Vienna, and St Petersburg, later travelling to England and Switzerland; with the Restoration, she was back in favour again. She exhibited at the Salon 1783–91, 1798, 1817, 1824.

E. Vigée-Lebrun, *Souvenirs*, 3 vols., 1835–7; P. de Nolhac, *Madame Vigée-Lebrun, peintre de la reine Marie-Antoinette*, 1908.

VINCENT, François-André
(Paris 1746 – id. 1816)
Pupil of Vien, he won the Prix de Rome in 1768; after studying at the Ecole des Elèves Protégés, he was in Rome 1771–5; *agréé* 1777; *reçu* 1782; Professeur 1792. Exhibited at the Salon 1777–1801. He was one of the artists favoured by d'Angiviller to promote his campaign to revive French history painting during the 1770s and 1780s.

De David à Delacroix (nos. 199–202.)

VLEUGHELS, Nicolas
(Paris 1668 – Rome 1737)
Son and pupil of a Flemish painter, Vleughels was in Italy c. 1706–13, and especially in the north, where he admired Veronese and Venetian art. *Reçu* 1716 as a history painter. In Paris he was of the circle of the collector Pierre Crozat, and a friend of Watteau. Directeur of the Académie in Rome from 1724, he was a successful and liberal teacher, fostering such talented artists as Boucher, Natoire, Carle Van Loo, and Subleyras (qq.v.).

B. Hercenberg, *Nicolas Vleughels*, 1975.

VOLAIRE, Pierre-Jacques
(Toulon 1729 – Naples 1802?)
One of a family of painters from Toulon, Volaire began his career when Vernet came there in 1754 and employed him as an assistant on the *Ports of France* commission he was then beginning. Volaire went to Rome in 1764, and finally settled in Naples in 1769. He painted views of Naples and environs, imaginary coast scenes derived from Vernet, and above all eruptions of Vesuvius. He exhibited in Paris, at the Salon de la Correspondance, in 1779, 1783, and 1786.

M. Causa Picone, 'Volaire', *Antologia di Belle Arti*, 5, London, 1978, pp. 24–48.

WATTEAU, Jean-Antoine
(Valenciennes 1684 – Nogent-sur-Marne 1721)
Trained first in Valenciennes, in Paris by 1702. He was in the studio of Gillot (q.v.) c. 1704–8, and then with Claude Audran (1658–1734). Having gained an interest in the theatre from Gillot, Audran then taught him the art of decorative arabesque. In 1709 he failed to win the Prix de Rome; but he studied Italian—especially Venetian—art in the collection of his friend Pierre Crozat, his sponsor during the next decade. In 1712 it was proposed that he should prepare a *morceau de réception* for the Académie, and he was finally *reçu* in 1717 as a *peintre de fêtes galantes*, his own individual genre. He died of tuberculosis in 1721, after a visit to London.

E. Dacier and A. Vuaflart, *Jean de Jullienne et les graveurs de Watteau au XVIIIe siècle*, 4 vols., 1922–9; H. Adhémar, *Watteau, sa vie, son œuvre*, 1950; E. Camesasca and P. Rosenberg, *Tout l'œuvre peint de Watteau*, 1970; D. Posner, 'Watteau mélancolique: la formation d'un mythe', *BSHAF*, 1973, pp. 345–61.

SELECT
BIBLIOGRAPHY

SELECT BIBLIOGRAPHY

This list includes the major published sources and a selection of general works and exhibition catalogues, some of which are also cited in abbreviated form under the biographical notes on individual artists (pp. 203 ff.). The important monographs and articles on individual artists are listed only with their biographical notes, and are not included here. Unless otherwise stated, the place of publication is Paris.

SOURCES

A great deal of the source material for our period has been published, especially towards the end of the last century, the great era of French archivists. In addition to the books cited, there is much to be found in the pages of: *Archives de l'art français*, 1851–65, 1879–85, 1907– ; *Nouvelles archives de l'art français*, 1872–8, 1884–1906; *Bulletin de la Société de l'Histoire de l'Art Français (BSHAF)*, 1875–8, 1907– ; *Revue de l'art ancien et moderne (RAAM)*, 1897–1913; *Revue universerselle des arts*, 1855–66.

L. Dussieux *et al.*, *Mémoires inédits sur la vie et les ouvrages des membres de l'Académie Royale de peinture et de sculpture*, 2 vols., 1854–6; Vol. 2 contains the eighteenth-century material (cited below as Dussieux).

F. Engerand, *Inventaire des tableaux commandés et achetés par la Direction des Bâtiments du Roi (1709–1792)*, 1901; essential for official patronage.

P. J. Mariette, *Abécédario de P. J. Mariette*, ed. P. de Chennevières and A. de Montaiglon, 6 vols., 1851–60; includes critical biographies of some eighteenth-century artists to *c.* 1760.

A. de Montaiglon (ed.), *Procès-verbaux de l'Académie Royale de peinture et de sculpture, 1648–1792*, 10 vols., 1875–92; proceedings of the Académie.

A. de Montaiglon and J. J. Guiffrey (eds.), *Correspondance des Directeurs de l'Académie de France à Rome*, 17 vols., 1887–1912.

J. Guiffrey (ed.), *Collection des livrets des anciennes expositions*, 5 vols., 1869–71 (reprinted by microfilm-xerography, London, 1978); reprints the *livrets* of the Paris Salons, 1673–1800.

J. Guiffrey, *Notes et documents inédits sur les expositions du XVIIIe siècle*, 1873.

The most readily accessible Salon criticism is that of Denis Diderot, for the years 1759–81: *Diderot: Salons*, ed. J. Adhémar and J. Seznec, 4 vols., Oxford, 1957–67; but a reading of Diderot should be complemented with other Salon critics, such as La Font de Saint-Yenne, Abbé Le Blanc, Charles-Nicolas Cochin, some of whose work has been reprinted in recent years. These critics can best be consulted (by scholars) in the Deloynes Collection at the Bibliothèque Nationale, Paris; there is a catalogue of this Collection by G. Duplessis, 1888. For a modern study of French art criticism before Diderot, based on this Collection, see H. Zmijewska, 'La critique des Salons en France avant Diderot', *Gazette des Beaux-Arts*, Period VI, 76, 1970, pp. 6–144.

SELECT BIBLIOGRAPHY

GENERAL WORKS

It is not intended here to list periodical articles of a general nature; but the periodicals cited under Sources, above, should be consulted, and the *Gazette des Beaux-Arts (GBA)*, 1859–, also has much relevant material. The latest research is most often found in the *Bulletin de la Société de l'Histoire de l'Art Français*, 1907– ; *La revue de l'art*, 1968– ; and *La revue du Louvre*, 1951– , in addition to the standard English-language art history journals.

There is no study of the Académie in the eighteenth century, but A. de Montaiglon, *Mémoires pour servir à l'histoire de l'Académie Royale de peinture et de sculpture*, 1853, and L. Vitet, *L'Académie Royale de peinture et de sculpture*, 1861, are thorough accounts of its foundation, early decades, and principles. Useful on art education in the mid eighteenth century is L. Courajod, *L'Ecole Royale des Elèves Protégés*, 1874. A specific aspect of art education is studied by J. H. Rubin *et al.*, *Eighteenth-century French life-drawing*, Princeton, 1977. For all aspects of official artistic life in the second half of the century, see the indispensable classic: J. Locquin, *La peinture d'histoire en France de 1747 à 1785*, 1912 (reprinted 1978, with an excellent anthology of illustrations). For art theory, Locquin can be supplemented by A. Fontaine, *Les doctrines d'art en France de Poussin à Diderot*, 1909. French neoclassical art is put in its international context by R. Rosenblum, *Transformations in late-eighteenth-century art*, Princeton, 1967. A classic on the last decade of the century is F. Benoît, *L'art français sous la Révolution et l'Empire*, 1897.

For the transition from the seventeenth to the early eighteenth century, consult: P. Marcel, *La peinture française au début du dix-huitième siècle 1690–1721*, 1906; A. Blunt, *Art and architecture in France 1500–1700*, Harmondsworth, 1953; *Au temps du Roi Soleil: les peintres de Louis XIV*, Lille, 1968 (exhibition catalogue by A. Schnapper, cited above as Schnapper, 1968).

As a historical curiosity, consult E. and J. de Goncourt, *L'art du XVIIIe siècle*, 3 vols., 1880–4 (a good English selection, translated and edited by R. Ironside, *French XVIII century painters*, London, 1948; reprinted Oxford, 1981). More useful general works are W. Graf Kalnein and M. Levey, *Art and architecture of the eighteenth century in France*, Harmondsworth, 1972 (but still with a 'Goncourt' bias in the treatment of painting) and L. Dimier (ed.), *Les peintres français du XVIIIe siècle*, 2 vols., Paris/Brussels, 1928–30, which has individual biographies by different authors (cited above as Dimier, with name of author in parenthesis). For the architectural context, L. Hautecœur, *Histoire de l'architecture classique en France*, Vol. III 1950, Vol. IV 1952; F. Kimball, *The creation of the Rococo*, Philadelphia, 1943 (and New York 1964); and M. Gallet, *Paris domestic architecture of the eighteenth century*, London, 1972.

Three recent exhibition catalogues, incorporating new research, are: *De Watteau à David: peintures et dessins des musées de province français*, Brussels, 1975 (by various authors); *The age of Louis XV: French painting 1710–1774*, Toledo, Chicago and Ottawa, 1976 (by P. Rosenberg); *De David à Delacroix: la peinture française de 1774 à 1830*, Paris, Detroit and New York, 1974–5 (by various authors; cited above as *De David à Delacroix*).

The great biographical dictionary, which also cites published source references, is E. Bellier de la Chavignerie and L. Auvray, *Dictionnaire général des artistes de l'école française*, 5 vols., 1882–7 (reprinted New York, 1979).

ACKNOWLEDGEMENTS
AND INDEX

ACKNOWLEDGEMENTS

The author and publishers would like to thank all those who have given permission for works in their collections to be reproduced and who have supplied photographs for use in the book. The following sources are acknowledged for specific photographs:

Alinari, Florence: Figs. 46, 117

Musée d'Angers: Fig. 55

Arts Council of Great Britain: Fig. 160

Bibliothèque Nationale, Paris: Figs. 2, 4, 5, 6, 10, 11, 12, 13, 14, 20, 24, 29, 30, 35

Bulloz, Paris: Col. Pl. 3; Figs. 3, 7, 9, 15, 31, 34, 36, 44, 45, 48, 49, 53, 60, 61, 71, 87, 91

Caisse Nationale des Monuments Historiques et des Sites, Paris (© Arch. Phot. Paris/S.P.A.D.E.M.): Figs. 17, 19, 21, 26, 37, 50, 81

Courtauld Institute of Art, London: Figs. 32, 115, 122, 155, 156

Jean Dieuzaide, Toulouse: Fig. 77

France-Publicité: Fig. 41

Giraudon, Paris: Figs. 25, 57, 125, 131, 136, 138, 157; Lauros-Giraudon, Figs. 28, 39, 40, 67, 73, 95, 124, 133, 134, 145

André Held, Ecublens: Fig. 47

IFOT, Grenoble: Figs. 38, 79

Photo MADEC, Nantes: Fig. 158

Claude O'Sughrue, Montpellier: Figs. 100, 107, 152

Réunion des Musées Nationaux, Paris: Col. Pls. 5, 6, 7, 12, 16; Figs. 8, 18, 23, 33, 51, 52, 54, 59, 62, 64, 65, 69, 70, 72, 75, 76, 78, 83, 84, 86, 88, 89, 92, 97, 99, 104, 105, 108 (and frontispiece), 111, 113, 119, 120, 121, 123, 135, 139, 140, 146, 147, 148, 150, 153, 159, 161, 167, 169, 170

Royal Academy of Arts, London: Figs. 82, 154

Joseph P. Ziolo, Paris: Col. Pls. 1 (photo K. Takase), 2 (photo Babey)

Col. Pl. 13 and Fig. 171 are reproduced by permission of The Bowes Museum, Barnard Castle, Co. Durham; Figs. 106, 127 and 128 are copyright The Frick Collection, New York; Figs. 85, 110, 130: all rights reserved, The Museum of Modern Art, New York; Figs. 101 and 116 are reproduced by courtesy of the Trustees of the National Gallery; Col. Pl. 4 and Figs. 90 and 137 are reproduced by permission of the Trustees of the Wallace Collection.

INDEX